After Disruption

After Disruption

A Future for Cultural Memory

TREVOR OWENS

UNIVERSITY OF MICHIGAN PRESS
ANN ARBOR

Copyright © 2024 by Trevor Owens
Some rights reserved

This work is licensed under a Creative Commons Attribution-NonCommercial 4.0 International License. *Note to users*: A Creative Commons license is only valid when it is applied by the person or entity that holds rights to the licensed work. Works may contain components (e.g., photographs, illustrations, or quotations) to which the rightsholder in the work cannot apply the license. It is ultimately your responsibility to independently evaluate the copyright status of any work or component part of a work you use, in light of your intended use. To view a copy of this license, visit http://creativecommons.org/licenses/by-nc/4.0/

For questions or permissions, please contact um.press.perms@umich.edu

Published in the United States of America by the
University of Michigan Press
Manufactured in the United States of America
Printed on acid-free paper
First published May 2024

A CIP catalog record for this book is available from the British Library.

Library of Congress Cataloging-in-Publication Data

Names: Owens, Trevor, author.
Title: After disruption : a future for cultural memory / Trevor Owens.
Description: Ann Arbor : University of Michigan Press, 2024. | Includes bibliographical references and index.
Identifiers: LCCN 2023056375 (print) | LCCN 2023056376 (ebook) | ISBN 9780472076673 (hardcover) | ISBN 9780472056675 (paperback) | ISBN 9780472904365 (ebook other)
Subjects: LCSH: Culture. | Collective memory. | Digital preservation. | Information services. | Preservation of materials. | Disruptive technologies. | BISAC: LANGUAGE ARTS & DISCIPLINES / Library & Information Science / General | LANGUAGE ARTS & DISCIPLINES / Library & Information Science / Archives & Special Libraries
Classification: LCC HM621 .O93 2024 (print) | LCC HM621 (ebook) | DDC 306—dc23/eng/20240205
LC record available at https://lccn.loc.gov/2023056375
LC ebook record available at https://lccn.loc.gov/2023056376

DOI: https://doi.org/10.3998/mpub.12410213

The University of Michigan Press's open access publishing program is made possible thanks to additional funding from the University of Michigan Office of the Provost and the generous support of contributing libraries.

Contents

Acknowledgments	vii
ONE. Cultural Memory and the Future	1
Part One: Three Bankrupt Ideas	
TWO. What Disruption Wants	21
THREE. Where Data Drives	43
FOUR. Why Memory Work Doesn't Work	79
Part Two: Three Ways Forward	
FIVE. The Maintenance Mindset	113
SIX. Concentric Circles of Care	135
SEVEN. Repair, Revision, and Return	156
EIGHT. A Future for Cultural Memory	181
Bibliography	197
Index	211

Digital materials related to this title can be found on the Fulcrum platform via the following citable URL: https://doi.org/10.3998/mpub.12410213

Acknowledgments

The ideas for this book started coming together toward the end of 2020. In that context, it is very much inspired by reflections on my work and career in the midst of the COVID-19 pandemic. Given the nature of my work and the teams I work with, I was able to work safely from home throughout roughly two years of the pandemic. So, for starters, I would like to acknowledge all the people whose work made it possible for me to do that. The staff at the Yes Organic Market around the corner from our home who made sure that we had access to food. The sanitation workers in Prince George's County who made sure that the trash and recycling were collected and processed. The people who worked in any number of similarly critical roles who were not able to work from home, particularly during the earliest period of the pandemic. Without all the maintenance and care work at the heart of contemporary infrastructure, research and scholarship like this wouldn't be possible.

A key catalyst for writing this book was the invitation to give the Elizabeth W. Stone Lecture for Catholic University's Library and Information Science Program. That talk, Caring for Digital Collections in the Anthropocene, served as a bridge from my last book, *The Theory and Craft of Digital Preservation*, into this one. It provided a chance to zoom out a bit from the specific issues of digital preservation to the broader issues facing the future of cultural memory. To that end, I am grateful for the opportunity and the questions I received from the audience.

The research and writing of a few specific people have been particularly inspirational to this book. First off, Bethany Nowviskie's talks and writing on capacity and care in the Anthropocene were a key part of setting me

up on this line of research. David Grinspoon's lectures and writing on the Anthropocene had a similar catalytic effect. Eria Tansey's work and writing on archives and climate change and Ruth Tillman's work and research on equity for labor in libraries and archives have played a key role in shaping ideas in this book. More broadly, I have tremendous gratitude for the full range of scholars and researchers whose work I engage with and attempt to synthesize throughout this book. To that end, consider my bibliography and the end notes of this book as an extension of this set of written acknowledgements.

This book draws on lessons and experiences from each of the places I have had the privilege to work. I want to make sure I acknowledge that up front. I owe much of my career to the opportunities that I was given when I started as the "technology evangelist" for the Zotero project at the Roy Rosenzweig Center for History and New Media. Before he passed away, Roy made an extensive and lasting impression on those of us lucky enough to work for him. My constant hope is that the compassion, dedication, and pragmatism Roy brought into every day of his work at the Center come through in my own. Despite everything he had going on, he was very generous with his time and feedback on work. My understanding of and appreciation for issues in digital history and the future of cultural-memory institutions were sparked by four years of discussion and collaboration with colleagues there: Dan Cohen, Josh Greenberg, Sean Takats, Tom Scheinfeldt, Sharon Leon, Sheila Brennan, Dave Lester, Jeremy Boggs, Jim Safley, Kari Kraus, Connie Moon Sehat, Miles Kelly, Mindy Lawrence, Jon Lesser, Kris Kelly, Ken Albers, Faolan Cheslack-Postava, John Flatness, Dan Stillman, Christopher Hamner, and many others.

When I joined the Library of Congress in 2010, I was invited into an amazing community of memory workers. I owe a considerable thanks to a wide range of folks I have learned from there, including Martha Anderson, Abbey Potter, Michelle Gallinger, Jane Mandelbaum, Dan Chudnov, Butch Lazorcheck, Erin Engle, Leslie Johnston, Jefferson Bailey, Abbie Grotke, Ed Summers, Nicholas Taylor, Krisztina Thatcher, Niki Saylor, Chris Adams, Thomas Padilla, Emily Reynolds, Gloria Gonzalez, Jimi Jones, Bertram Lyons, Kate Murray, Caroline Arms, Carl Fleischhauer, Caitlin Stewart, Andrew Cassidy-Amstutz, Kathleen O'Neill, Meg McAleer, Moryma Aydelott, Beth Dulabahn, David Brunton, Kate Zwaard, Robin Dale, Camille Salas, Jesse Johnston, Grace Thomas, Chase Dooley, Lauren Seroka, Mark Lopez, Laurie Allen, Christa Mahar, Dan Krech, Bill Kellum, Carlyn Osborn, Abby Shelton, Lauren Algee, Kristy Darby, Carla

Miller, Al Banks, Steve Morris, Ann Della Porta, Steve Short, Aly DesRochers, Melissa Hire, Mark Cooper, Marcus Nappier, Charlotte Kostelic, Liz Holdzkom, and many others.

Part of this book draws on my experience working in federal grant-making at the Institute of Museum and Library Services. I am grateful for everything I learned from my colleagues at IMLS, in particular Maura Marx, Emily Reynolds, Sarah Fuller, Tim Carrigan, Mary Allice Ball, Ashley Sands, Sandy Toro, Bob Horton, Mary Estelle Kennelly, Gladstone Payton, Nancy Weiss, Calvin Trowbridge, Connie Bodner, Matt Birnbaum, Helen Wechsler, Sarah Glass, Reagan Moore, Mark Feitl, Mark Isaksen, Jill Connors-Joyner, James Neal, Teresa DeVoe, Madison Bolls, and Dennis Nangle.

Across all these places and spaces I've been lucky to have a set of mentors who have taught me so much about how cultural institutions work: Roy Rosenzweig, Dan Cohen, Josh Greenberg, Martha Anderson, Maura Marx, Kim Sheridan, and Richard Staley.

I would also like to thank people who took the time to comment on the public drafts of this book that I shared on my blog: Hillel Arnold, Shannon Mattern, Zack Ellis, Kathleen Fitzpatrick, Bertram Lyons, Maureen Callahan, Eira Tansey, Rick Fitzgerald, Dragan Espenschied, Meredith Martin, Cynthia Boyden, Jen Johnson, John Dewees, Carl Fleischhauer, Steven Lubar, and Maureen Callahan. Many thanks, too, to the team at the University of Michigan Press. My editor Sara Cohen provided great advice and guidance on how to develop the proposal into this full book, my production editor Mary Hashman significantly improved the clarity of my prose, and the anonymous reviewers provided thoughtful suggestions that helped to improve the final version of the book you have in front of you. Many of the strengths of this book are the result of insights from people I've listed here. Its weaknesses are my own. I should add that what follows is my own limited personal perspective anchored in my experience and should not be taken as representing a perspective of any institution I am now or have been affiliated with.

Lastly, and most importantly, I would like to thank and acknowledge Marjee Chmiel. My wife. My constant collaborator. As we always do, we took turns reading the first drafts of each part of each other's books. Many of the ideas here were worked out through discussion over coffee, tea, or wine. You are so present in my life and in my work that it is impossible to articulate specific things to attribute to you. I do know that I really have no idea who I would be or what I would be doing outside of the life we

live together. We did our dissertations together. Each took a turn powering through writing and research while the other made dinner, washed the dishes, and walked the dogs. Your accomplishments inspire me. Your insights refine my thinking. Your thoughtfulness and compassion inspire me to work to be a better person.

CHAPTER I

Cultural Memory and the Future

The digital age is burning out our most precious resources, and the future of the past is at stake. TED Talk–style hype about tech innovation and unending growth is in part responsible for the era of social, economic, cultural, and ecological calamities we are now facing. Our institutions of cultural memory—libraries, archives, museums, humanities departments, and research institutes—have been "disrupted," and largely not for the better.

The future of our past is dependent on the future of cultural-memory institutions and their workers. This is a book about that future. This introductory chapter focuses on establishing a framework for thinking about memory and the future throughout the book. The challenge of the Anthropocene, the era we find ourselves in where humanity has brought itself to the brink of extinction, forces us to question core cultural assumptions in capitalism about technology and our future.[1] Simultaneously, digital media have played a role in changing how we collectively conceptualize memory itself. As a starting point for the book, this chapter focuses on clarifying what is at stake for both the future and memory in the wake of the disruption that the tech sector has brought about in the last half century.

As the tech sector and social media took center stage in cultures of management and management consulting in the '90s and '00s, ideologies of disruption became a driving force in civic, social, and cultural institutions. University deans talk of disruptive innovation. Library directors track key performance indicators on data analytics dashboards. Historians stress the importance of scholars developing their personal brands on Twitter. Along

1. David Grinspoon, *Earth in Human Hands: Shaping Our Planet's Future* (New York: Grand Central Publishing, 2016).

with access to millions of digitized books and an abundance of forms of digital scholarship, we memory workers find ourselves in institutions with increasingly precarious labor, mounting financial challenges that threaten their survival, and among the public, a loss of trust in expert analysis of the historical record. All the while, we continue to be told to be vigilant, and fearful, about the ways that digital technology will still yet disrupt our organizations' futures.

I am describing things that have already happened. This prompts a question: What comes after disruption? Is there anything? Is it just one disruption after another? Tech ideology demands perpetual anxiety about the next coming disruption, then, later, about the next one after that. There is no end state in the rhetorical frame of disruption. Just disruption after disruption. When we recognize that talk of disruption is a rhetorical move and not an actual social or technical fact, we have an opportunity to move beyond disruption discourse to something new. My question to cultural heritage institution leaders and workers is instead, what should we do now, after disruption? How do we make sense of both the good and the bad that have come from our tech-sector-disrupted memory institutions? We are no longer planning for a digital future but living in a digital present. In that context, how do we plan for and develop a more just, sustainable, and healthy future for cultural memory? Over the next century, as sea levels and temperatures rise, we will see a widespread breakdown of norms and assumptions that have driven society over the previous century. At the same time, we have seen growing income inequality and increased precarity for workers in nearly all fields. Given these developments, what is the future of cultural memory in the face of a breakdown in our shared assumptions about both memory and the future? These are the questions this book sets out to answer.

I've used the terms "cultural heritage institutions" and "memory workers" a few times already, and before going further it is necessary to be explicit about what I mean by both those terms, and about who I imagine my audience for this book to be. I intend these terms to broadly refer to all the institutions that function to keep alive and enable access to and use of cultural memory. That includes libraries, archives, museums, planetariums, zoos, botanical gardens, historical societies, universities, colleges, high schools, middle schools, and publishers, among others. In terms of memory workers, I mean librarians, archivists, curators, historians, folklorists, archeologists, anthropologists, K–12 teachers, authors, editors, and journalists. I also recognize that there is a lot of gatekeeping around who counts as having a given status as a worker in any of these kinds of

organizations—for instance, struggles between definitions of professional and "para-professional" roles in any of those organizations. While I believe that credentials and degrees are important, I also respect that a lot of credentialism works to pit workers with different statuses against each other. To that end, when I talk about "memory workers," I intend to be inclusive and broad. Anyone who works for a memory institution and identifies with that work counts for me. I also intend my definition of memory institutions to be inclusive and broad, including but not limited to national libraries, house museums, K–12 schools, institutions of higher education, grassroots community archives, and religious organizations. With that noted, my experience, and many of my examples, draw directly from the areas of work I have the most direct experience in, humanities centers and libraries and archives, but given the crosscutting nature of these issues, I also aim to more broadly engage in issues related to the future of memory work and institutions beyond that experience. As a result of my experience and work in libraries and archives, the book focuses most directly on the work of memory institutions with cultural heritage collections. In this regard, there is a strong focus throughout the book on work with objects and artifacts of memory, on care for those objects, and on considerations of entanglements of relationships and networks of belonging with communities and people over time. So, while I intend the book to be of broad use to anyone working in or with the full range of cultural-memory institutions, it will be most directly applicable and relevant to the work of memory institutions that hold collections.

The central thesis of this book is that it's time for memory workers and memory institutions to take back control of envisioning the future of memory from management consultants and tech-sector evangelists. Before fully diagnosing issues with tech-sector thinking and subsequently weaving together what I've come to believe are better ways to envision a future for cultural memory, it is important to first pick apart assumptions about the future and memory as concepts. Our forward-looking vision of the future and our backward-looking notion of memory have also been warped and shaped by tech-sector thinking, so we must start by addressing them before working through the rest of the issues this book focuses on.

Whose Imagined Future?

Uber, a company that makes an app that loses money quarter over quarter that lets you hail cars much like a taxi, is valued at more than forty billion

dollars.² Before it collapsed in on itself, WeWork, a company that rents office space and then rents that out to individuals, was similarly valued at nearly fifty billion dollars. Those valuations have nothing to do with assets, or really with anything those companies do. They have everything to do with a belief system about the future that financiers and Silicon Valley push. That belief system is anchored in unrealistic notions of limitless growth and an urgency regarding near-term growth at all costs that serve as places to park a huge glut of global investment capital.³ Who sets the terms for how we imagine the future has very real implications for where our societies invest their resources and energy. In this context, it is essential that we second-guess the stories we are told about what futures are and aren't viable.

The tech sector in this third decade of the twenty-first century doesn't have a novel or creative idea or vision for a future, and it shows. It's reheating increasingly unmoored and out-of-touch notions of technolibertarianism. Where the internet was at least rhetorically advanced on liberatory language regarding access and empowerment, the tech sector has moved on to become obsessed with blockchain and cryptocurrencies. While they can try and tell us that blockchain will liberate us all in some way, there are justified suspicions that its actual function is to liberate dark money from being trackable and traceable. In reaction to our climate crisis, tech-sector luminaries like Elon Musk are focused on increasingly outlandish ideas about launching rockets to colonize Mars. That kind of space-colony fantasy is much easier to promulgate and sell than the stark reality that if things get bad enough on Earth, we are going to be far better off trying to terraform this planet back into something we can all live on than terraforming Mars.⁴

In contrast to the tech sector's visions of blockchain-enabled colonization of space, serious scholarship exploring ideas of the future has become darker and more pessimistic. In philosopher Franco Berardi's terms, we

2. Alexis Madrigal, "The Uber IPO Is a Landmark," *The Atlantic*, April 11, 2019, https://www.theatlantic.com/technology/archive/2019/04/ubers-ipo-historic-despite-its-10-billion-loss/586999/

3. For information on Uber, see Hubert Horan, "Will the Growth of Uber Increase Economic Welfare?" *Transportation Law Journal* 44 (2017): 33–105. For information on WeWork, see Matthew Zeitlin, "Why WeWork Went Wrong," *The Guardian*, December 20, 2019, http://www.theguardian.com/business/2019/dec/20/why-wework-went-wrong

4. Mike Berners-Lee, *There Is No Planet B: A Handbook for the Make or Break Years* (Cambridge: Cambridge University Press, 2019).

find ourselves living and working "after the future."[5] In hindsight, somewhere around the great recession of 2008, general faith in technology's potential for progress dimmed. While Google still tells us it exists to organize the world's knowledge, there is growing skepticism about the kinds of algorithmic biases they promote.[6] At the same time, faith in the creative freedom provided by knowledge-work careers lost out to the growth of precarity in the "gig economy."[7] Memory institutions are increasingly offering temporary jobs to individuals who carry more and more student debt. Those lucky enough to find jobs and employment, as librarian Fobazi Ettarh observes, are often further burdened by the logic of vocational awe.[8] Memory-work careers generally come with a notion that the work is a kind of calling or vocation for which memory workers should put up with all kinds of challenges, such as low pay and long hours, for the privilege of practicing their calling. The COVID-19 global pandemic has worked to exacerbate all of these issues. The present and the future grow more dystopian.

In retrospect, the last broad-based positive vision of technological future for our world, and our memory along with it, came at the end of the twentieth century. Berardi calls it "the *Wired* imagination." *Wired* magazine popularized and sold us a vision of a world where we would become netizens, citizens of the internet, who would participate in a free and democratic global electronic commons.[9] As a lead in to the precarity of the gig economy, independent creative professionals were told that their entrepreneurial selves would be continually revolutionizing and democratizing how people and cultures tell their stories and connect with each other through the medium of the open web. The "new economy" of the '90s was supposed to emerge as a place where a creative class of freelancers would find fulfillment and financial success as their own bosses. This is also the context in which notions that "information wants to be free" and the open-source

5. Franco Berardi, *After the Future* (Oakland, CA: AK Press, 2011).

6. Safiya Umoja Noble, *Algorithms of Oppression: How Search Engines Reinforce Racism* (New York: New York University Press, 2018).

7. Anne Helen Petersen, *Can't Even: How Millennials Became the Burnout Generation* (Boston: Houghton Mifflin Harcourt, 2020).

8. Fobazi Ettarh, "Vocational Awe and Librarianship: The Lies We Tell Ourselves," *In the Library with the Lead Pipe*, January 10, 2018, http://www.inthelibrarywiththeleadpipe.org/2018/vocational-awe/

9. Michael Hauben, "The Netizens and Community Networks," Hypernetwork '95 Beppu Bay Conference, Beppu Bay, Japan, November 24, 1995), http://www.columbia.edu/~hauben/text/bbc95spch.txt

software movement grew and thrived.[10] Those movements wove their ways into the academy in the emergence of digital history, digital preservation, digital scholarship, and the digital humanities. I experienced them firsthand working as the "technology evangelist" at the Center for History and New Media at George Mason University. As the banks got their bailouts and the Great Recession set in at the end of the '00s, libraries, archives, and museums found themselves struggling with increasingly vexing budget shortfalls and working situations. Meanwhile, the effects of damage to the environment from anthropogenic climate change have grown more and more pressing.

We have reached the point where scholars are arguing that societies need to begin to consider how to die in the Anthropocene.[11] Humanity is likely to survive beyond the twenty-first and twenty-second centuries, but it will come out the other side of the centuries with its civilizations and institutions transformed. What should be the purpose of memory work and memory institutions in civilizations facing extinction? In archivist Sam Win's terms, it is now important to think about palliative practice for cultural and social memory.[12] In short, our assumptions about perpetual growth and progress in imagining the future need to change.

Given the bleakness of the realities of our present and our future and the failure of the tech sector's notions of a horizon of boundless innovation, where in all of this do we find hope? To what extent can memory workers establish a positive vision for a future for memory and memory work? The current order for envisioning and provisioning the future is, quite literally, running out of gas. The gleaming vision of the bright white technological future of the Apple commercials failed to live up to the realities of cracked glass in iPhone screens cutting our fingers. Through those cracked screens, we are becoming more aware of the exploitation of workers around the globe involved in their production and the vast quantities of e-waste that results from their continual planned obsolescence. Yet, in the ruins of that *Wired* imagination, a range of voices are emerging that propose and suggest new positive projects for envisioning our collective future. Significantly, over the last half century, feminist, black, disabled, indigenous, and

10. Richard L. Florida, *The Rise of the Creative Class* (New York: Basic Books, 2002).

11. Roy Scranton, *Learning to Die in the Anthropocene: Reflections on the End of a Civilization* (San Francisco: City Lights Books, 2015).

12. Samantha R. Winn, "Dying Well In the Anthropocene: On the End of Archivists," *Journal of Critical Library and Information Studies* 3, no. 1 (May 17, 2020), https://doi.org/10.24242/jclis.v3i1.107

queer scholars, thinkers, and activist communities have been advancing fundamentally different alternative ideas about how to approach and envision our collective future.

While the wheels were coming off much of our economy and society in the '00 decade, authors such as José Esteban Muñoz were advancing fundamentally different lines of thinking for our future in such books as *Cruising Utopia: The Then and There of Queer Futurity*. On Muñoz's terms, hope could itself become a hermeneutic. Hope could become part of a method for scholarly inquiry. By returning to late '60s and early '70s gay liberation manifestos, Muñoz argues for a return to radical envisioning of the future that includes things like the end of capital punishment and "free food, free shelter, free transportation, free health care, free utilities, free education, free art for all."[13] Further, he argues that instead of focusing on highly pragmatic goals, "We must vacate the here and now for a then and there," that the way forward involves the "need to engage in a collective temporal distortion," and that "We need to step out of the rigid conceptualization that is a straight present."[14] In this context, the challenges of the present offer an opportunity to step back from the pragmatism and satisficing that are the hallmarks of liberal movements in the '90s and '00s and return to much deeper sets of more radical ideas about striving for a more queer and liberated future.

Social justice movements, increasingly led by black women and women of color, are advancing vital visions for the future as well, specifically on notions of Afrofuturism. On adrienne maree brown's terms:

> Science fiction is not fluffy stuff. Afrofuturism is not just the coolest look that ever existed. The future is not an escapist place to occupy. All of it is the inevitable result of what we do today, and the more we take it in our hands, imagine it as a place of justice and pleasure, the more the future knows we want it, and that we aren't letting go.[15]

From brown's perspective, it's critical to "fight for the future" and "create and proliferate" a "compelling vision of economies and ecologies that

13. José Esteban Muñoz, *Cruising Utopia: The Then and There of Queer Futurity*, 10th anniversary edition, Sexual Cultures (New York: New York University Press, 2019), 19.
14. José Esteban Muñoz, *Cruising Utopia: The Then and There of Queer Futurity*, 10th anniversary edition, Sexual Cultures (New York: New York University Press, 2019), 185.
15. Adrienne M. Brown, *Emergent Strategy* (Chico, CA: AK Press, 2017), 164.

center humans and the natural world over the accumulation of material."[16] That work starts with imagination. For brown, the fight for social justice is first and foremost "an imagination battle."[17] Significantly, brown's Afrofuturism is as much forward looking as it is backward looking. It is also a practice of memory work. As brown argues, "Slaves who ran to freedom, and slaves who ran to their deaths, were Afrofuturists. It is the emphasis on a tomorrow that centers the dignity of that seed, particularly in the face of extinction, that marks, for me, the Afrofuturist."[18] From this framing, the work of Harriet Tubman, Sojourner Truth, Frederick Douglass, Martin Luther King, Malcolm X, Toni Morrison, Octavia Butler, Nnedi Okorafor, and Ben Okri are understood and appreciated for providing insight into practices of both imagining and enacting a more just future.

Similarly drawing on science fiction, as part of a multispecies feminist theory, Donna Haraway argues that notions of the Anthropocene, an era of "man," falsely note the source of our problems and the idea of human extinction.[19] In her terms, it is more accurate to identify the calamities we are facing as the Capitalocene, an era produced by a specific destructive moment in time resulting from a specific enactment of carbon-fueled capitalism. The geologic-time-level markers of human impact on the Earth are not traces of humanity writ large. The damage done to the Earth is specifically damage wrought by the invention and dissemination of carbon-fueled capitalism in the last few centuries. In this context, drawing on Ursula Le Guin and Octavia Butler's work in science fiction and speculative fiction, Haraway argues for the value of authoring speculative fiction for imagining a positive future path through the results for interspecies collaborations.

The disability justice movement has also been forwarding important and vibrant concepts for envisioning and enacting better, more equitable and just futures. In writing about care futures, Leah Lakshmi Piepzna-Samarasinha positions experiments around creating and sustaining collective access communities as critical work toward better futures. In her work, dreaming, imagining, and enacting are tightly coupled. In her words, "I want us to dream mutual aid in our post-apocalyptic revolutionary societies where everyone gets to access many kinds of care" as ways to "enshrine sick and disabled autonomy and choice." Further, "I want us to keep dreaming

16. Adrienne M. Brown, *Emergent Strategy* (Chico, CA: AK Press, 2017), 18.
17. Adrienne M. Brown, *Emergent Strategy* (Chico, CA: AK Press, 2017), 18.
18. Adrienne M. Brown, *Emergent Strategy* (Chico, CA: AK Press, 2017), 162.
19. Donna Haraway, *Staying with the Trouble: Making Kin in the Chthulucene* (Durham: Duke University Press, 2016).

and experimenting with all these big, ambitious ways we dream care for each other into being."[20] This vector of work is particularly significant in that much futurist thinking, for example in movies like *GATACA*, dystopian futures are premised on eradication of sick and disabled peoples. Instead, work in disability justice focuses on the ways that sick and disabled people are experts on their own bodies and experts on understanding care and interdependence. Significantly, care and interdependence are likely to be essential and critical areas we will all need to know more about as we enact a better future together.

Much of the fear associated with the oncoming Anthropocene is a fear of scarcity. As Candace Fujikane argues, "Rather than seeing climate change as apocalyptic, we can see that climate change is bringing about the demise of capital, making way for Indigenous lifeways that center familial relationships with the earth and elemental forms."[21] Through her analysis of Kanaka Maoli (Native Hawaiian) cartographies, Fujikane identifies how developers mark areas as "wasteland" despite its ability to produce abundant food through farming. The marking of land as wasteland establishes spaces as disposable and pollutable. By marking land as wasteland, it becomes possible to turn it into an industrial park or a golf course, land uses that hasten oncoming climate disaster. From Fujikane's perspective, the presumed running out of commoditized resources can well be perceived as an opportunity for envisioning a future anchored in indigenous approaches to creating more sustainable and less extractive ways to engage with each other and the natural world.

Collectively, these multispecies feminist, queer, Afrofuturist, disability-justice, and indigenous practices for futurist thinking harmonize and connect as an integrative framework for establishing intersectional solidarity for envisioning and enacting a better future. In centering the peoples and communities that have been marginalized, we have the chance to build a future together that is more just, more equitable, and much more deeply engaged in the interdependence and cyclicality that is essential to a sustainable future. It is in fact not humanity's future that is coming to an end, but rather the settler colonialist patriarchal extractive vision for a future tied to never-ending growth of economic markets.

20. Leah Lakshmi Piepzna-Samarasinha, *Care Work: Dreaming Disability Justice* (Vancouver: Arsenal Pulp Press, 2018), 65.

21. Candace Fujikane, *Mapping Abundance for a Planetary Future: Kanaka Maoli and Critical Settler Cartographies in Hawai'i* (Durham: Duke University Press, 2021), 3.

Memory, Dead or Alive?

We often take for granted that our ideas about something as fundamental as our faculty for memory are solid and persistent. In fact, notions of mind and memory change and develop over time, in dialogue with what our media afford us. Published shortly after the invention of recorded sound, an 1880 article on memory and the phonograph defines "the brain as an infinitely perfected phonograph."[22] We build our media in the imaginations of our minds and, conversely, we imagine our minds through our media—as phonographs, video cameras, and hard drives. What we think of as memory has changed and will continue to change over time.

The conception of history is itself intimately tied in with notions of memory and acts of remembering. As historian Carl Becker noted in his 1931 American Historical Association address, "Everyman His Own Historian," history is itself "an unstable pattern of remembered things redesigned and newly colored to suit the convenience of those who make use of it."[23] Of key importance, this involves re-membering, where the "re" requires a return to memory, acts of re-collection that occur in the present, in each moment and situation.

The intervention that digital media has made in conceptions of memory is particularly significant and problematic. As media scholar Wendy Chun argues, through the development of computing, and its advancement in culture, memory has been hardened into storage. Computers "write to memory." Computers put things "into memory." In so doing, the metaphors of computing, when turned inward on ourselves and on our cultural imagination, conflate storage with memory.[24]

Memory has always been an enacted process, a recalling of information and interpretation in a given context. However, when memory is conflated with storage, and data as the thing that we store, memory becomes conceptually static. Data presents itself as being objective and neutral, literally in keeping with its Latin root, as "the given." In fact, the distillation

22. Jean-Marie Guyau, "Memory and Phonograph," 1880, quoted in Kittler, *Gramophone, Typewriter, Film*, 33. These examples are central to the argument Friedrich Kittler develops as part of media archeology in *Gramophone, Typewriter, Film* and also play a central role in Lisa Gitelman's *Always Already New: Media, History, and the Data of Culture*.

23. Carl Becker, "Everyman His Own Historian," *American Historical Review* 37, no. 2 (1932): 221–36.

24. Wendy Hui Kyong Chun, *Programmed Visions: Software and Memory*, Software Studies (Cambridge, MA: MIT Press, 2011). Much of the book engages with issues of memory, but the key focus for this set of issues occurs starting on p. 133.

and recording of observation and information is always perspectival.[25] We are awash in documentation and recordings of the world and life, and we are faced with ever-larger quantities of information and data to consider collecting, preserving, and providing access to. As a result of computing, in culture, memory is now a tangible object, data encoded in a medium. Memory has been made conceptually static, dead, and inert and ostensibly objective as encoding on a medium.

The conflation of memory with storage is a lie. We need to second-guess the technical assumptions about memory as storage, or memory as data. It is critical to return to ideas of social and cultural memory as a lived part of identity, belonging, and community. When we take a more expansive notion of "social memory" or "living memory," we also find ways to better imagine a future for our shared cultural memory.

Scholarship on memory, in particular collective memory of communities and nations, stresses that memory is in fact not static. At a base level, memory is social. At the same time, memory is itself perpetually entangled with our technologies. Memory is transmitted, enacted, and sustained through the conscious work of institutions and people.[26] There is indeed an extensive literature on the ways that societies remember, which is anchored in ritual, ceremony, and acts of commemoration.[27] As historian Lynn Abrams explains, "Memory is not just the recall of past events and experiences in an unproblematic and untainted way. It is rather a process of remembering: the calling up of images, stories, experiences and emotions from our past life, ordering them, placing them within a narrative or story and then telling them in a way that is shaped at least in part by our social and cultural context." Furthermore, "Memory is not just about the individual; it is also about the community, the collective, and the nation. In this regard, memory—both individual and collective—exists in a symbiotic relationship with the public memorialization of the past."[28] In this context, data is more like memory, not the other way around. That is, data and storage mentalities assert that it is possible for information to be "raw" or

25. Trevor Owens, "Defining Data for Humanists: Text, Artifact, Information or Evidence," *Journal of Digital Humanities* (2011): 1–1.
26. Maurice Halbwachs and Lewis A. Coser, *On Collective Memory*, The Heritage of Sociology (Chicago: University of Chicago Press, 1992).
27. See Paul Connerton, *How Societies Remember* (Cambridge: Cambridge University Press, 1989), as well as essays and frameworks in John R. Gillis, ed., *Commemorations: The Politics of National Identity* (Princeton, NJ: Princeton University Press, 1996).
28. Lynn Abrams, *Oral History Theory*, 2nd ed. (London: Routledge, Taylor & Francis Group, 2016), 78–79.

just simply "the givens," but instead, as Geoffrey Bowker has argued, "Raw data is both an oxymoron and a bad idea." All data is collected with sets of assumptions and, much like memory, reflects particular perspectives and points of view.[29]

Just as there is no raw data, there is no raw memory or history. History and memory are indeed only possible through the interpretive act of storytelling. As historian Hayden White argues, to present a history one must leverage the tools of fiction and storytelling. Histories have a beginning, middle, and end. They come with protagonists and antagonists.[30] Even the rawest facts about a past require acts of narrative framing to become sensible. This isn't to suggest that all stories, all memories, or all retellings are created equal. While on some level, all those acts are acts of interpretation, our sources, our records, and our data serve as the basis by which hermeneutic practices function to make specific framings and stories viable given what the sources will allow.

Given that all history and memory is social and results from the memory work necessary to support ritual, ceremony, and acts of commemoration, it becomes essential that we ensure that there is equity and justice around the practices of memory. When individuals, and peoples, are left out of those acts and rituals of community memory, they face a form of symbolic annihilation. Symbolic annihilation is a framework for exploring the ways that mainstream media ignore and misrepresent minoritized groups. Archival scholar Michelle Caswell has demonstrated how absence from archives and repositories similarly enacts symbolic annihilation. Caswell's work and analysis of community archives advances a notion of "representational belonging" as a key aspect and function of the memory work that cultural heritage institutions need to engage in within society.[31]

As a result of rapid digital media change, the kinds of memory work that families and community institutions need to practice has also changed. This has resulted in broader challenges for ensuring the durability of personal and community sources of memory information. While it's easier than ever for many people to create digital photos and other kinds of digi-

29. Geoffrey C. Bowker, *Memory Practices in the Sciences*, Inside Technology (Cambridge, MA: MIT Press, 2005), 184.
30. Hayden V. White, *Metahistory: The Historical Imagination in Nineteenth-Century Europe*. Baltimore: Johns Hopkins University Press, 1973).
31. Michelle Caswell, Marika Cifor, and Mario H. Ramirez, "'To Suddenly Discover Yourself Existing': Uncovering the Impact of Community Archives," *American Archivist* 79, no. 1 (June 1, 2016): 56–81, https://doi.org/10.17723/0360-9081.79.1.56

tal records, it is at the same time complicated to figure out how to store and manage copies of that data. Further, as more and more computing shifts to cloud computing, all sorts of individuals are at risk of losing access to the kinds of memory practices, like scrapbooking, that have served as key parts of local community memory work. In this context, it is worth noting that initiatives like the D.C. Public Library's Memory Lab, a space that provides legacy digital equipment and tools as well as staffing support to help community members recover and transfer photos, recordings, and other media to new formats, are emerging as key sites to support and sustain personal and community digital memory.[32]

In the face of false notions of memory, it is critical to establish and sustain living memory activities, like the memory labs, as sites to enable the replay, review, and recollection of memory objects. The interaction between memory and the future plays out in the various futurisms discussed earlier in this chapter. All forms of future thinking play with notions of memory as well. Queer futurism involves a return to memories of a more radical queer agenda. Social justice movements anchored in Afrofuturism also read it into the past as a long history of the black imaginary for a better and more just future. The practices of memory and memory work, the need for representational belonging in collective memory, are essential to dreaming, envisioning, and enacting a better future.

Many write off this kind of memory work, work that returns to the surface the stories and voices of the marginalized, as "revisionist." However, those assertions are themselves an attempt to privilege a recently imagined ideology about the past and assert it as cold, raw, static fact. As Anthony Giddens argues, most of the reactionary notions of fundamentalisms were invented in reaction to cosmopolitanism.[33] The tartans for kilts that white nationalists wear are not from an ancient Scottish highland past, they are the product of tensions in the industrial revolution.[34] The white-hooded dress-up garb of the KKK is not their historical clothing, instead it involves donning the costumes made up to represent the KKK in the film *Birth of a*

32. For more on the Memory Labs, see Jaime Mears, "Memory Lab Network: An Interview with Project Manager Lorena Ramirez-Lopez," webpage, *The Signal* (blog), December 7, 2017, //blogs.loc.gov/thesignal/2017/12/memory-lab-network-an-interview-with-project-manager-lorena-ramirez-lopez/

33. Anthony Giddens, *Runaway World: How Globalisation Is Reshaping Our Lives*, 2nd ed. (New York: Routledge, 2003).

34. Hugh Trevor-Roper, "The Invention of Tradition: The Highland Tradition of Scotland," in *The Invention of Tradition* (Cambridge: Cambridge University Press, 1983), 15–41.

Nation in the early twentieth century.[35] Most of the confederate memorials built across the United States were not built in the era of the Civil War, but were constructed either between 1900 and 1920, when southern states began enacting Jim Crow laws to disenfranchise blacks and enforce segregation after a period of integration, or in the 1950s and 1960s in direct response to the Civil Rights Movement.[36] Those monuments do not represent the historic periods they commemorate, but instead directly represent racist revisionist efforts to assert white supremacy as heritage.

All memory is social memory. It's a weaving together of stories and pasts. However, the tactics of patriarchy and white supremacy conspire in much the same way that tech-sector thinking works. They attempt to make memory into storage and interpretation into fact. The attempts of white nationalists to naturalize and normalize their social memory as cold fact and to call out other attempts to more accurately tell stories of the past as revisionism are themselves processes of memory. In this context, the impulse from digital technology to treat memory as storage and not as a negotiated living process is itself a sleight of hand that attempts to naturalize patriarchy and whiteness as ground truth instead of recognizing it for what it is, a contemporary effort to mobilize symbols and notions of the past to project its own vision of a future.

Recognizing the centrality of identity and belonging, and the tendency for patriarchy, whiteness, ableism, and colonialism to tacitly assert hegemony in language, it's important for me to be clear about my own positionality and intentions as the author of this book. I am an enabled, straight, white male, who lives inside the Capital Beltway in Maryland just outside Washington D.C. As a descendent of German, Irish, and English immigrants, I am also, like them, a settler whose presence in the Americas is part of the continued presence of settler colonialism. When I started writing this book in June of 2021, my day job was working as a middle manager in a large library/U.S. federal agency. As I finish the full draft of this manuscript in November of 2022, I find myself working for the same organization, but as a senior-level executive. Simultaneously, I hold part-time positions as adjunct faculty in the history department of a private university and a college of information at a public university. Given my experience and background, this book is primarily focused on issues in the US context.

35. Alison Kinney, *Hood*, Object Lessons (New York: Bloomsbury Academic, 2016).

36. Southern Poverty Law Center, "Whose Heritage? Public Symbols of the Confederacy" (Montgomery, AL: Southern Poverty Law Center, February 1, 2019), https://www.splcenter.org/20190201/whose-heritage-public-symbols-confederacy

However, recognizing the range of contexts in which American hegemony operates, many of the observations in this book may be relevant to other parts of the world too. At thirty-eight years old, I am also an "elder millennial." I graduated college and went looking for my first full-time job in the brief interlude between the dotcom bust and the Great Recession. I recognize that the intersections of my identities have afforded me an extensive array of privileges.

This book is principally a work of synthesis. As illustrated already in this chapter, I have concluded that the nexus of privilege I have benefited from is in large part responsible for the creation of the global calamities we are facing. In keeping with that point of view, throughout the book, I work to draw attention to and credit perspectives from a range of brilliant marginalized people and voices that I am convinced need to take center stage in envisioning and enacting a better future for cultural memory. My hope and intention in doing so is to use whatever platform I have, in large part due to the reinforcing vectors of privilege I benefit from, to draw attention to the work of thinkers from marginalized and underplatformed perspectives. In doing so, my hope is that the book lifts up and draws further attention and engagement with their work. With that noted, I engage in this effort with some trepidation, realizing how histories of appropriation and misattribution of marginalized thinkers and communities present conundrums for an author like myself to do this kind of work. I hope that what follows can be a model for how to cite and draw attention to the work of others and offer synthesis that is not overly reductive. I aspire to engage in this project in a spirit of allyship, but I accept that if and when I fail to live up to that it is entirely my fault, and my responsibility to keep trying to do better.

Throughout the book, I use the term "we" as part of my dialogue with you, the reader. I realize that "we" can function to perpetuate exclusion. We can on some level establish an "us" and a "them," but my intention with the term is to attempt to establish a big-tent "we" with all those who want to work together toward a more just culture for cultural memory. With that noted, I have attempted to be deliberate in how and when I use "we." It's not "we" in some general sense of the whole of humanity who have produced our current ecological, social, and economic set of calamities. To that end, I make every effort to take care regarding when I appeal to my community of readers together with the term. My "we" is intended to not be universalizing, but instead to work as an invitation that can encompass difference.

Regarding my positionality, I realize that many of those in control of

the resources that support and sustain memory institutions have benefited from the same kinds of privilege that I have. One might rightly ask if the world needs more people with my particular positionality filling pages of books. While I hope for a wide range of readers for this book, I do hope that among that readership it also finds its way to the many straight, enabled, white men who, primarily because of our unearned privilege, have been granted substantial institutional power. In that regard, I hope and intend that my relative privilege and power work to help those readers in particular to see that they need to change where they are looking for their ideas about the future and that they need to work to credit, resource, stand with, make common cause with, and empower marginalized peoples who are already working to enact a better future for the past.

A Roadmap for After Disruption

Building on intersectional justice work, we now have a firm footing on which to more genuinely imagine a liberatory future anchored in a reflective and reflexive process of social memory work. With that as a basis, I use the remainder of this chapter to provide a roadmap for the rest of the book. What follows is an excavation of the recent past to document the emergence of three bankrupt ideologies that created the disrupted present. Facile, naive, and problematic, start-up ideology came bundled with digital technologies. It's essential to name and trace those ideas and their effects.

The first half of the book draws on critical scholarship on the history of technology and business to document and expose the sources of these ideologies and their pernicious results. Chapter 2 focuses on the obsession with disruptive innovation and its origins and effects. Chapter 3 focuses on the myopia that emerges from an obsession with data analytics practices made popular through practices such as key performance indicators. Chapter 4 focuses on the insistence on the importance of "the hustle" and the solipsism of personal brands and a persistent focus on atomizing all of us into imagined individual entrepreneurs running the business of ourselves. Collectively these three chapters document interrelated bankrupt ideologies that have brought us to our disrupted present and still claim to be the only way out to an even more broken future.

It's not enough to identify problematic ideologies. We need powerful and compelling counter-frameworks and values to replace them. Drawing on work in science and technology studies, feminist theory, and educational philosophy, the second half of the book offers maintenance, care, and

repair as three intertwined notions to moor the future of memory work and memory institutions. The fifth chapter makes the case for the need to invest in a maintenance mindset for our memory infrastructure. The sixth chapter argues for the need to create physical, digital, and social infrastructure that supports networks of care for memory workers, collections, communities, and the environment. The seventh chapter argues for the need to commit to repair and remodel our institutions to cut out patriarchy, settler colonialism, white supremacy, and manifest destiny and replace them with allyship, centering the voices and needs of the vulnerable, marginalized, and oppressed. Significantly, in keeping with Roopika Risam's vision for a postcolonial digital humanities, I work to eschew the language of "disruption in favor of conversation, communication, and collaboration."[37] That is, through maintenance, care, and repair, I believe we have the tools to engage in remodeling cultural-memory institutions and infrastructure to support social justice and the social well-being of all. The book concludes, in Chapter 8 with discussion of the realities of working to enact and live these values as a memory worker, a manager in a cultural heritage institution, and an educator of historians, librarians, and archivists.

37. Roopika Risam, *New Digital Worlds: Postcolonial Digital Humanities in Theory, Praxis, and Pedagogy* (Evanston, Il: Northwestern University Press, 2019), 13.

PART ONE

Three Bankrupt Ideas

CHAPTER 2

What Disruption Wants

Disrupt. Fail faster. Asking, in almost any meeting, "but will it scale?" Over the last three decades the language of Silicon Valley start-ups and venture capitalists has followed digital technologies into a wide range of industries, cultural-memory institutions included. This vocabulary, which historians of technology Lee Vinsel and Andrew Russell call "innovation-speak," is now a core part of management cultures across the US and beyond.[1] This chapter explores and unpacks the ideology that comes with this way of speaking and thinking.

A central aspect of innovation-speak is the ideology of disruption, a concept that has evolved over time. The chapter starts by delving into the origins of disruptive innovation as a concept in the '90s. Significantly, the very idea of disruption isn't novel to technology and innovation. As humanities scholars Dorothy Kim and Jesse Stommel note, disruption "is not something that tech circles have invented, but rather have erased or coopted from the work of scholars on race."[2] As they note, "In feminist critical race theory, black, indigenous, and women of color (BIWOC) bodies disrupt the narratives of mainstream white feminism by having voices, by creating counternarratives, by calling out the frameworks of the hegemonic center."[3] When Silicon Valley co-opted the vocabulary of disrup-

1. Lee Vinsel and Andrew L. Russell, *The Innovation Delusion: How Our Obsession with the New Has Disrupted the Work That Matters Most* (New York: Currency, 2020).
2. Dorothy Kim and Jesse Stommel, "Disrupting the Digital Humanities: An Introduction," in *Disrupting the Digital Humanities* (Santa Barbara, CA: Punctum Books, 2018), 24.
3. Dorothy Kim and Jesse Stommel, "Disrupting the Digital Humanities: An Introduction," in *Disrupting the Digital Humanities* (Santa Barbara, CA: Punctum Books, 2018), 22.

tion, it removed the genuinely radical ideas that had come from feminist critical race theory and shifted them into a blunt fear-inducing instrument. While the rhetoric around disruption often comes with a revolutionary sentiment, at its core, disruptive innovation's roots are in fear. This rhetoric is about making us afraid and pushing us to believe that Silicon Valley has the secrets to how we address the fear of being made obsolete or being replaced.

Disruption language in the tech sector came to the foreground in the '90s and stuck around, but it connects to a longer history of the hacker ethic that goes back to the midcentury development of computing cultures. The hacker ethic emerged as an ideology in Silicon Valley that made the notion of liberating information through disruption a moral imperative. The hacker ethic's demand for free access to information is used to justify disruption. Much of the disruption narrative is itself focused on a technological determinist set of ideas about the industries that produce and disseminate the media of cultural memory (books, music, film, etc.). The language of disruption positions the disruptor as a positive change agent against what are painted to be large old-guard industries and bureaucracies. Those upstart tech companies have dramatically grown into a small cohort of platform monopolies that largely control whole sectors of our cultural information ecosystem. This itself is in direct contradiction to the original hacker ethic that was opposed to the centralization that the platforms have come to represent.

Having mapped that history of disruption, the hacker ethic, and their transformation into large platform monopolies, I conclude this chapter by unpacking the implications of this understanding of disruption for memory institutions and memory workers. The language of disruption and the hacker ethic has become central to how technology is described in business and government. When we come to see all of this as part of the massive growth of monopolies in the information ecosystem instead of as seemingly innate ideas about technological progress, we are left with a need to significantly reframe how we think of our relationships to major technology companies and platforms like Facebook, Google, Amazon, YouTube, and Apple.

Disruption's Roots in Fear

The language of disruption is everywhere. Since 2010, *Disrupt* has been the name of a series of high-profile annual conferences for startups hosted

by TechCrunch in cities around the world. Every year publishers bring us a new slate of business and self-help books with "disrupt" in their titles. A nonexhaustive rundown of some of those book titles illustrates both the popularity of disruption and the key concepts related to it. In 2015, there was *Disrupt: Think the Unthinkable to Spark Transformation in Your Business*, as well as *Disrupt You! Master Personal Transformation, Seize Opportunity, and Thrive in the Era of Endless Innovation*, and *Disrupt Yourself: Putting the Power of Disruptive Innovation to Work*.[4] In 2016, there was *Lead and Disrupt: How to Solve the Innovator's Dilemma*.[5] In 2017, *Disrupt or Die: What the World Needs to Learn from Silicon Valley to Survive the Digital Era* and *Do Disrupt: Change the Status Quo or Become It*.[6] In 2019, *Disrupt-It-Yourself: Eight Ways to Hack a Better Business—Before the Competition Does*.[7] In 2020, illustrating that the titles are reusable, *Disrupt or Die: How to Survive and Thrive the Digital Real Estate Shift* was published.[8] In 2021, there was both *Disrupt Your Now: The Successful Entrepreneur's Guide to Reimagining Your Business & Life* and *Think Lead Disrupt: How Innovative Minds Connect Strategy to Execution*.[9] The exuberant word salad of those book titles is useful for getting a feel for what the ideology of disruption has come to mean.

Fear is central. Disrupt or be disrupted. It's disrupt or die. This is about survival. Your organization needs to abruptly transform. You need to transform. Both you and your organization are falling behind. You need to figure things out before the competition does. This is the reality of the "era of endless innovation." The only way out is hacking. Silicon Valley, the origin

4. Luke Williams, *Disrupt: Think the Unthinkable to Spark Transformation in Your Business* (Upper Saddle River, NJ: FT Press, 2010); Jay Samit, *Disrupt You! Master Personal Transformation, Seize Opportunity, and Thrive in the Era of Endless Innovation* (New York: Flatiron Books, 2015); Whitney Johnson, *Disrupt Yourself: Putting the Power of Disruptive Innovation to Work* (Brookline, MA: Bibliomotion, 2015).

5. Charles A. O'Reilly III and Michael L. Tushman, *Lead and Disrupt: How to Solve the Innovator's Dilemma*, 2nd ed. (Stanford: Stanford Business Books, 2021).

6. Jedidiah Yueh, *Disrupt or Die: What the World Needs to Learn from Silicon Valley to Survive the Digital Era* (Carson City, NV: Lioncrest Publishing, 2017); Mark Shayler, *Do Disrupt—Change the Status Quo or Become It* (London: Do Book Co., 2017).

7. Simone Bhan Ahuja and James M. Loree, *Disrupt-It-Yourself: Eight Ways to Hack a Better Business—Before the Competition Does* (New York: HarperCollins Leadership, 2019).

8. Geoff Zimpfer, *Disrupt or Die: How to Survive and Thrive the Digital Real Estate Shift* (independently published, 2020).

9. Lisa Kipps-Brown, Steve Sims, and Charles Kipps, *Disrupt Your Now: The Successful Entrepreneur's Guide to Reimagining Your Business & Life*, (Halifax, VA, Dragon's Tooth Publishing: 2021); Peter B Nichol, *Think Lead Disrupt: How Innovative Minds Connect Strategy to Execution*, (independently published, 2021).

of hacking and "the hack," is the only place that holds the secrets. Read about them in this book.

In those books, and in our culture at large, disruption has come to be a somewhat general and broad fuzzy concept. However, when the idea of disruptive innovation first emerged in the mid-'90s it was a much more specific concept, and it was focused on the technology industry itself. Disruptive innovation entered the zeitgeist through a 1995 *Harvard Business Review* article, "Disruptive Technologies: Catching the Wave." Written by management consultant, business school professor, and former Reagan administration appointee Clayton Christensen and his colleague Joseph Bower, the popular article became the basis for a series of books. Christensen went on to publish best-selling business books that further promulgated and generalized the concept: *The Innovator's Dilemma: When New Technologies Cause Great Firms to Fail* in 1997 and *The Innovator's Solution: Creating and Sustaining Successful Growth* in 2003. Over the course of the article and the books the concept shifted from a focus on disruptive technologies to a general concept of disruptive innovation.

In its original framing, disruptive technologies were something for large established technology companies to fear. The *Harvard Business Review* article opens, "One of the most consistent patterns in business is the failure of leading companies to stay at the top of their industries when technologies or markets change." Christensen and Bower argue that the central issue is distinguishing between two kinds of emerging technologies: disruptive technologies and sustaining technologies. In their framework, sustaining technologies gradually and slowly improve over time for a given function. This is a kind of technology that large companies have managed well. In contrast, disruptive technologies are technologies that are substantially worse in several key areas that existing customers prefer, but end up being valuable in very different, initially niche markets, and often have much lower profit margins. It makes sense that established companies don't invest in these kinds of technologies, given that they don't fit their customers' needs and that they have lower profit margins. However, those initially niche-seeming markets had demonstrated that they could grow dramatically, creating economies of scale. For example, from their perspective, this explains why Xerox missed out on the small-copier market that Canon succeeded in, and how Apple Computer could lead the world in personal computing but lag the PC market in the early to mid-'90s. The article ends with suggestions about how large technology companies can begin to track and follow potential disruptive tech-

nologies and resource teams outside their normal business operations, to attempt to keep up with them.

This is a rather specific niche concept about technology, but it is one that in 2017 *The Economist* would describe as "The most influential business idea of recent years."[10] It's similarly been described as "both a cliché and a driving force in business ever since."[11] The flurry of books that start off this section with "disruption" in their titles aren't talking about the specifics of this framework. Disruption has come to be a relatively empty buzzword, but the fear at the heart of the concept has remained.

The subtitle of Christiansen's book is *When New Technologies Cause Great Firms to Fail*. The purpose of the book is to help those running established organizations avoid being left behind. Ultimately, the answer has less to do with the value of the concept than it does with the way that disruption itself could become a banner and a buzzword. As you might guess, the particulars about disruptive technologies as an explanation of the history of technology have come under significant criticism.[12] However, given that the particulars of the concept aren't that relevant to the life that the concept has taken on, this isn't particularly significant to our consideration at this point. Far more significant is the way the buzzword language of disruption positions those in charge of the status quo of current industries and technologies as needing to watch out for and fear the disruptors that are coming for them.

The buzzword nature of disruption is now widely observed. Within the tech industry, Peter Thiel, the founder of PayPal and an early funder of Facebook, suggests that "disruption has recently transmogrified into a self-congratulatory buzzword for anything posing as trendy and new."[13] It will be important to return to Thiel's ideas on the primary goals and objectives of the tech sector later in this chapter in the context of platforms and monopolies, but at this point it is sufficient to underscore that even within the tech sector, it is widely appreciated that disruption is largely empty of any specific conceptual value. Conferences like TechCrunch Disrupt are

10. "Jeremy Corbyn, Entrepreneur," *The Economist*, June 15, 2017, https://www.economist.com/britain/2017/06/15/jeremy-corbyn-entrepreneur

11. Warren Berger, *A More Beautiful Question: The Power of Inquiry to Spark Breakthrough Ideas* (New York: Bloomsbury, 2014).

12. Jill Lepore, "What the Gospel of Innovation Gets Wrong," *New Yorker*, June 16, 2014, http://www.newyorker.com/magazine/2014/06/23/the-disruption-machine

13. Peter A. Thiel, *Zero to One: Notes on Startups, or How to Build the Future* (New York: Crown Business, 2014), 57.

not anchored in any theory of technology. Instead, the Disrupt conferences operate from two more basic assumptions. First, disruption is something that Silicon Valley technology companies do. Second, disruption is something that is ultimately good for our society. Disruption is coming for you and your organization and Silicon Valley is the only place that can help you cope.

If disruption is so empty a concept, why does it persist? In *What Tech Calls Thinking*, humanities scholar Adrian Daub draws out the ideological function of disruption. Daub explains, "disruption acts as though it thoroughly disrespects whatever existed previously, but in truth it often seeks to simply rearrange whatever exists." As an example, he notes that, "Uber claims to have 'revolutionized' the experience of hailing a cab, but really that experience has stayed largely the same." He goes on to explain, "What it managed to get rid of were steady jobs, unions, and anything other than Uber's making money on the whole enterprise."[14] In this context, "The disrupter portrays even the most staid cottage industry as a Death Star against which its plucky rebels have to do battle."[15] This raises a broader historical question: who gets to do the disrupting and who warrants disruption? Furthermore, when disruption paints people, industries, and companies as good or bad, what are those moral claims warranted by? To answer this, we need to go further back into the history of the development of Silicon Valley ideology in the development of the hacker ethic.

The Hacker Ethic Knows What Information Wants

In 1984, journalist Stephen Levy popularized and presented a notion of an emerging digital culture in *Hackers: Heroes of the Computer Revolution*. Levy presents a narrative of the history of computing from MIT and the Bay Area from the '50s through the '80s and ties that history to the mythology and function of what he identified as the six principles of the "hacker ethic." In the context of this book, it's worth observing that this kind of historical storytelling and mythmaking is part of the tech sector's memory work.

Given what we understand about memory, tradition, and mythology from the previous chapter, it is necessary to approach the kinds of historical storytelling and mythology building that happens in books like *Hackers* not

14. Adrian Daub, *What Tech Calls Thinking* (New York: Farrar, Straus and Giroux, 2020), 105.
15. Adrian Daub, *What Tech Calls Thinking* (New York: Farrar, Straus and Giroux, 2020), 128.

as factual representations of the past, but as interventions to build models of the past that support arguments about the present and future. The ideological function and valorization of the hacker as a concept, like disruption, is part of the way Silicon Valley has colonized the cultural imagination of people and organizations in a wide range of fields.

While there is considerable discussion of nuances about each of the six principles in the hacker ethic, the widespread popularity of the book meant that Levy's synthesis of hacker culture played a key role in establishing the story that hackers, and Silicon Valley more broadly, present about themselves. The six principles of the hacker ethic are as follows.

1. Access to computers—and anything which might teach you something about the way the world works—should be unlimited and total. Always yield to the Hands-on Imperative!
2. All information should be free.
3. Mistrust authority—promote decentralization.
4. Hackers should be judged by their hacking, not bogus criteria such as degrees, age, race, or position.
5. You can create art and beauty on a computer.
6. Computers can change your life for the better.[16]

The six principles are illustrative of the kind of strange mixture of countercultural and conventional thinking at work in the tech sector. There are seemingly noncontroversial platitudes about how computers can "change your life for the better" and that you "can create art and beauty on a computer." We also can see the already strong belief in the tech sector's mythology of meritocracy in "hackers should be judged by their hacking." Along with that, the hacker ethic makes clear who are the key targets that warrant disruption from the hackers and the computing community.

Anyone standing in the way of allowing information to be free and those who support central power and authority are at odds with the hacker ethic and thus warrant being disrupted. The gatekeepers of centralization are the problems. In *From Counterculture to Cyberculture: Stewart Brand, the Whole Earth Network, and the Rise of Digital Utopianism*, media studies scholar Fred Turner has documented the development of the hacker ethic and more broadly the development of the computing industry in Silicon

16. Steven Levy, *Hackers: Heroes of the Computer Revolution* (Garden City, NY: Anchor Press/Doubleday, 1984).

Valley. As Turner demonstrates, the hacker ethic and computing culture more broadly emerged through an odd and somewhat counterintuitive mixing of the idea to create and maintain self-sufficient communes in the 1960s with libertarian notions of entrepreneurship.[17]

From the '60s through the '80s, computing and computing cultures fundamentally rebranded themselves in the cultural imagination. In the 1960s, students protesting the war in Vietnam and the draft saw punch cards and IBM as synonymous with the military industrial complex that was sending young people to die in Vietnam. Rightfully so: computing systems were largely created through the investment of the US Defense Department. However, that funding went in large part into university research centers at places like Stanford and MIT, where engineers, funded by the Defense Department to create technologies of control and surveillance for the Cold War, were also developing new kinds of work cultures and identities around computing.[18] Those university and industry research lab cultures at places like Stanford and Xerox PARC are where computing reimagined itself as part of an independent and countercultural movement. Those contexts were ideal places for concepts to emerge like what Marshall McLuhan put forward in 1962 in *The Gutenberg Galaxy: The Making of Typographic Man*, positing that "electronic interdependence" would develop in the coming "global village" era. Liberatory rhetoric became central to how engineers and computing businesses saw themselves and their work, but that liberatory rhetoric was, in contrast to McLuhan's, deeply individualistic.

It is in this context that tech magazines in 1988 could declare that the "electronic frontier" was the place where "The old information elites are crumbling. The kids are at the controls."[19] It's also the context where someone like Stewart Brand, who straddled the back-to-the-earth commune movements and tech boosterism, could proclaim that hackers were "the most interesting and effective body of intellectuals since the framers of the U.S. Constitution. No other group I know of has set out to liberate a technology and succeed."[20] The same vein of thought comes through in John

17. Fred Turner, *From Counterculture to Cyberculture: Stewart Brand, the Whole Earth Network, and the Rise of Digital Utopianism* (Chicago: University of Chicago Press, 2008).

18. For more on the role of the Cold War in the development of computing technologies see Paul N. Edwards, *The Closed World: Computers and the Politics of Discourse in Cold War America*, Inside Technology (Cambridge, MA: MIT Press, 1996).

19. Queen Mu and R. U. Serious, *Mondo 2000*, (Berkeley, CA: Fun City MegaMedia), 11. https://archive.org/details/Mondo.2000.Issue.01.1989

20. Fred Turner, *From Counterculture to Cyberculture: Stewart Brand, the Whole Earth Network, and the Rise of Digital Utopianism* (Chicago: University of Chicago Press, 2008) p. 138.

Perry Barlow's 1996 "Declaration of the Independence of Cyberspace," in which he asserts that "Your legal concepts of property, expression, identity, movement, and context do not apply to us. They are all based on matter, and there is no matter here."[21] The old information and media elite were on notice. They were prime targets for disruption. Significantly, those media institutions were also central to the way that cultural memory functions.

Disruption, Media, and Cultural Memory

The "old information elites" and beliefs based in "matter" were the first and foremost targets of disruption. As the web grew and took center stage in society in the mid to late '90s, the start-ups that came on the scene shifted the ideology of disruption from an internal explanation of dynamics in the technology industry to explain and justify an assault on the media organizations involved in producing and disseminating the media of culture and memory (music, film, publishing, journalism, etc.). Napster disrupts the music industry. Amazon disrupts book selling. YouTube hits at both music and film. Web publishing takes aim at journalism. All these disruptions are anchored in a vision about platforms and media that much of the rest of this chapter will focus on.

The stories that set precedent for disruption of media industries are largely focused on the production of media that serve as a basis for our cultural record. In *Here Comes Everybody: The Power of Organizing without Organizations*, published in 2008, Clay Shirky spends a number of pages on an analogy between contemporary publishing's disruption via the web to the disruption of scribal traditions with the invention of the printing press in the fifteenth century. Shirky's discussion is worth engaging with both because of the broad popularity of his work in this field and for the way it illustrates a pervasive set of deeply technological determinist frames of thinking about information, media, and professions that aligns with the hacker ethic's ideology.

For Shirky, the scribes, who painstakingly produced copies of texts by hand, were a particular kind of social gatekeeper. In his framework, "A professional often becomes a gatekeeper, by providing a necessary or desirable social function but also by controlling that function." Of note, already the framing of functions as "gatekeeping" aligns with the hacker ethic of tar-

21. John Perry Barlow, "A Declaration of the Independence of Cyberspace," Electronic Frontier Foundation, February 8, 1996, https://www.eff.org/cyberspace-independence

geting functions involved in centralization. For Shirky, it was important to distinguish between the varied purposes of gatekeeping functions in societies: "Sometimes this gatekeeping is explicitly enforced (only judges can sentence someone to jail, only doctors can perform surgery) but sometimes it is embedded in technology, as with scribes, who had mastered the technology of writing."[22] In this framing, the scribe's function was effectively completely technologically determined. In this story, when technology advanced, it was inevitable that there was no longer a need for their profession and its gatekeeping function. Shirky explains this story about scribes to show how publishing is changing as a result of web technologies. "Just as movable type raised the value of being able to read and write even as it destroyed the scribal tradition, globally free publishing is making public speech and action more valuable, even as its absolute abundance diminishes the specialness of professional publishing."[23] This is a major leap. It requires us to accept that the functions of contemporary professional publishing are entirely about the technology of making something public, and it also requires us to accept the idea that the printing press and the web are in effect analogous technologies. Both of those issues are worth considering further as they illustrate the functioning of much of the logic of the tech sector and its supporters.

First, to what extent are the various professions involved in publishing working as gatekeepers whose role is "embedded in technology"? Publishing books or magazines entails a wide range of functions, such as developing stories, editing them, assembling issues, and marketing. In short, publishing is a lot more than a button in a blogging platform. Editors make judgments and invest resources in paying authors to produce work that aligns with the missions of their publishing houses or publications. The professions involved in publishing are part of the process by which creative and scholarly works are developed and enhanced. In short, the analogy between publishing and other media industries and scribes in this story doesn't work. The publishing industries aren't at their heart tools for making copies of text. They are so much more. Significantly, Shirky and those following his line of thought have already anticipated this complaint.

It's not enough to note that the scribes' demise was inevitable. Shirky also notes that of course the scribes and anyone in their situation will try to

22. Clay Shirky, *Here Comes Everybody: The Power of Organizing without Organizations* (New York: Penguin Books, 2009), 68.
23. Clay Shirky, *Here Comes Everybody: The Power of Organizing without Organizations* (New York: Penguin Books, 2009), 79.

claim they are special and their work is worth keeping around. Shirky notes that when the printing press was coming on the scene, scribes attempted to make the case for the value of their work by claiming "that preserving the scribe's way of life was more important than fulfilling their mission by nonscribal means." This provides a ready-made answer to any attempt from people working in publishing, or journalism, or for a film studio, or a record label from defending themselves. In this logic, which works in the logic of disruption in any context, those gatekeepers are being displaced because of the inherent improvement in technology, and their attempt to explain why their work matters more than the narrow function of the technology in question is just a professional defense mechanism. It's important to see this for what it is: a ready-made way to dismiss professions based on faulty assumptions. Publishing professions do a lot more than just make things public, but through the logic of disruption any assertion to the contrary is written off as a survival mechanism of a dying profession.

Beyond the false analogy between scribes and the publishing industry, it is important to delve into Shirky's analogy between the printing press and the web, a comparison frequently made in discussions of the web. Significantly, the technology of the printing press is a critical technology that was necessary in bringing about the existence of the publishing industry, which he notes is now being disrupted by the web. As a technology that enables reproduction of text and images, it might seem to make a lot of sense to compare that to the technologies of the web, but in so many other ways they are very different. For example, Facebook lets anyone publish for free, but Facebook generates ad revenue on everything we write, and controls the flow of what things are featured at what points. Things have gone so far that most publishers, for instance of journalism, get most of their web traffic from Facebook. In contrast to the now-disrupted competitive marketplace of gatekeepers that acted as publishers in a wide range of industries, the gatekeepers have become the far more centralized platform monopolies like Facebook, Google, YouTube, and Spotify. In this context, it can feel like the shift to the platform monopolies is turning all of us into unpaid scribes working for the small number of platforms that now control digital media and content. Significantly, unlike record labels, magazines, film studios, and book publishers, the platform monopolies engage in rent seeking to generate massive profits from their monopolies without really investing anything in the production of content itself. In this context it becomes important to explore how the hacker ethic's focus on decentralization mutated into a shockingly centralized set of platform monopolies.

From Hacker Upstarts to Platform Monopolies

In *Zero to One: Notes on Startups, or How to Build the Future*, billionaire venture capitalist and Silicon Valley's most outspoken libertarian/conservative figure Peter Thiel offers his take on the source of Silicon Valley's power. As previously noted, he is not a fan of using the word "disruption." His opposition to the term is, intriguingly, part of an overt tactic to mask the intentions of the work of companies he funds and supports. As part of his contrarian impulse, he specifically advises those wishing to make it rich in technology that their work is best accomplished if they "don't disrupt." With that noted, his approach and theory directly align with, and help to explain, the disruptive ideology of Silicon Valley.

Much like Christensen, Thiel offers a binary framework for describing technological advancement. For Thiel this is a distinction between vertical change and horizontal change. In his language, horizontal change is general improvement over time for a technology, whereas vertical change involves "Doing something no one has ever done before." In keeping with the frequent use of media technologies as analogies, he explains, "If you take one typewriter and build 100, you have made horizontal progress. If you have a typewriter and build a word processor, you have made vertical progress."[24] In practice, this is not radically different from the same binary distinction Christensen observed in the difference between sustaining technologies and disruptive technologies in the theory of disruptive innovation. That itself is a key part of these kinds of technology business books. They play fast and loose with ideas about what is novel and different. In this vein, Theil's ideas here aren't even internally consistent. They largely work as a way for him to praise people he likes. For example, he claims that Elon Musk's work with Tesla is indicative of vertical change, when in his own theory it seems to clearly be a situation of marginal horizontal improvement on the technology of electric cars. While the value of Theil's book in explaining the history of technology is lacking, his book does offer useful context for understanding ideology at work in the tech sector. His explanation for why he thinks those vertical technology changes are so important is telling.

According to Theil, the real value for startups comes from the realization that "competitive markets destroy profits."[25] He explains, "Google

24. Peter A. Thiel, *Zero to One: Notes on Startups, or How to Build the Future* (New York: Crown Business, 2014), 7.

25. Peter A. Thiel, *Zero to One: Notes on Startups, or How to Build the Future* (New York: Crown Business, 2014), 21.

is a good example of a company that went from 0 to 1: it hasn't competed in search since the early 2000s, when it definitely distanced itself from Microsoft and Yahoo!"[26] Theil makes clear that the real successes in the tech sector aren't about competition but are instead about monopolies. Further, in his description of the success of Google, he underscores that "Monopolists lie to protect themselves. They know that bragging about their great monopoly invites being audited, scrutinized, and attacked."[27] In Theil's playbook the focus of tech-sector work is to establish platform monopolies. This involves four areas of activity: (1) building proprietary technology that can fully monopolize an area, (2) establishing platforms that leverage network effects so that they can rapidly grow, (3) reaching economies of scale quickly from those network effects, and (4) turning platforms into brands to help sustain monopolies but also to make those monopolies appear to be natural.[28] By becoming a monopoly and escaping any need to compete, those platform companies can then exercise sweeping control over how much profit they generate and can fully exert pressure on parts of their supply chain.

As a key example, when Jeff Bezos left working for a hedge fund to start Amazon, it was on some level less about the potential for an internet bookstore to offer a new kind of service than it was a hack to an emerging loophole in tax law. The 1992 *Quill Corp v. North Dakota* Supreme Court decision established that "the lack of a physical presence in a state is sufficient grounds to exempt a corporation from having to pay sales and use taxes to a state." Given how thin the margins are for profit in bookselling, avoiding sales tax results in a huge opportunity for an internet bookstore to both undersell its brick-and-mortar counterparts while still generating more revenue.[29] That isn't an effect of the technology of the web. It is the result of the way an out-of-state internet bookstore can skirt tax law for an advantage.

The "information wants to be free" part of the hacker ethic targets the presumed "fat cats" of the record labels, the movie studios, the big bookstore chains, etc. But those "old guard" gatekeepers functioned in much

26. Peter A. Thiel, *Zero to One: Notes on Startups, or How to Build the Future* (New York: Crown Business, 2014), 25.

27. Peter A. Thiel, *Zero to One: Notes on Startups, or How to Build the Future* (New York: Crown Business, 2014), 26.

28. Jonathan Taplin, *Move Fast and Break Things: How Facebook, Google, and Amazon Cornered Culture and Undermined Democracy* (New York: Little, Brown and Company, 2017), 77–79.

29. For more on this example of Amazon's development and it's relation to tax law see Jonathan Taplin, *Move Fast and Break Things: How Facebook, Google, and Amazon Cornered Culture and Undermined Democracy* (New York: Little, Brown and Company, 2017), 79.

less monopolistic and parasitic ways than the platforms that have largely seized control. The big companies of the culture industries add value and invest resources in the creation of works. Publishers pay authors, record labels pay artists, etc. Ideologically, in the logic of big tech, content should be free and the money making should happen in the platforms, which is fundamentally rent-seeking behavior. To be sure, YouTubers can get a small slice of the advertising revenue that comes off their videos, but that is fundamentally different than proactive investment and cultivation of the work of creators that publishers and record labels historically engaged in. Significantly, despite the imperatives of the hacker ethic, the information is still not free. I, and 150 million other people, pay for Spotify subscriptions. We watch a wide range of ads on YouTube and are extensively surveilled by Google. At this point, far less of the money generated off those activities is going to the artists who create the work than was the case in the era of CDs, cassette tapes, and vinyl records.

The rhetoric of innovation has been consistently tied in with rhetoric about the media on which memory is inscribed, as with discussions of the printing press, typewriters, etc. But those technologies are fundamentally different than the web platforms. Facebook isn't the printing press or a typewriter, it's a singular monopoly that controls who sees what. Same for Google search, or Spotify. At the same time, they consistently position themselves as democratizing media, when they are in fact monopolizing it.

Move Fast and Break Civic and Social Institutions

Facebook's motto was "move fast and break things." In 2014, things were apparently broken enough that the last part of the motto needed to change. Reflecting the shift from Facebook as an upstart company to a major platform monopoly, the motto was changed to "move fast with stable infrastructure." Given that Facebook was starting to come under significant scrutiny for the way it was breaking all kinds of social institutions and federal regulations, it was also probably not a great idea to have "break things" in their motto anymore. The "break things" mentality functions as a further example of what the disrupt impulse comes to be. Facebook founder Mark Zuckerberg consistently explains that the original motto was an outgrowth of what it meant for him to be a hacker. While the motto changed, the physical address of Facebook hasn't. You can still find them all working at "1 Hacker Way."

Facebook and the other platform monopolies did indeed live up to their

missions to break things. The net results of this invert many of the original notions of the hacker ethic. What started as being against centralization and prodemocratization of information has instead become an infrastructure that is centralized in a handful of monopolies. As Jonathan Taplin argues in *Move Fast and Break Things: How Facebook, Google, and Amazon Cornered Culture and Undermined Democracy*, "What we have been witnessing since 2005 is a massive relocation of revenue from creators of content to owners of platforms."[30] The tech sector intended to "eliminate the gatekeepers" like the big studios and record labels. But "what's really happened is that a new set of gatekeepers—Google and Facebook—has replaced the old." At this point, Google's market capitalization is $1.8 trillion, and Time Warner's is $75 billion.

The success of the tech sector in developing and advancing these methods has resulted in fundamental shifts in the nature of the global economy. As economist Nick Srnicek argues in *Platform Capitalism*, "The platform has emerged as a new business model, capable of extracting and controlling immense amounts of data, and with this shift we have seen the rise of large monopolistic firms."[31] Unlike the function of media organizations, the platform monopolies do not exist to invest, promote, and advance the work of media creators and producers. Instead, they function entirely on rent-seeking behaviors to generate revenue from advertising or other monopolistic modes of extracting tolls on the use of their platforms. In his words, "A platform positions itself (1) between users, and (2) as the ground upon which their activities occur, which thus gives it privileged access to record them."[32] That privileged access to the record of activities then becomes the basis of how these systems hoover up and aggregate immense amounts of data, which will be a subject of further discussion in the next chapter. Because of their monopolistic positions, organizations like Spotify can pay next to nothing to the creators of media whose content they distribute. Srnicek underscores how and why these monopolies are particularly problematic: "Far from being mere owners of information, these companies are becoming owners of the infrastructure of society."[33] The net result of this change is that tech-sector ideology has emerged to upend much of what we think about the future of institutions.

30. Jonathan Taplin, *Move Fast and Break Things: How Facebook, Google, and Amazon Cornered Culture and Undermined Democracy* (New York: Little, Brown and Company, 2017), 104.
31. Nick Srnicek, *Platform Capitalism*, Theory Redux (Cambridge, UK: Polity, 2017), 7.
32. Nick Srnicek, *Platform Capitalism*, Theory Redux (Cambridge, UK: Polity, 2017), 44.
33. Nick Srnicek, *Platform Capitalism*, Theory Redux (Cambridge, UK: Polity, 2017), 92.

Disrupted Cultural-Memory Institutions

This tour of the history and values of disruptive innovation illustrates the way that tech- sector thinking rooted originally in values about decentralization has ultimately brought about highly centralized platform monopolies. This counterintuitive set of results presents significant challenges and questions for memory institutions and how these institutions engage with these platform monopolies.

I end this chapter by offering three initial sets of observations about how the cultural-heritage sector should respond to the realities of the now-disrupted world that we find ourselves in. We need to cultivate our own digital talent. We need to cultivate our own digital collaborations between institutions. Lastly, we need to cultivate the narratives, stories, and alliances that our sector engages in with other fields.

Cultivate Our Own Digital Talent

Many cultural-heritage institutions have approached digital media as something they can outsource or manage entirely through consultants. This often results in bringing in people from the tech sector or major consulting firms to tell us what our future should be, as opposed to having our institution's permanent staff develop and articulate what that future will be. When you believe the surface-level narrative about what Google or Facebook is here to do, this seems like a benign and beneficial thing. It is in this context that Jeff Jarvis, a journalism professor, could borrow a slogan about Jesus for the title of his 2009 book, *What Would Google Do? Reverse-Engineering the Fastest Growing Company in the History of the World*.[34] If Google is here to "not be evil" and to "organize the world's knowledge," then why wouldn't libraries, archives, and museums be all in on that? But as this chapter has illustrated, the surface intentions of the platform monopolies are fundamentally at odds with the ideology of disruption and their goals of monopoly. Their first intention is to erase the idea that there is meaningful work in other sectors that can't be replaced by technology, and then to establish the monopoly over that replacement technology to then seek rent through that monopoly. In this context, it is essential that memory institutions be wary of how and when tech-sector insiders come into our organizations and promote the idea of outsourcing our digital infrastructure and systems to the tech sector.

34. Jeff Jarvis, *What Would Google Do?* (New York: HarperCollins, 2009).

When we understand the logic of the platform monopolies at the heart of the tech sector, we can better understand the way that they function to displace public and community goods and services. There is no area of work or knowledge that the technological determinist imperative can't imagine replacing or automating. With that noted, it is critical to remember that the attempts to reduce an area of work to being described as scribes being replaced by the coming printing presses is a false equivalency. The tech sector tries to tell everyone engaged in knowledge and memory work that they are going to be replaced by machines, but that is mostly just hype and mythology. However, if we and the publics we serve come to believe in that hype, it will become a self-fulfilling prophecy.

The key here is that cultural heritage institutions need to invest in supporting and growing their own leaders and thinkers who can shape the digital future of our institutions and our sector. A key point from Russell and Vinsel's *Innovation Delusion* is that, in nearly all kinds of organizations and across fields, the logic of innovation-speak establishes a caste system of "innovators" and "maintainers." The net result of this logic is that the people who best understand the issues and problems in a field, who are close to the actual work and the people served by the work, are left to deal with all the problems, while the distant innovation class imagines futures that are increasingly distanced from the real issues at hand in the work of an organization. To that end, the more we can ensure that the memory workers steeped in the wisdom of the work of cultural heritage institutions are supported and empowered to shape the future of that work, the more we can improve institutions and better serve our missions.

This is not a Luddite or anti-innovation argument. The argument is that memory institutions need to believe in themselves and their fields, and invest time and resources to support librarians, archivists, curators, and others in becoming experts in technology who can help us manifest the future we want for memory. In this context, I think the work of the team in LC Labs, a unit of the Library of Congress explicitly set up and supported as a place to support innovative work with technology, is a valuable case study in how this can work. Significantly, LC Labs isn't run by consultants or former Google staffers. It's staffed by permanent federal employees with substantial experience in the cultural-heritage sector, and it is also part of a growing international movement around library technology labs.[35] LC

35. Sally Chambers, "Library Labs as Experimental Incubators for Digital Humanities Research," in *TPDL 2019, 23rd International Conference on Theory and Practice of Digital Librar-*

Labs illustrates how memory institutions can empower civil servants who are savvy about technology and who work closely with teams across an organization to get past divides between innovators and maintainers.

Cultivate Our Own Digital Collaborations

When Google began scanning and indexing millions of books from twenty-five of the world's major research libraries in 2004, it's platform play was clear. When it originally approached libraries, it did so by contacting them individually, without letting them know it was operating in a wide range of libraries, and it forced nondisclosure agreements on the participating libraries. In doing so, Google produced a massive trove of digitized books that the libraries were free to use just like anyone else, but the core value was transferred to Google as the platform owner. That could have been a huge blow to the ability of libraries to control and manage their collections and the services they provide their users, but it went a different way.

In the New York Times, long-time tech enthusiast and *Wired* editor Kevin Kelly asserted how Google's digitization play would change the world, prognosticating that "the universal library will deepen our grasp of history, as every original document in the course of civilization is scanned and cross-linked."[36] In no way, shape, or form did Google Books live up to that hype. The hubris of Google in this context serves as one of the key case studies in Siva Vaidhyanathan's 2011 book, *The Googlization of Everything (and Why We Should Worry)*. As Vaidhyanathan notes, the project resulted in a massive lawsuit with major publishers that ended up defining major components of the assumed legal framework around digitization of books, and also clearly represented a situation where libraries might end up "disrupted" in much the same way that Google was intervening elsewhere in our knowledge infrastructure. Vaidhyanathan ends his book with a call to action to establish a "Public Knowledge Project" modeled on the Human Genome Project, where governments and cultural institutions around the world could collaboratively develop a shared knowledge platform.[37] This is still a great idea, and while that call to action didn't take off, the library community did indeed respond with a form of collective action. Recognizing that giving over control and ceding this combined corpus of

ies, Abstracts, 2019, http://hdl.handle.net/1854/LU-8645483

36. Kevin Kelly, "Scan This Book!" *New York Times Magazine*, May 14 2006.

37. Siva Vaidhyanathan, *The Googlization of Everything: And Why We Should Worry* (Los Angeles: University of California Press, 2012), 199.

books from the world's libraries to a single business was a major problem, cultural-heritage institutions involved in the scanning project banded together to found HathiTrust, a nonprofit organization that could be led and managed by libraries as a public good.[38]

HathiTrust has grown beyond the original stakes of the Google Books digitization and has become its own community-controlled platform, which is supporting a wide range of new kinds of computational-use digitized materials through the HathiTrust Research Center.[39] This is a great example of how cultural-memory institutions can band together and sort out the terms on which they are willing to engage with the platform monopolies. Significantly, organizations like HathiTrust also demonstrate how cultural-memory institutions can bring about broad-based nonprofit and member-owned and -directed collaborations that are in keeping with our institution's values.

Cultivate Our Sector's Narratives, Stories, and Alliances

The tech-sector ideology of disruption can be pointed at any "legacy" or "old guard" institution. This ideology is powerful, and portrays the seeming inevitability of the old falling prey to the new. It's essential that we cultivate and develop our own counternarratives regarding the tech sector's inevitable advance to replace institutions with platforms. As an example, consider the trajectory of Massive Open Online Courses (MOOCs). In 2011, Stanford launched a series of free and open online courses. In a matter of months, hundreds of thousands of students signed up. These online courses were going to disrupt higher education. Based on interest in registrations for those courses, many institutions of higher education poured resources into their own MOOC offerings and entered partnerships with tech startups like Coursera and Udacity. These were promulgated and launched with the idea that technology could replace the functions of institutions of higher education, but they failed to capture the full range of elements that make institutions of learning meaningful, valuable, and worthwhile. In much the same way that there was an attempt to reduce

38. Heather Christenson, "HathiTrust: A Research Library at Web Scale," *Library Resources & Technical Services* 55, no. 2 (April 29, 2011): 93–102, https://doi.org/10.5860/lrts.55n2.93

39. J. Stephen Downie, M. Furlough, R. H. McDonald, B. Namachchivaya, B. A. Plale, and J. Unsworth, "The HathiTrust Research Center: Exploring the Full-Text Frontier.," May 1, 2016, https://experts.illinois.edu/en/publications/the-hathitrust-research-center-exploring-the-full-text-frontier

the publishing industry to scribes being replaced by an oncoming technology, MOOCs attempted to frame education as fundamentally a problem of "content delivery."

By 2012, it seemed as if MOOCs were going to take over higher education, but at this point a decade later, it appears to have largely fizzled out. Companies developed to run MOOCs are still around and are providing services, but much like Google Books, they have not panned out as anything near what the hype had promised. It turns out that self-paced sets of videos and problem sets on websites just isn't really a proxy for the range of functions that higher education plays. The MOOC hype cycles fundamentally missed the mark in understanding what education is, but in the process, it steered substantial resources away from thoughtful investments in how technology can advance higher education toward an ideological framework that at its core was intended to displace a wide range of good jobs and the good work involved in teaching and learning.[40] We need to take back that narrative and put forward our own stories about the value of our work and our sector. We also need to rethink our relationships to the other institutions that the tech sector has written off as the "old guard" worthy of being disrupted.

Many of us in the library, archives, and museums community grew up with the "information wants to be free" hacker-ethic mentality. To be sure, equitable access to information is core to the missions of libraries. With that noted, as many of us have grown up alongside the development of the platform monopolies, it's important that we reevaluate the effects and intentions of tech-sector ideology in this space. It was one thing to be a teen cheering on another teen like Sean Parker when he was thumbing his nose at and working to disrupt the recording industry with Napster in 1999. It is a completely different thing to watch as YouTube becomes a primary platform on which music and music videos are watched, where artists and the recording industry receive a tiny fraction of the profit the platform generates. The upstart technologists have become massive, centralized monopolies, but still present themselves as the outside disruptors.

Former Google executives and other tech-sector luminaries have taken leadership roles in government, nonprofit, and business sectors and functionally naturalized many of their assumptions and much of their ideology

40. Audrey Watters, "MOOC Mania: Debunking the Hype around Massive Open Online Courses," *The Digital Shift* (blog), April 18, 2013, http://www.thedigitalshift.com/2013/04/featured/got-mooc-massive-open-online-courses-are-poised-to-change-the-face-of-education/

about information and content. The balance of power has shifted, and the tech-sector platform monopolies are very much engaged in regulatory capture as part of their efforts. Whatever one's feelings about Napster in 1999 were, at this point, the tech sector has become a small number of companies that have made their executives enormously wealthy while fewer and fewer people out there can make a living producing creative work.

Now that we are several decades into the disruption brought about by the web, what do we make of arguments like Shirky's about the publishing industry's inevitable demise as determined by the technology of the web? Returning to the beginning of this chapter, all those books about disruption talk a big game about how everything is changing, and we need to watch out. However, (1) all of those books were published in print, and (2) most were published by imprints of "old guard" publishers who were ostensibly doomed to disappear, by Shirky's logic. One was published by Taylor and Francis (founded in 1852), one by HarperCollins (Harper Brothers was founded in 1817), and another by Macmillan (founded in 1843). As much as those authors want to tell the fearmongering story of how disruption is going to get you, they all apparently still feel the need to do so with the help of a publisher that provides editorial services and helps to promote and distribute their book in print. As new disruption books are published every year, those print books and their publishers testify to the lie at the heart of the hype of disruption.

When the elaborately decorated Library of Congress Jefferson Building was constructed in the 1890s as a temple to knowledge, a key feature of its decoration was the printer's marks of major publishing houses that enable the publication and diffusion of knowledge. In fact, the printer's mark of Harper Brothers, one of the publishers of those disruption books, is still clearly visible on the ceiling today. The symbols in the Harper Brothers printer's mark are illustrative of the role publishers have played and still play in cultural memory. The mark shows one hand passing a torch to another hand. Underneath this handoff, in Greek, is a line from Plato's *Republic*, which translates as "Running in the race, they pass the torch one to another."[41] Publishing, at its heart, is about these handoffs of knowledge and memory—a tradition that this book participates in, alongside that stack of books with "disrupt" in their title.

41. Ralph Mackay, "Publisher's Devices: Harper & Brothers: Passing the Torch," *Chumley & Pepys on Books* (blog), May 17, 2010, http://chumleyandpepys.blogspot.com/2010/05/publishers-devices-harper-brothers.html

The printer's mark and its location on the ceiling of the Library of Congress reflects the mission shared by the publishing industry and other institutions that facilitate the production and sharing of memory work and manage handoffs of knowledge from generation to generation. In this case, those print books about how everything will be disrupted exemplify that that is completely not the case. Despite disruption, publishers and libraries persist as key infrastructure for the creation and dissemination of knowledge.

As general supporters of the creation, diffusion, and preservation of creative and documentary works, records, and sources, it's critical for the cultural-memory sector to not tacitly absorb or internalize the ideology of Silicon Valley and its assumptions about how industries function, in particular the industries that produce the media of cultural memory. This isn't to say that the cultural-heritage sector needs to fully ally with the media and content industries, but instead to acknowledge that the cultural-memory sector needs to step up more to be an independent arbiter of the impacts and motives of both the media industries and the tech sector.

Tragically, it appears to now be the case that in this era after disruption, many of the media-publishing companies believe that to survive into the future, they need to transform themselves into the image of the platform monopolies that Silicon Valley invented. In this context, it is even more critical for the cultural-memory community to look out for and explore how to intervene on behalf of the broader communities influenced by these shifts toward platform monopoly. As publishers merge and change, several are repositioning their work around one of the key realizations of the platform era: that the data they can collect and warehouse and mine is increasingly important to how they talk about themselves and their business going forward. This leads directly into our next chapter, which will focus on the way that an obsession with data and data analytics has similarly functioned to disrupt many key aspects of management cultures in a wide range of sectors.

CHAPTER 3

Where Data Drives

In 2012, I presented at a "Focus on Innovations" panel at the Association of Research Libraries fall forum. For context, the Association of Research Libraries is a member organization of the 124 largest research libraries in the US and Canada. I was there to spread the word about Viewshare, a free online platform for creating interactive visualizations of digital collections data that I was working on at the Library of Congress. One of my copanelists, Greg Raschke, gave a talk called "Moneyball, the Extra 2%, and What Baseball Management Can Teach Us About Fostering Innovation in Managing Collections."[1] The talk focused on "what the statistical revolution and analytics can bring to managing library collections." The audience for these events is executive leadership, the deans and associate deans of research libraries. Raschke was one of those executive leaders. At that point in his career, he was the associate director for collections and scholarly communication at North Carolina State University Libraries. The talk was engaging and well received by attendees. At the time, I was impressed by the sophistication of the kind of data analysis that Raschke was sharing. However, over time I've come to believe that the message of

1. Slides from the presentation are available online: "ARL Collections Presentation: Moneyball, the Extra 2%, and What Baseball Management Can Teach Us About Fostering Innovation in Managing Collections," https://www.slideshare.net/gkraschk/arl-collections-presentation-moneyball-the-extra-2-and-what-baseball-management-can-teach-us-about-fostering-innovation-in-managing-collections. Along with the slides, an audio recording of the full session is available on ARL's YouTube channel. Association of Research Libraries, *Focus on Innovations, ARL-CNI Fall Forum,* Oct. *2011,* 2012, https://www.youtube.com/watch?v=um3f_FLCL8s

that talk exemplifies problematic approaches to data, measurement, and goal setting that cultural-heritage institutions have adopted from Silicon Valley and the broader world of business.

The title of Reschke's talk alluded to two best-selling books marketed to business leaders and managers: *Moneyball: The Art of Winning an Unfair Game* from 2003 and *The Extra 2%: How Wall Street Strategies Took a Major League Baseball Team from Worst to First* from 2011. "Moneyball" describes the implementation of sabermetrics, a statistical approach to building the winning Oakland A's team. In 2011 *Moneyball* was made into a movie starring Brad Pitt. *The Extra 2%* similarly focuses on applying a metrics-based approach to creating a winning team. It explains how "three financial industry whiz kids and certified baseball nuts take over an ailing major league franchise and implement the same strategies that fueled their success on Wall Street." In short, both books argue that the kinds of quantitative data analytics skills used on Wall Street are the right tools, and ostensibly the only tools you need, to get results in just about any field. The books support the idea that what you need to run any kind of organization well is not deep expertise in the field. What you need is the kind of objectivity that comes from being a "quant."

As part of the talk, Raschke made the case to his fellow library leaders that they need to "Do whatever you can to hire analytical statistical staff." The objectivity of data-driven decision-making allows one to "identify market inefficiencies" and "question long-established wisdom." The core idea is that you shouldn't trust the "hunches" of staff. As he explained, drawing on *Moneyball*, baseball scouts' judgment about the potential of players was supplanted by quantitative analysis of data, ostensibly with great results. In the same vein, he suggested that a seasoned librarian's judgment would not be as useful in the future, when we can turn our attention to quantitative analysis of hard data on metrics about a library's collections and use.

The idea seemed compelling at the time. We could get away from the hunches that had informed how libraries develop their collections and shift to a more data-driven approach. No one in the audience questioned the idea in the discussion portion of the event. From Rachke's SlideShare page, you can see that he gave versions of this talk at several other library conferences. In short, it was a hit. Library leaders were interested in how they could learn from the Wall Street quants.

Looking back on the talk, I find myself questioning how and why it seemed to make so much sense then. In what ways is the work of a library like the work required to win baseball games? To what extent is winning

baseball games like building collections intended to support all the areas of scholarship that a research library supports? In baseball, there are clear short-term and well-defined win conditions. In collection development, many libraries are continuing to build collections developed over centuries, or at least decades. Those library collections are often developed with the explicit intention to support the creation of somewhat ineffable, novel, and creative kinds of new knowledge. The appeal of, and beliefs about, the power of data in this Moneyball mode of thinking, and the problems it presents, is the central focus of this chapter.

Leaders of all kinds of organizations have become obsessed with data. In 2006, data scientist Clive Humby declared "Data is the new oil." This bit of hype reoccurs every so often in headlines in *Wired* and *The Economist*. In the minds of the consultant classes, data is out there, waiting to be mined, extracted, processed, and exploited. This chapter focuses on the way notions of data-driven decision making, key performance indicators (KPIs), and objectives and key results (OKRs) have resulted in reductionist and myopic perspectives for planning and envisioning the future of memory institutions.

Various organizations, cultural-memory institutions included, now have chief data officers. They are often people who know data analysis techniques, the people that Raschke advocated hiring, but aren't themselves experts in the issues at hand for the organization's missions. Of course, making decisions informed by evidence is a good thing, but when the quest for data and the desire to track it become central to all areas of work and planning, it warps perspectives on what matters, and literally, what counts.

As a result of the ascendance of this kind of thinking in the last half of the twentieth century, we find ourselves in what historian Jerry Muller describes as the tyranny of metrics. Seemingly all work needs to be tied to quantifiable goals that can be easily counted and tracked. Leaders in library organizations have sought Moneyball approaches to statistical analysis of their collections and collections-use patterns. Federal agencies supporting the advancement of scholarship have been pushed to track reductive performance measures such as citation counts. In each of these cases, chasing data creates a dichotomy between the analyst and the analyzed. The experts at their craft (librarians, archivists, historians, etc.), who can appreciate the full range of issues and challenges in each context, are to be distrusted. It is worth noting that scholars such as Roma Harris argued in the early 1990s that exactly this kind of discounting of expertise is itself part of a method of using technological change to deprofessionalize historically feminized

professions such as librarianship and social work.[2] In Moneyball thinking, the on-the-ground expert's judgment is dismissed as subjective instead of being understood as nuanced, contextualized, and embedded.

As I write this chapter, we are now two decades out from the release of the critically acclaimed HBO series *The Wire*. The show's depiction of teachers, police officers, journalists, and civic leaders working to "juke the stats" and put spin on what does and doesn't get counted could very well describe the functions and operations of our civic and cultural institutions today. One of the central social critiques of *The Wire* is the problematic effects of implementing CompStat-like programs, a data-analytics-driven approach to policing. CompStat is anchored in the same set of assumptions as sabermetrics.[3] For decades we have been broadly aware that data-driven decision-making produces potentially pernicious results, but this has not stopped the hype from continuing to grow. We need to be thinking about how to undermine the false notions of objectivity in data and sort through how to make sure that any uses of data still connect with and value the knowledge of experts on the ground working in their fields.

In what follows, I delve deeply into the context of how a key case study of YouTube's approach to goal setting from *Measure What Matters* proves just how dangerous this kind of narrow quantitative thinking can be for organizations and society. From there, I move into lessons that psychometrician Gene Glass draws from his experience attempting to improve learning outcomes in schools through the development of complex statistical methods. With more context on the theatrical and performative nature of power games around data, I then offer further consideration of the way that companies like Oracle and Palantir present themselves as objective seers of the future while at the same time making the case that their ways of knowing are on some level mystical or magical. Drawing on my own involvement in the development of a performance measurement framework for grants to support the work of libraries, archives, and museums at the Institute of Museum and Library Services, I demonstrate how working to meet requirements in the Government Performance and Results Act undermines the ability of the institution to fulfill its mission. This provides another point to reflect on the deeply problematic ways that quantification

2. Roma M. Harris, *Librarianship: The Erosion of a Woman's Profession* (Norwood, NJ: Ablex Publishing Corporation, 1992).

3. Anmol Chaddha and William Julius Wilson, "'Way Down in the Hole': Systemic Urban Inequality and *The Wire*," *Critical Inquiry* 38, no. 1 (2011): 164–88, https://doi.org/10.1086/661647

became central to work in government, through considering the career of Robert McNamara. Connecting this chapter to the previous chapter, I then demonstrate how an obsession with metrics, especially when combined with the effects of platform capitalism, becomes even more problematic, considering the disastrous effect of the "pivot to video" in digital journalism that resulted from the way Facebook misrepresented web metrics for videos on its platform. I end the chapter by exploring powerful countertrends in data analytics, in work on data feminism and in terms of goals and metrics for evaluating the results of organizations in the form of Blue Marble Evaluation.

Before getting into all of that, it is worth circling back to Raschke's talk about Moneyball and sabermetrics. It turns out, as it often does for stories that valorize narrowly defined, near-term, quantifiable, trackable, metrics-driven goals, that this didn't work out so great for baseball. As a result of the dominance of the quants, batters have been trained by analysts with deep metrics experience to focus on things like "launch angles" that are more likely to generate home runs. This has arguably changed the game for the worse. As Muller explains in *The Tyranny of Metrics*, "The result is a game that is more boring to watch, resulting in diminished audiences."[4] Big picture, the quants were great at, quite literally, hitting their narrowly defined near-term metrics. However, in the long run, they have had a significant negative effect on the whole game. The attempt to min-max and win on the stats had a systematically detrimental long-term effect. While the "hunches" of the baseball scouts may have been off about who would help an individual team win more, it seems clear that they were spot-on in terms of what made the game worthwhile. This theme, of quants working with "hard data" leading us astray, will recur across a range of contexts in this chapter.

What Matters Is What's Measured

In the 2018 book, *Measure What Matters: How Google, Bono, and the Gates Foundation Rock the World with OKRs*, John Doerr, chair of the venture capital firm Kleiner Perkins, presents the framework he introduced to the founders of Google when he invested $12 million in the company in 1999.[5]

4. Jerry Z. Muller, *The Tyranny of Metrics* (Princeton: Princeton University Press, 2018), xix.

5. John E. Doerr, *Measure What Matters: How Google, Bono, and the Gates Foundation Rock the World with OKRs* (New York: Portfolio/Penguin, 2018).

You too could "rock the world" like Bono with objectives and key results (OKRs). It's hard to understate how big a hit this book was in the world of management and leadership. Al Gore described it as a "must-read for anyone motivated to improve their organization." Bill Gates recommended it to "anyone interested in becoming a better manager." I've had it independently recommended to me by leaders of multiple library and museum organizations, several of whom were implementing the frameworks from the book in their organization's methods for planning and metrics. The book has become a go-to resource for leaders in business, government, and nonprofits interested in establishing goals and tracking performance.

Measure What Matters is a how-to manual for institutional leaders interested in running data-driven organizations. The book is significant on two fronts. First, Doerr has been a key player in shaping how Silicon Valley tech firms work over the last two decades. Second, the book has become a key resource for leaders across sectors. It presents a series of case studies demonstrating how the tech sector has approached goal setting and measurement. Beyond that, the book is also valuable in how it documents how the ideology that drives the tech sector is then repackaged and sold as the way for all sectors to approach their work and goal setting.

The key concepts of the framework are reflected in two acronyms: OKR (objectives and key results) and KPI (key performance indicators). In the framework, objectives need to be "significant, concrete, action oriented, and (ideally) inspirational," and key results are intended to "benchmark and monitor how we get to the objective." Key results need to be "specific and time-bound, aggressive yet realistic. Most of all, they are measurable and verifiable." Doerr explains that it's not a key result "unless it has a number."[6] In this line of thinking, if it's not quantifiable it may as well not exist.

Along with making all goals countable, the framework requires organizations to narrow their focus to a small number of objectives with aggressive short-term timelines. In Doerr's words, "Measuring what matters begins with the question: What is most important for the next three (or six, or twelve) months?" It also requires successful organizations to only "focus on the handful of initiatives that can make a real difference, deferring less urgent ones."[7] The result of these definitions is a bit of a trick. It sounds like you are going to "measure what matters," but by definition

6. John E. Doerr, *Measure What Matters: How Google, Bono, and the Gates Foundation Rock the World with OKRs* (New York: Portfolio/Penguin, 2018), 7.

7. John E. Doerr, *Measure What Matters: How Google, Bono, and the Gates Foundation Rock the World with OKRs* (New York: Portfolio/Penguin, 2018), 47.

the approach ends up defining "what matters" as things that you can affect change on in a matter of months.

Obsessing over near-term quantifiable results may strike you as a bad idea for organizations that need to plan for the long term. To assuage readers' concerns, the book opens by acknowledging that aggressive goal setting is known to cause problems. Citing contemporary management research, Doerr notes, "Goals may cause systemic problems in organizations due to narrowed focus, unethical behavior, increased risk taking, decreased cooperation, and decreased motivation."[8] As a case study, he notes Lee Iacocca's aggressive goal setting to create the Ford Pinto. To meet targets, he pushed product managers to cut all kinds of corners. All of this resulted in the Pinto being a notorious, and deadly, fire trap.[9] While acknowledging those caveats, one of the central case studies held up in the book as an exemplar of the great success of OKRs and KPIs resulted in the same sort of narrowing of thought and negative outcomes.

The book devotes a full chapter to a key case study of how YouTube came to completely dominate online video. The chapter includes sections written by Susan Wojcicki, YouTube's CEO, and Cristos Goodrow, YouTube's vice president of engineering. In keeping with the need for business books to make up and reference each other's acronyms, the chapter starts by referencing the importance of what Jim Collins describes in *Good to Great: Why Some Companies Make the Leap and Others Don't* as Big Hairy Audacious Goals, or BHAGs.[10] It is worth delving into the details of this YouTube case study because it illustrates just how deeply problematic the outcomes of this kind of narrow metric-driven thinking can be.

Watch Time, and Only Watch Time

The story starts in 2011 at YouTube, which had been working under the OKR/KPI framework as a part of Google for years. Managers had concluded that "YouTube's OKRs needed work" in large part because "they

8. John E. Doerr, *Measure What Matters: How Google, Bono, and the Gates Foundation Rock the World with OKRs* (New York: Portfolio/Penguin, 2018), 9. For more management literature on the problems of goal setting, see Lisa D. Ordóñez, M. E. Schweitzer, A. D. Galinsky, and M. H. Bazerman, "Goals Gone Wild: The Systematic Side Effects of Overprescribing Goal Setting," *Academy of Management Perspectives* 23, no. 1 (2009): 6–16.

9. John E. Doerr, *Measure What Matters: How Google, Bono, and the Gates Foundation Rock the World with OKRs* (New York: Portfolio/Penguin, 2018), 52.

10. James C. Collins, *Good to Great: Why Some Companies Make the Leap and Others Don't* (New York: HarperBusiness, 2001).

had hundreds of them."[11] At that point, over 800 people were working on YouTube, so it makes a lot of sense that something that complex could result in having hundreds of related and supporting goals. YouTube's hundreds of targets and goals were not delivering the results for growth that Goodrow and Wojcicki wanted to see. As a result, in 2012, a new framework came together. There would be one single overarching goal, "Watch time, and only watch time." YouTube's success would solely be measured by how many aggregate hours of video were watched on the platform every day.

This was an internally controversial idea. As Goodrow explains, many YouTube staff believed that the benchmarks should be tied to a video's quality, or the extent to which a given video satisfied your need. Goodrow offers a hypothetical to illustrate the divergences of opinion. Imagine you search YouTube for "how to tie a bow tie." There are two videos that might show up in the top search result spot. One is short and highly accurate. In a minute it successfully communicates how to tie a bow tie. The other is "ten minutes long and is full of jokes and really entertaining, and at the end of it you may or may not know how to tie a bow tie."[12] Many of Goodrow's colleagues believed the first video, the one that efficiently answers your question, should be the first result. He disagreed.

For Goodrow, YouTube wasn't about getting to a video with accurate information. If people kept watching the longer video, then, from his perspective, that was the better video. The good news was that this meant they didn't have to count something challenging related to the quality of a video. If they took aggregate watch time to be the only indicator of quality, then they could chase a simple metric that was straightforward to count. As part of this metric, YouTube accepted and embraced the idea that the goal of their platform is not to get you to a high-quality result, but that "Our job was to keep people engaged and hanging out with us." In his words, "by definition, viewers are happier watching seven minutes of a ten-minute video, than all of a one-minute video. And when they're happier, we are, too."[13] That statement is useful in demonstrating how an obsession with quantitative data can end up with slippage between "what's measured" and

11. John E. Doerr, *Measure What Matters: How Google, Bono, and the Gates Foundation Rock the World with OKRs* (New York: Portfolio/Penguin, 2018), 159.

12. John E. Doerr, *Measure What Matters: How Google, Bono, and the Gates Foundation Rock the World with OKRs* (New York: Portfolio/Penguin, 2018), 162.

13. John E. Doerr, *Measure What Matters: How Google, Bono, and the Gates Foundation Rock the World with OKRs* (New York: Portfolio/Penguin, 2018), 162.

"what matters." He takes us from a discrete countable thing, like how long someone watches a video, to a totally unwarranted line of inference from that data. It's not at all clear how watching for longer can really serve as a proxy for happiness. For better and, more dramatically, for worse, total watch time became the sole focus of YouTube. Quality, happiness, and whatever else might matter had been equated to the total amount of time the video was watched.

In 2012, YouTube set the goal that by 2016 they wanted to have one billion hours of video watched on their platform every day. In his own words, somewhat missing the point of *Moby Dick*, Goodrow explains, "The billion daily hours had become this white whale."[14] They did it. By making hundreds of minor tweaks to their search algorithms and their infrastructure they drove daily watch time higher and higher.[15] They got that whale. They got their bonuses. But at what cost?

There is a direct and clear connection between the Ahab-like focus on watch time and YouTube becoming what sociologist Zeynep Tufekci has called "The great radicalizer."[16] In making "Watch time, and only watch time" the sole thing to measure, they also made it the only thing that mattered. As a result, by definition, nothing about the quality of the videos could possibly matter. In the words of one tech blogger, "so it is for YouTube and their watch time goal. A veritable swamp that has swallowed YouTube whole, and, in the process, Western democracy as we know it."[17] Since meeting the watch-time goal, a wide range of scholarship and research has documented the widespread detrimental effects of a watch-time-obsessed platform. YouTube is a key driver of "flat-earth" conspiracy theories.[18] YouTube is a key resource in advancing antisemitic conspiracies.[19] YouTube

14. John E. Doerr, *Measure What Matters: How Google, Bono, and the Gates Foundation Rock the World with OKRs* (New York: Portfolio/Penguin, 2018), 166.
15. Cristos Goodrow, "You Know What's Cool? A Billion Hours," *YouTube Official Blog* (blog), February 27, 2017, https://blog.youtube/news-and-events/you-know-whats-cool-billion-hours/
16. Zeynep Tufekci, "YouTube, the Great Radicalizer," *New York Times*, March 10, 2018.
17. Jacques Corby-Tuech, "OKR's, YouTube and the Danger of Unintended Consequences," *Jacques Corby-Tuech* (blog), January 22, 2020, https://www.jacquescorbytuech.com/writing/okr-youtube-unintended-consequences.html
18. John C. Paolillo, "The Flat Earth Phenomenon on YouTube," *First Monday*, December 1, 2018; Shaheed N. Mohammed, "Conspiracy Theories and Flat-Earth Videos on YouTube," *Journal of Social Media in Society* 8, no. 2 (2019), 84–102.
19. Daniel Allington and Tanvi Joshi, "'What Others Dare Not Say': An Antisemitic Conspiracy Fantasy and Its YouTube Audience," *Journal of Contemporary Antisemitism* 3, no. 1 (2020): 35–53; Daniel Allington, Beatriz L. Buarque, and Daniel Barker Flores, "Antisemitic

played a vital role in the creation and spread of the QAnon conspiracies.[20] Significant to the intentions of this book, each of these areas of disinformation is directly detrimental to cultural memory, and they work to further erode public trust in legitimate and nuanced explorations of the past. Much like the Moneyball example, in obsessing over a set of metrics, they were able to meet their goals but ended up having huge negative effects on what, ostensibly, anyone would say matters.

What is particularly galling in this is that YouTube's narrowly defined short-term goals resulted in exactly the kind of negative effects that we know those kinds of goals result in. As noted already, *Measure What Matters* starts out by acknowledging that this kind of aggressive metric-driven goal setting can result in narrowed focus with ancillary negative results. To be sure, Doerr does explicitly want organizations to narrow their focus in an obsessive chase after "10x growth," and the result is a wide swath of problems that we are all left to face in its wake. It would seem like it should matter to YouTube that it has become a huge attention-sucking machine that radicalizes people, but to Doerr's point, they didn't measure that, so it didn't matter.

It's possible to think through that story and conclude that they picked the wrong "single thing" to obsessively measure. But the point is much broader. It's an indictment of the whole concept. Narrow, metric-obsessed, short-term thinking focused on 10x growth does this. It's worth remembering that in the context of your body, unchecked, dramatic growth is cancer. Oddly, and significantly, none of this matters for *Measure What Matters*. The book went to press featuring a case study that just a few years later would clearly illustrate how the ideas it advances had broad negative effects on our media ecosystem. The belief in this kind of metric-driven goal setting is so strong and singular that it doesn't matter that the evidence that it is harmful and destructive keeps piling up.

No Mass of Data Resolves Debates

When Gene Glass completed his PhD in educational psychology and statistics in 1965, he was excited to make a difference. He was dedicated to finding definitive evidence on how to improve public education in the

Conspiracy Fantasy in the Age of Digital Media: Three 'Conspiracy Theorists' and Their YouTube Audiences," *Language and Literature* 30, no. 1 (2021), 78–102.

20. Daniel Taninecz Miller, "Characterizing QAnon: Analysis of YouTube Comments Presents New Conclusions about a Popular Conservative Conspiracy," *First Monday*, 2021.

United States and beyond. Over decades, he would have a major impact on fundamental tools for statistical analysis. His reflections on the limits of that analysis, and the reasons for the limits of that analysis, are relevant to questions about how data should be used to make decisions and set goals. They are also invaluable in understanding how calls for rigor and data in public education institutions, critical institutions that support cultural memory, have worked to hinder our ability to educate.

In the 1970s, Glass led the development of new statistical methods called meta-analysis. At that time, you could pile up individual studies, but rigorous practices for integrating the data across those studies hadn't been established. He developed meta-analysis to do just that. The methods he developed are now widely used in many fields beyond education. In 1975, largely due to his leadership in advancing these quantitative data analysis methods, he served as the president of the American Educational Research Association.

In 2008, he reflected on his work in these areas and its effects. His reflections are relevant for understanding the extent to which data resolves questions of public concern. "Like many of my generation, I shared a galvanizing faith in the power of social science research to find the way to a better life for all." He goes on, "I truly believed, for a while, that the synthesis of dozens or even hundreds of empirical studies into an aggregated, overall conclusion would command the attention and consent of all sides in debate."[21] As a key example, "One hundred studies when properly integrated show unequivocally that students in smaller classes learn more than students in larger classes. Can there be any doubt?" The answer to his rhetorical question is no, there can be no doubt that smaller class size improves learning. However, the clarity and certainty that his work generated had no effect. Classes are still huge.

From this experience, Glass learned something broadly relevant to the role of data in resolving public policy questions. His primary takeaway from his body of work was that "no mass of data regardless of its size or its consistency resolves debates about the best way to educate children."[22] Finding the "right" answer has had effectively no impact. Beyond that, the demand for better data, or demonstrations of the effectiveness of a given initiative or program, can function to stall or destabilize that program or effort.

21. Gene Glass, *Fertilizers, Pills, and Magnetic Strips: The Fate of Public Education in America* (Charlotte, NC: Information Age Publishing, 2008), xii.

22. Gene Glass, *Fertilizers, Pills, and Magnetic Strips: The Fate of Public Education in America* (Charlotte, NC: Information Age Publishing, 2008), xii.

With that realization in hand, Glass turned his data analysis skills to explore the apparent effects of major education reform efforts across the United States. His primary takeaway from analysis of a broad swath of educational statistics and demographic data is that "The older, white voting public, facing their own exigencies in an uncertain retirement, is increasingly unwilling to shoulder the tax burden of educating 'other' people's children, particularly when those children do not physically resemble or act like their own grandchildren."[23]

From his perspective, it is necessary to not consider policy questions one at a time, but to look more broadly at what questions are asked about what kinds of initiatives and who frames the questions. When issues like virtual schools, charter schools, homeschooling, English as a second language, alternative teacher certification, or high-stakes testing are raised, two primary questions are asked: "Will it improve student's academic achievement?" and "What does it cost?" He explains, "while important, these questions are secondary to questions that are too seldom asked: Why *this* proposal and not others? *Who* is proposing this reform? Who wins and who loses (money, status, freedom) if we go down this path?"[24] When those broader questions are asked, the ideological ends on which most debates about public education are focused become clear.

It's not a question of the data, it's a question of who asks what questions about the data. He further explains, "Too often in policy research, those who set the agenda win the debate. When most things one might do will accomplish a little bit of good and their bad side effects are harder to see or far in the future, being in a position to ask the question (Do charter schools 'work'? Is homeschooling successful?) guarantees that most other questions will be pushed into the background."[25] Thinking back to *Measure What Matters*, the narrowing effect of setting a limited number of goals and metrics has the same kind of effect. The decision to "defer" to the future what are imagined to be less pressing issues removes them from consideration in the present. It pushes to the background the broader long-term issues that must be considered and explored.

In considering these points, Glass opens a related set of issues. In the

23. Gene Glass, *Fertilizers, Pills, and Magnetic Strips: The Fate of Public Education in America* (Charlotte, NC: Information Age Publishing, 2008), 145.

24. Gene Glass, *Fertilizers, Pills, and Magnetic Strips: The Fate of Public Education in America* (Charlotte, NC: Information Age Publishing, 2008), 146.

25. Gene Glass, *Fertilizers, Pills, and Magnetic Strips: The Fate of Public Education in America* (Charlotte, NC: Information Age Publishing, 2008), 144.

face of a continual demand for results and calls for more data, public education "has been subjected to assaults on its autonomy and its professionalism in an attempt to reduce its costs." In this context, educators and educational researchers are denied the ability to advance the work they are close to, on which their expertise centers; instead, a range of political forces and outside groups run roughshod over what educators know and have the data to show needs to happen to improve education. In this context, the demand for data, the constant call for reform, and various reform initiatives only make sense when we recognize that this isn't about getting better answers from available data; rather, it's about advancing an ideological agenda focused on undermining public education.

This isn't a book about public education, but public education is central to the function of public memory and cultural memory. That is, public education institutions are themselves all institutions of cultural memory. Public education is the central institution through which young people learn about history and the past. Significantly, because of an obsession with quantification, K–12 schools increasingly fail to devote time and resources to teaching history and the humanities. It's critical in this context to recognize that questions about the goals of memory work and what should count as evidence of success are inherently political. Pushing a field into a perpetual search for justification in data is intentionally exhausting, and it has a goal. It works to destabilize the field and the work and undermines efforts by those in the field to make progress and demonstrate results.

It's critical that we appreciate what Glass learned through a whole career of developing new ways to make the case and justify good work in education. For the most part, data don't win arguments. In practice, those who determine who gets to decide what counts can use the process to advance their own ends and goals. To illustrate this point, I delve into my own experience in providing input on what to count and track regarding the goals of library and museum grant projects.

What Counts for Library and Museum Programs?

In 2015 I took a new job as a senior program officer at the Institute of Museum and Library Services (IMLS). Created by the Museum and Library Services Act of 1996, the agency provides $240 million a year in funding to libraries and museums. With about 60 staff, the IMLS is in fact a very small "micro-agency." The Office of Management and Budget in the White House defines a small agency as one having 6,000 or fewer staff,

and a micro agency as having 500 staff or fewer. The 60 staff at IMLS must collectively make sure they do all the things required of a federal agency. As you might imagine, it often means that folks need to wear a lot of hats.

One of my first assignments at IMLS was to join a working group charged with developing a set of agency-wide performance measures. As it was explained to me, the agency, like many federal agencies, had a lot of work to do to fully comply with the Government Performance and Results Act (GPRA). Originally passed in 1993, it was expanded in 2010 through the GPRA Modernization Act. GPRA requires federal agencies to set specific goals in formalized strategic plans, and to measure and report on results in relation to those plans. For grant-making agencies like IMLS, GPRA largely requires development of frameworks to systemically track and report on the collective outcomes of their grant programs. Given my background as a subject matter expert on libraries and my PhD in social science research and evaluation methods, it was an assignment that made a lot of sense. My experience working on these performance measures illuminated the kinds of problems that come from the metrics obsession promoted by initiatives like GPRA.

On the surface, it seems to make a lot of sense to have a common set of measures and indicators developed to track performance in all the IMLS grant programs. In practice, as is often the case with work to comply with GPRA, the effort falls into the central traps of metrics fixation. As Muller explains in *The Tyranny of Metrics*, "When proponents of metrics advocate 'accountability,' they tacitly combine two meanings of the word. On the one hand, to be accountable means to be responsible. But it can also mean 'capable of being counted.'"[26] The distinction between those two points is significant, and focusing on countable results can in fact be at odds with the broader goals of grant programs.

An agency like IMLS engages in a whole host of activities that ensure its work is responsible—that is, accountable in the first sense. IMLS convenes experts to identify key priorities in an area and publishes reports synthesizing input from the field. Program officers with expertise in their fields develop Notifications of Funding Opportunities (NOFOs), which are functionally calls for proposals that provide guidance to applicants. Those NOFOs build on input from experts while making sure the calls for projects align with statutory requirements defined by Congress that

26. Daniel Taninecz Miller, "Characterizing QAnon: Analysis of YouTube Comments Presents New Conclusions about a Popular Conservative Conspiracy," *First Monday*, 2021, 17.

specify what a given grant program can support. Experts in the relevant fields provide peer review of proposed projects based on criteria from the NOFOs. Program officers provide input to agency executives on portfolios of proposed projects. The agency's presidentially appointed and Senate-confirmed director makes final decisions on which projects will be funded. Once competitive grants are awarded to the strongest proposals, grantees are required to produce interim and final reports accounting for the results of their work. If those grantees need to significantly deviate from their approved proposals, they need to make requests of program officers to approve any changes in their project plans. At the same time, agency staff who manage the financial aspects of grants process requests for approved funds in accordance with legal requirements. Grantees awarded major funding are required to pay for external financial audits, which are submitted to all the federal agencies they receive funding from. The federal agencies are audited regularly as well. Altogether, this represents a considerable and rather comprehensive set of approaches to ensure responsible management and the investment of resources in accordance with the intentions of the legislation. However, when it comes to explaining the results of the programs, the process I have just outlined does not provide any simple, general set of countable metrics to track performance outcomes.

To illustrate the problems that emerge from establishing a single set of countable measures for an agency's grant programs, it's useful to consider some examples of major grant programs. The National Leadership for Libraries program and the related National Leadership Grants for Museums program focus on funding projects that demonstrate and test new ways of running and operating programs for libraries, archives, and museums. They can also support fundamental research that can demonstrate new approaches to the work of libraries and museums. These programs have funded projects ranging from hosting convenings that bring together experts on the potential role of school libraries in supporting K–12 open-educational-resource initiatives, to studies of the efficacy of rural library programs that lend Wi-Fi hot spots, to major grants to scale up the development and implantation of nonprofit national e-book programs, to studies to identify the best methods for inseminating elephants in zoos. In keeping with the intent of the agency's legislation, those national leadership projects are not intended to generate immediate near-term countable results that can be reasonably aggregated together. These are projects that by design are exploratory, involve risk, and have the potential to have a

long-term impact on the field. That kind of work is at odds with the metric fixation inherent in laws like GPRA.

Ultimately, the IMLS implemented a set of performance measures that relate to what, of necessity, must be very high-level goals in its strategic plan. To make this at all workable, when applying for a grant, applicants are required to pick which agency-level goal their project relates to. When they select that goal, they are agreeing to the set of measures they will be required to report on. So, if you as an applicant identify that your project is related to the IMLS goal to "train and develop museum and library professionals," then you would be required to get each participant or beneficiary of your project to respond on a scale from strongly agree to strongly disagree to the following three questions.

1. My understanding has increased as a result of this program/training.
2. My interest in this subject has increased as a result of this program/training.
3. I am confident I can apply what I learned in this program/training.

Along with asking those questions, you must also provide data on the number of participants, the total number of responses, the number of responses per answer, and the number of nonresponses. All that data is to be filled in on a PDF form that is submitted along with the final report of your project.

Of what possible use is an aggregation of those three questions across the range of programs the agency supports? As one example, the Laura Bush 21st Century Librarian program can support projects focused on generating interest in library careers for students in middle school and high school, the development of new kinds of graduate certificate programs, support for convenings that explore issues for new areas of library school curricula, the development of continuing education and professional training for staff who have worked in libraries for decades, and scholarships to doctoral students in library and information science. Across each of those areas, most of the grants are like the National Leadership Grant programs, intended to try out new ideas and develop novel approaches to programs. If you have responses to the questions above from a set of middle-school students who went to a one-day event intended to spark interest in library careers, and also responses from individuals supported with funding to pursue doctorates in library and information science, there is zero value

in aggregating their responses in some sort of agency-level tracking effort. The one-size-fits-all measures developed to meet the compliance requirements of having performance measures won't measure anything related to the real impact of these projects. From my perspective, the entire set of performance measures is a poor use of time and resources. The extra burden and confusion they generate for grantees, who already must establish project specific outcomes for their proposed projects, end up causing the projects themselves to suffer.

In short, this GPRA compliance activity effectively requires agencies to discount the nuanced and thoughtful project-specific judgment of expert program officers and peer reviewers for simplistic, one-size-fits-all quantitative measures. For Muller, this illustrates a central mistaken belief in the metric fixation: that "it's possible and desirable to replace judgment, acquired by personal experience and talent, with numerical indicators of comparative performance based on standardized data (metrics)."[27] The expert judgment of program officers and the subject matter experts who review projects are already in place as means to ensure accountability and results; in practice a fixation with metrics can make things countable but in fact hurt the broader goals of accountability.

While I think it's clear that the questions and data from the performance measures are not useful, I want to underscore that they are in practice the best possible questions to ask of projects within the framework that GPRA requires the agency to work in. It's not that there could be better questions, it's that the need to produce this kind of metrics that can be theoretically rolled up into countable data like this is fundamentally a fool's errand. This is true for IMLS, but it's just as true for the National Science Foundation, or the National Institutes of Health, the National Endowment for the Humanities, or any federal agency that makes grants intended to have long-term broad and systematic impacts. The kinds of grant programs that work under the metrics fixation must by design have clear and specific, narrow, near-term objectives. That is, if you run a grant program intended to build more libraries, then you can count how many libraries get built. If you're trying to produce novel and creative new kinds of knowledge but you are required to ensure accountability in terms of countable units, you end up doing tortured things like counting how many times academic papers are cited, which ends up mostly just incentivizing researchers to write the kinds of papers that get cited more often. As Muller observes,

27. Jerry Muller, *Tyranny of Metrics* (Princeton: Princeton University Press), 2018, 18.

this often results in "measuring the most easily measurable," when "what is most easily measured is rarely what is most important, indeed sometimes it's not important at all."[28] Books like *Measure What Matters* end up defining what matters as what's measurable in the near term. This is blatantly false for most areas of concern, which are longer term and not straightforwardly quantifiable, at least in the near term.

For an example of how this could all go much worse, you need look no further than the effects of the 2001 *No Child Left Behind Act*, which implemented a wide range of countability-based initiatives that significantly harmed education and the ability to conduct educational research that could have a genuine impact on teaching and learning. By requiring educational research to follow a clinical-medicine-style approach to research in the development of the "What Works Clearinghouse," the Institute of Educational Sciences in the Department of Education has functionally ruled out a wide range of relevant research methods that illuminate sociocultural and affective aspects of education. As educational researcher Yong Zhao notes in the 2018 book *What Works May Hurt: Side Effects in Education*, the effect has been to push schools to narrow the curricula, teach to the test, and urge teachers to focus attention on the students that can push their numbers up the most.[29] At the same time, this has narrowed the kinds of questions and research on education that is even fundable or supportable.

Returning to the IMLS context, the net result of the performance measures is a significant cost of time and effort that in large part works against the goals of the programs. Every grantee must learn about performance measures. Every grantee must produce data and report it on a PDF form they submit with their final report. That resulting data is, as far as I'm concerned, not useful. Beyond that, the costs of effectively aggregating that data and interpreting it, for whatever good that would do, is well beyond the agency's administrative budget. All that data is submitted on forms that are reviewed by program officers along with final reports, and then filed away. Given the wide range of variation in the nature of the projects, it wouldn't be useful to aggregate any of that data to begin with, but even if you wanted to it, would take a lot of resources to establish processes to extract and aggregate all that data and then attempt to analyze it. This is

28. Jerry Muller, *Tyranny of Metrics* (Princeton: Princeton University Press), 2018, 17.
29. Yong Zhao, *What Works May Hurt: Side Effects in Education* (New York: Teachers College Press, 2018).

another central problem of metrics fixation: not only is it largely ineffective, it's costly.

On the surface, metrics fixation appears to be a cold, clinical, and practical focus on results. As illustrated by my experience with performance measures at IMLS, and more broadly in grant making in the federal government, that appearance is misleading. In practice, metrics fixation is costly and distracting, and it undermines the long-term goals of programs. In practice, metrics fixation is part of a cultlike, mystical belief system anchored in ideas about the power of numerical data as the best and only really viable kind of information. That mystical aspect is clearly evident in a range of ways that industry leaders involved in data platforms and services present their work.

Divination, Oracles, and Palantirs

At the start of the Cold War, the US Army wanted to forecast the future of the impact of technology on warfare. In response, the RAND Corporation developed the Delphi method, which quantifies the subjective judgments of experts to predict the future. One of the biggest database companies in the world is called Oracle. Both the Delphi method and Oracle pay homage to a mythology of divination as an element of their power. Palantir, one of the biggest purveyors of data analytics platforms intended to help corporate and government leaders see the future, is named for magical stones in *The Lord of the Rings* books. Somehow, big data gets to present itself as hard-nosed and objective, and simultaneously as a sort of magical fantasy. The latter is more accurate than the former.

In keeping with Raschke's desire to hire more data analytics staff to second-guess the hunches of seasoned expert bibliographers, there is a pervading belief that the quants and data wonks have access to truly objective sources of knowledge that are invisible to those closer to the problems. On the Delphi method, management scholar Len Styles noted, "Apparently our society, not unlike the Greeks with their Delphic oracles, takes great comfort in believing that very talented 'seers' removed from the hurly-burly world of reality, can foretell coming events."[30] That same logic played out in my own experience dealing with the realities of GPRA conformance

30. As cited in Henry Mintzberg, *The Rise and Fall of Strategic Planning: Reconceiving Roles for Planning, Plans, Planners* (New York, Toronto: Free Press, Maxwell Macmillan Canada, 1994), 257.

at IMLS. There is an impulse to distrust experts working in a given field to appeal to a more abstract kind of expertise related to data analytics.

When Peter Thiel, Nathan Gettings, Joe Lonsdale, Stephen Cohen, and Alex Karp decided to start a big-data analytics company in 2003, they chose to call it Palantir Technologies. They named the company after the palantíri, the seeing stones from Tolkien's *Lord of the Rings*. When used by powerful sorcerers, those stones allow one to see things from a distance. They are best known to readers of the books and watchers of the movies as the orb that the evil sorcerer Sauron uses to support his various nefarious activities. Even within the fictional universe of that story, these imagined magical devices are notoriously unreliable. In the books, they present selective, out-of-context, misleading views. In this regard, the extensive surveillance network that feeds data into the Palantir platforms really does live up to its namesake. It's a fraught collector of partial data that is then used for a wide range of problematic ends. In much the same way that the cultish adherence to the belief system around KPIs and metrics opened with recognition that metric-driven goal setting tends to promote narrow-mindedness and short-termism, the namesakes for big-data technologies clearly warn about the inherent problems and limitations of their ideologies.

The limitations of "hard data" have been well known in organizational research for decades. In management scholar Henry Mintzberg's framing, there is always a "soft underbelly of hard data." Mintzberg notes four key problems with hard data: (1) hard information is often limited in scope, lacks richness, and often fails to encompass important noneconomic and nonquantitative factors; (2) much hard information is too aggregated for effective use; (3) much hard information arrives too late to be of use; and (4) a surprising amount of hard information is unreliable.[31] All of those points are relevant to just about any story in this chapter. They are true of the problems with IMLS performance measures, and clearly true about the problems of big-data mythology that companies like Palantir thrive on.

It is both strange and confusing that the cultural imagination can hold that big data, machine learning, and AI can be bought into as objective and grounded in hard data. The warnings about the problems of "far seeing" were evident even in the imaginary world that Palantir borrowed its name from. That hasn't stopped the huge flows of money and data that have gone

31. Henry Mintzberg, *The Rise and Fall of Strategic Planning: Reconceiving Roles for Planning, Plans, Planners* (New York, Toronto: Free Press, Maxwell Macmillan Canada, 1994), 257.

to the company from large corporations and governments. In 2013, Alex Karp appeared on the cover of *Forbes* with the title "Meet Big Brother." That title might make you think that the cover story was critical of Karp and the company, but the exuberance of the subtitle clarifies its perspective: "How a 'Deviant' Philosopher Built Palantir, a CIA-Funded Data-Mining Juggernaut."[32] In keeping with the general tone of *Forbes*, this essay is in fact a celebration of the "eccentric" CEO of this company hoovering up data and selling its far-seeing capacities to governments and major companies. This sort of "bad boy" framing of Silicon Valley technologists as deviant, eccentric outsiders fit into the broader logic of disruptive innovation that frames technologists as creative revolutionaries when they are very much working toward mainstream corporate interests.

It turns out that the company has been able to live up to the sinister implications of its namesake. While the company was originally formed to work primarily and principally for the CIA to use big data to track terrorist organizations, in part because of the wave of positive press it got for being cited as an important platform that supported the killing of Osama Bin Laden, it quickly found a range of corporate and other civic customers. The company began working with the LAPD in 2009, applying its oracle powers to "identify and deter people likely to commit crimes."[33] That initiative identifies "pre-crime" suspects; the police then seek excuses to pick up these people for things like jaywalking. That area of work expanded into support for a mass surveillance system that synthesized data pulled from tracking systems on police cars in California to enable continuous broad surveillance of anyone and everyone driving around the area.[34] In support of the Trump administration's anti-immigrant stance, for the US Customs and Border Patrol Palantir played a key role in tracking and supporting the arrest of family members crossing the border.[35] In relation to that work,

32. Andy Greenberg, "How A 'Deviant' Philosopher Built Palantir, A CIA-Funded Data-Mining Juggernaut," *Forbes*, September 1, 2013, https://www.forbes.com/sites/andygreenberg/2013/08/14/agent-of-intelligence-how-a-deviant-philosopher-built-palantir-a-cia-funded-data-mining-juggernaut/

33. Peter Waldman, Lizette Chapman, and Jordan Robertson, "Palantir Knows Everything About You," *Bloomberg.com*, accessed September 11, 2021, https://www.bloomberg.com/features/2018-palantir-peter-thiel/

34. Ali Winston, "License-Plate Readers Let Police Collect Millions of Records on Drivers" (Center for Investigative Reporting, June 26, 2013), https://web.archive.org/web/20170616021807/http://cironline.org/reports/license-plate-readers-let-police-collect-millions-records-drivers-4883

35. Spencer Woodman, "Palantir Provides the Engine for Donald Trump's Deporta-

Amnesty International issued a detailed report documenting how the company fails to carry out due diligence on human rights for migrants and asylum seekers in the systems and services it provides.[36] Despite all of that, at this point, Palantir continues to win huge contracts and has a market capitalization of over $50 billion.

For quite some time it has been realized that analysts claiming far-seeing abilities in fact subscribe to a magical belief system. In 1984, Martin Gimpl and Stephen Dakin made that case in an article titled "Management and Magic" in the *California Management Review*. They explained that "Management's enchantment with the magical rites of long-range planning, forecasting, and several other future-oriented techniques is a manifestation of anxiety-relieving superstitious behavior."[37] They further observe that "forecasting and planning have the same function that magical rites have . . . they make the world seem more deterministic and give us confidence in our ability to cope, they unite the managerial tribe, and they induce us to take action, at least when the omens are favorable." The absurd notion that a company like Palantir can stop "pre-crime" is a sci-fi story brought to life. When we juxtapose the reality of governments pouring funding into this kind of mystical thinking because it comes with the patina of data-driven technology while stifling genuinely rigorous processes like peer review for grant making draws into high relief the irrational nature of metrics fixation.

Dashboards and Illusions of Control

Over the last two decades, we have seen the rise of dynamic real-time data-dashboard visualizations. They might provide data on anything from the overall health of a city, a university, or at this point just about any other kind of system one might want to manage. Borrowing from the instrumentation of cars and cockpits, digital dashboards are now frequent features of governments, too. The promise of the dashboard is to provide a real-time at-a-glance view of any number of key metrics one is tracking. Far from

tion Machine," *The Intercept* (blog), March 2, 2017, https://theintercept.com/2017/03/02/palantir-provides-the-engine-for-donald-trumps-deportation-machine/

36. Amnesty International, "Failing to Do Right: The Urgent Need for Palantir to Respect Human Rights" (London, September 27, 2020), https://www.amnestyusa.org/wp-content/uploads/2020/09/Amnest-International-Palantir-Briefing-Report-092520_Final.pdf

37. Martin L. Gimpl and Stephen R. Dakin, "Management and Magic," *California Management Review* 27, no. 1 (October 1, 1984): 125–36, https://doi.org/10.2307/41165117

inviting explorations of the complexities of collected data, these dashboards often attempt to distill messy realities and assumptions embedded in data into things as simplistic as smiley- and frowny-face icons.

In the 2021 book *A City Is Not a Computer: Other Urban Intelligences*, anthropologist Shannon Mattern documents the history of these dashboards and demonstrates that "The dashboard conceals as much as it reveals. What's left out are those urban subjects and dynamics that simply don't lend themselves to representation in the form of dials and counters, that resist algorithmization, and widgetization."[38] Along with that, she argues that these platforms "cultivate a top-down, technocratic vision—a mode of looking and thinking that, despite the dashboard's seeming embarrassment of datalogical riches, is partial, reductive, distorted, and driven by choice and faith—faith in the data and the truth they represent."[39] In effect, the dashboards work largely on the same kind of logic underlying the Palantir fable, and they come with the same inherent flaws.

Significantly, the dashboards present the illusion of control and a false sense of comprehensive knowledge. They give leaders a sense that they can "fly by instruments," like how a pilot flies in the dark, but the lack of agreement on what to count, how to count it, and the always partial and limited scope of the underlying data means that in many contexts dashboards are actively misleading. Mattern's conclusions bring us back to the set of observations about oracles and magic seeing stones. She concludes by explaining that "Today's talismans manifest not as rings or stones but as glowing screens. The dashboard-as-talisman, when deployed in municipal buildings, on trading floors, and in operations centers around the world, is intended to aggregate data for the purpose of divining the future—and shaping policies and practices to bring a desired world into being."[40]

Mattern observes that a key issue of working toward dashboards is moored in the practice of approaching every concern as an information-processing problem. In any given object or context there is potentially an infinite amount of information, so every aspect of how one operationalizes models of the world and of people into data changes how those things are understood, seen, and approached.

38. Shannon Mattern, *A City Is Not a Computer: Other Urban Intelligences* (Princeton: Princeton University Press, 2021), 16.

39. Shannon Mattern, *A City Is Not a Computer: Other Urban Intelligences* (Princeton: Princeton University Press, 2021), 40.

40. Shannon Mattern, *A City Is Not a Computer: Other Urban Intelligences* (Princeton: Princeton University Press, 2021), 19.

Critically, it's possible to approach the work of data visualization as a fundamentally different kind of activity, one that is not focused on surfacing definitive correct answers from underlying data, but instead as part of a hermeneutic set of practices that draw out and make apparent problems in underlying data. This is exactly the case that historian Fred Gibbs and I made in our essay "Toward a Hermeneutics of Data." When visualization is taken not as an end, but as a means of seeing how and where data are inherently partial, it becomes possible to appreciate from a macro level patterns that weren't visible at the micro level.[41] In this context, we can make use of data visualization tools that Johanna Drucker argues are "generative and iterative, capable of producing new knowledge through the aesthetic provocation."[42] That is a fundamentally different way of approaching data and data visualization. Instead of looking for dashboards with green thumbs-up icons or red frowny-faces, we need data science and data visualization practices to draw us into more nuanced questioning of our assumptions about the state of the world—not practices that affirm existing assumptions through facile representations.

Making the World Conform to the Data

For aspects of the world to show up in a dashboard, or become a variable in one of Palantir's databases, aspects of people and nature need to be simplified and made legible. Our lived experience of the world is infinitely complex and not reducible to numbers. Even "raw" data comes to us with a wide range of baked-in assumptions about how it simplifies and makes legible the information extracted. As media scholar Lisa Gitelman reminds us, "raw data" is an oxymoron. Producing a dataset requires one to process, simplify, normalize, and filter aspects of the infinite and irreducible complexity of the world. As such, every dataset comes with a theory of the world embedded in its very structure.[43] In some cases, that theory of the world is rigorous, nuanced, and intentional. More often, particularly for those who are compelled by metrics fixation like Goodrow, those models

41. Fred Gibbs and Trevor Owens, "The Hermeneutics of Data and Historical Writing," in *Writing History in the Digital Age* (Ann Arbor: University of Michigan Press, 2012). 159

42. Johanna Drucker, "Graphesis: Visual Knowledge Production and Representation," *Poetess Archive Journal* 2, no. 1 (December 10, 2010), http://paj.muohio.edu/paj/index.php/paj/article/view/4

43. Lisa Gitelman, ed., *"Raw Data" Is an Oxymoron*, Infrastructures Series (Cambridge, MA: MIT Press, 2013).

of the world smuggle in laughably bad assumptions, like the idea that the more of a YouTube video you watch, the happier you are.

When aspects of people and nature are processed into data, they are fundamentally changed. This is not a novelty of computing, or a recent invention. It's a core part of a now-lengthy process of datafication that involves making the world more simplified and legible to those interested in controlling it. As anthropologist and political scientist James Scott argues in *Seeing Like a State: How Certain Schemes to Improve the Human Condition Have Failed*, even the process by which permanent last names were assigned to people was primarily undertaken as part "of the state's exertions to put its fiscal system on a sounder and more lucrative footing." In his words, "No administrative system is capable of representing any existing social community except through a heroic and greatly schematized process of abstraction and simplification."[44] In this context, the heart of metrics fixation is tied back to the very invention of nation-states and the logic of control that developed and matured from them over time. In this context, Palantir big-data boasting and huge government contracts can be understood as part of a long history of trying to control the world through hoovering up data and providing dashboard views of it. To understand its ideological underpinnings it is useful to review the maturing of this logic and its movement between the US military and the development of management as a field of study. The career of Robert McNamara, one the biggest contributors to metrics fixation, can illustrate this relationship.

In 1939, a twenty-three-year-old Robert McNamara graduated with an MBA from Harvard Business School. He spent the next year working for the accounting firm Price Waterhouse, and a year later returned to the Harvard Business School as a professor. During World War II he applied the approaches to metrics and analytics he had developed in accounting and business to the war effort as part of a team in the Air Force Office of Statistical Control. After the war, he, and many of his colleagues from that office brought their metrics fixation into the Ford Motor Company. There, McNamara's quantitative thinking got the right attention, and he was eventually promoted to become the company's president.

Impressed by all McNamera had accomplished, when JFK became president in 1960, he offered McNamara the choice of two cabinet appointments: he could be secretary of defense or the secretary of treasury. Appar-

44. James C Scott, *Seeing Like a State: How Certain Schemes to Improve the Human Condition Have Failed*, Yale Agrarian Studies (New Haven: Yale University Press, 1998).

ently, his experience with accounting and metrics qualified him to do either job. The story of McNamara's rise to prominence is itself a story about the changing nature of expertise. As Muller explains, McNamara "was part of a transformation of what expertise meant." Expertise had meant a "career-long accumulation of knowledge in a specific field," but that was increasingly replaced by "McNamara-like bean counters" adept at "calculating costs and profit margins."[45] One of the most famous, and disastrous, examples of this kind of metric fixation is how McNamara approached the Vietnam War.

Looking for simple and clear metrics, he championed the view that the best metric for the war was body count. For the bean counters, this was taken to be a "reliable index of American progress in winning the war."[46] Significantly, "few of the generals in the field considered the body count a valid measure of success, and many knew the body counts to be exaggerations or outright fabrications." The results of McNamara's body count metrics have been called a 'quagmire of quantification.'[47] This example is so widely known that "making a decision based solely on quantitative metrics and ignoring all other observations" has been named the McNamara fallacy. This example also works as a glib summary of the primary argument in *Measure What Matters*. The results of using body count as a singular metric were disastrous, and that practice increased the suffering caused by the Vietnam War. Nevertheless, the quest for metrics persisted untarnished. It wasn't even problematic for McNamara's career. Despite the horrors of the Vietnam War and the key role he played in it, McNamara was rewarded with the opportunity to shape yet another institution based on his quantification ideology. He went on to lead and shape the development of the World Bank, another role where he could put his bean-counter spreadsheet skills to use to shape the future of the world based on things that are easy to count and account for.

McNamara's trajectory, from the Harvard Business School, to Price Waterhouse Cooper, to the US Military, to Ford Motor Company, and back to run the Defense Department directly illustrates the history of what historians Peter Stearns and Margaret Brindle document in the history of

45. Jerry Muller, *Tyranny of Metrics* (Princeton: Princeton University Press, 2018), 18.
46. Jerry Muller, *Tyranny of Metrics* (Princeton: Princeton University Press, 2018), 23.
47. Kenneth Cukier and Viktor Mayer-Schönberger, "The Dictatorship of Data," *MIT Technology Review*, May 31, 2013, https://www.technologyreview.com/2013/05/31/178263/the-dictatorship-of-data/

"management faddism."[48] Unlike professionalization in fields like law or medicine, when business schools and MBA programs were established in the 1920s there weren't strong professionalized accrediting institutions or major government-based initiatives that they drew support from. Instead, the professionalization of management as a field largely required flows of money from wealthy-benefactor corporate leaders. As management consulting grew out of the development of accounting firms, arguably as a way to enable collusion between businesses after antitrust laws made direct collusion illegal, the business schools, consulting firms, and executive roles of companies became a set of revolving doors increasingly distanced from the practices of any particular area of business expertise.[49] In that context, as someone like McNamara shifts from business school faculty, to consultant, to military strategist, to executive, to cabinet secretary, to NGO leader, he or she navigates that small set of revolving doors that create the appearance of distinct and impressive credentials. However, those credentials largely result from the continual churn of rather facile management fads. While those fads come and go, they collectively work to advance the ideology: only the quants on Wall Street, the management consultants, the business school faculty, and the executives have truly objective, data-driven ways of thinking. Therein is the source of the mythology and ritual about data-driven organizations. In that context, it is no wonder that works like *Measure What Matters* come along and provide a slightly reframed version of the same kinds of quantitative quagmire thinking that McNamara advanced. Those books are not so much about advancing knowledge as they are about selling the same answers in new packaging with a slightly different spin.

Returning to Scott's points about legibility and simplification, the effect and function of datafication and quantification of the world are not just to understand the world, but to change it. In Scott's words, the McNamaras and other analysts approach all our organizations and areas of work with the self-proclaimed objectivity of analysts, as "tailors who are not only free to invent whatever suit of clothes they wish, but to trim the customer so that he fits the measure."[50] The belief system about data and quantification

48. Margaret Brindle and Peter N. Stearns, *Facing Up to Management Faddism: A New Look at an Old Force* (Westport, CT: Quorum Books, 2001).

49. Christopher D. McKenna, *The World's Newest Profession: Management Consulting in the Twentieth Century* (Cambridge: Cambridge University Press, 2006).

50. James C Scott, *Seeing Like a State: How Certain Schemes to Improve the Human Condition Have Failed*, Yale Agrarian Studies (New Haven: Yale University Press, 1998), 146.

is not neutral, it is an ideological frame that has been developed and promulgated through the professionalization of management. In large part, Silicon Valley thinking is just another mouthpiece for those ideas. In large part, data-driven visions for the world do not emerge from an attempt to understand the world on its own terms. They don't present reality as much as they shape reality and make it conform to predetermined visions. This becomes even more pernicious when we connect this back to the continued dramatic growth of the platform monopolies emerging from the disruptive innovation ideology detailed in the last chapter.

Control the Platform, Control the Universe

The problems of metrics fixation intensify due to the way emerging platform monopolies, like Facebook, are exerting control. An example from Facebook and the pivot to video in journalism is illustrative. In 2015, Facebook executives pushed hard on the importance of video as the future of how users wanted to interact with their platform. "We're entering this new golden age of video," reported Zuckerberg to BuzzFeed. "I wouldn't be surprised if you fast-forward five years and most of the content that people see on Facebook and are sharing on a day-to-day basis is video."[51] By 2015 the walled garden of Facebook had become the primary method by which people around the United States and much of the world access the content of news media and web publishers. The implications were huge: if Facebook is pivoting to video, then journalism needed to pivot to video too.

Brendan Gahan, of the ad agency Epic Signal, explained, "For publishers who are reliant upon Facebook, as most are, this means they've got to adapt. While Facebook has been a great traffic source, publishers have grown reliant upon the platform and therefore are at the mercy of its whims, goals, and desires, leaving them exposed."[52] A wide range of publishers, who like many other leaders in other industries had become fixated on metrics, chose to pivot to video. In keeping with the logic of disruption, fear dictates that it is essential to make just these kinds of pivots to avoid being left behind. To make way for video, newsrooms fired many of the

51. Mat Honan, "Why Facebook And Mark Zuckerberg Went All In On Live Video," *BuzzFeed News*, April 6, 2016, https://www.buzzfeednews.com/article/mathonan/why-facebook-and-mark-zuckerberg-went-all-in-on-live-video

52. Ross Benes, "What's Driving the Publisher Pivot to Video, in 5 Charts (Hint: Ad $$$)," *Digiday*, August 31, 2017, https://digiday.com/future-of-tv/publishers-pivoting-video-5-charts/

journalists involved in producing long-form editorial material and hired staff to make video content.

The problem is that Facebook misrepresented their data. As the *Columbia Journalism Review* reported, "Facebook based its video push on a quicksand of faulty metrics,"[53] inflating view metrics by 60 to 80 percent. The depths of the deception involved in the pivot to video are still not fully understood. An ongoing class-action lawsuit against Facebook has made documents public that demonstrate that employees in the company knew there were problems with the way its data was calculated and reported. Ultimately, this is a critical example of the way that data and metrics obsessions fit together with the results of platform monopolies to produce a perfect storm for undermining the function of a social and civic institution like journalism.

Facebook controls the platform. Facebook makes up the metrics. It is also viewed as having its own oracle-like function of seeing the future. In keeping with Thiel's vision for platforms, Facebook is a black-box monopoly. The analytics-driven managers of the companies that produce the news at this point are going to chase the numbers and distrust the wisdom of their own experts to pursue what is perceived as the next disruptive wave they need to ride. Even if Facebook had not manipulated the data to support the narrative they were telling, it is entirely possible that the web media publishers would have chased after the story they were telling. Significantly, producing good-quality video is far more expensive and time consuming than producing timely news in text form. To that point, the pivot to video didn't make any sense on its face from the start. Those points were made by many individuals at the time, even before the depths of the deception were known, but the key point in all of this is that at its heart, the belief in quantification is a kind of theater. It's a belief system that needs to be actively challenged and countered in our everyday practices.

Data Feminism as a Response to Metrics Fixation

What are we do in the face of the management class's now-entrenched belief in metrics fixation and quantification? On one level, it's important for us to continue to point out when this data fixation becomes irrational.

53. Suzanne Vranica and Jack Marshall, "Facebook Overestimated Key Video Metric for Two Years," *Wall Street Journal*, September 22, 2016, sec. Business, https://www.wsj.com/articles/facebook-overestimated-key-video-metric-for-two-years-1474586951

In that context, books like Muller's *Tyranny of Metrics* are invaluable. In parallel, it is important for us to invest in advancing more nuanced ways of supporting engagement with data. To that end, I conclude this chapter by connecting some key points from Catherine D'Ignazio and Lauren F. Klein's work in data feminism with more holistic frameworks for planning and evaluation, such as Michael Patton's Blue Marble Evaluation approach. Collectively, these frames offer a powerful counter-approach to the cult of data.

Drawing on a wide range of examples and contexts, in their 2020 book *Data Feminism* Catherine D'Ignazio and Lauren F. Klein assess the myriad problems in datafication and the role that data science is taking on.[54] They articulate seven principles of data feminism "examine power, challenge power, elevate emotion and embodiment, rethink binaries and hierarchies, embrace pluralism, consider context and make labor visible." Those principles work to produce both better knowledge and understanding and advance a more just and caring world.[55] An intersectional feminist lens brought to bear on data science has the effect of largely countering the range of issues we have discussed relating to metrics fixation and data obsession.

To conclude this review, I offer three primary suggestions for those interested in supporting and sustaining the work of cultural-memory institutions to ensure a future for cultural memory. I see each of these suggestions as being directly in line with the broader project of data feminism that D'Ignazio and Klein argue for. First, we need to recognize that when we discuss goals and metrics, we are entering a highly performative/theatrical context, and we must be prepared to expose that fact. Second, when we discuss goals and measurement, we need to insist that people directly involved in the work and the people directly affected by decisions have relevant, situated expertise. Their knowledge needs to be engaged with and respected, not dismissed in the face of the presumed expertise of data analysts. Lastly, as we set goals for ourselves and our organizations, we need to respect that they need to be meaningful goals, and that may well mean that they do not need to be countable goals.

54. Catherine D'Ignazio and Lauren F. Klein, *Data Feminism*, Strong Ideas Series (Cambridge, MA: MIT Press, 2020).

55. Catherine D'Ignazio and Lauren F. Klein, *Data Feminism*, Strong Ideas Series (Cambridge, MA: MIT Press, 2020), 213.

Recognize and Call Out the Rhetorical Theater around Data

Gene Glass devoted decades of his career to building better, stronger, clearer statistical methods. He hoped to use that work to resolve fundamental policy questions in educational policy. He was successful in developing those methods, and the data has been clear for a long time. Reducing class sizes would clearly improve learning outcomes for students, but nothing has been done to address that. We can all benefit from the lessons he learned. Getting better data, or doing more exhaustive analysis of data, does not result in policy changes. Instead, calls for more data, or more rigor, can often function as tactics to stall changes that would clearly be beneficial.

Companies like Palantir and Oracle want to have it both ways. They present themselves as talismans for far-seeing imbued with mystical power, and at the same time as objective analysts of "hard data" sources for empirical truth. As the examples in this chapter demonstrate, all data collecting, and all efforts to operationalize and process data on people and the environment, are reductive. As a powerful corrective to this way of thinking, D'Ignazio and Klein identify this in terms of the "who question," specifically asking "on whom is the burden of proof placed?"[56] As communications scholar Candice Lanius has argued, demands for statistical evidence are often placed on minoritized groups, whereas anecdotal evidence suffices for those in privileged groups.[57] A core part of the performative nature of data analysis is what Donna Haraway identified as "the god trick of seeing everything from nowhere."[58]

The first step in responding to this kind of problem is to call it out when you see it and draw out how lacking in rigor and thoughtfulness seemingly objective, ostensibly data-driven policies and practices are. To do this well, it's critical that we make sure that staff in cultural-memory institutions learn more about frameworks like data feminism that provide tools and approaches to respond to rhetorical and theatrical performances around data. With that noted, this can't be just an issue to push staff to

56. Catherine D'Ignazio and Lauren F. Klein, *Data Feminism*, Strong Ideas Series (Cambridge, MA: MIT Press, 2020), 52.

57. Candice Lanius, "Fact Check: Your Demand for Statistical Proof Is Racist," *Society Pages*, January 12, 2015, https://thesocietypages.org/cyborgology/2015/01/12/fact-check-your-demand-for-statistical-proof-is-racist/

58. Donna Haraway, "Situated Knowledges: The Science Question in Feminism and the Privilege of Partial Perspective," *Feminist Studies* 14, no. 3 (1988): 575–99, https://doi.org/10.2307/3178066

advocate for, it's also critical that executives and leaders in cultural-memory organizations move beyond popular management fad books, like *Moneyball* and *The Extra 2%*, and delve deeper into critical literature on evaluation and measurement that will help them set up frameworks that are more nuanced and rigorous.

Expertise Lives Close to the Work, Not in Analysts' Data

One of the central myths around data is that objectivity and clarity emerge from the generic expertise of analysts when applied to large sets of data. That was evident in Raschke's Moneyball story at the start of this chapter. When we recognize the theatrical nature of this kind of data storytelling, it becomes clear that the storytelling around "hard data" works to get analysts and managers promoted and supports making cuts to nonmanagement and analyst positions. It apparently doesn't matter that, even in the work the quants did to change baseball, they ostensibly broke the game. When it came to the narrowly defined metrics, they were successful on their own terms. Through this, and many of the other examples in this chapter, one thing is clear. The wisdom of expertise is embedded in the craft and practice of people close to the problems, and in the lived experience of those most directly affected by decisions.

This has been widely known and understood in rigorous scholarship that explores the nature of good management and leadership. In the 1994 book *Rise and Fall of Strategic Planning*, management scholar Henry Mintzberg delves deeply into the history and results of methods of strategic planning and concludes that "Effective strategists are not people who abstract themselves from the daily detail but quite the opposite: they are the ones who immerse themselves in it, while being able to abstract the strategic messages from it." In his words, "Perceiving the forest from the trees is not the right metaphor at all, therefore, because opportunities tend to be hidden in the leaves."[59] This is one of the reasons Mintzberg insists that detaching those close to the work from planning and analysis, far from producing objectivity, produces myopia. The people close to the work tend to be in the best position to read the signals and see trends as they are happening, not those far away looking at ostensibly "hard" data.

This point is similarly true for considering who is affected by and impli-

59. Henry Mintzberg, *The Rise and Fall of Strategic Planning: Reconceiving Roles for Planning, Plans, Planners* (New York, Toronto: Free Press, Maxwell Macmillan Canada, 1994), 257.

cated in decisions. There is no view from nowhere. As is evident in multiple examples throughout this chapter, those who pose the questions and set the terms for how data is collected and interpreted shape the outcomes and results. The implications of work in feminist standpoint epistemology are critical to draw out these points.

Starting in the 1970s and 1980s, a feminist critique of notions of objectivity in science and research more broadly was led by philosophers such as Nancy Hartsock and Patricia Hill Collins. This body of scholarship has documented the critical need to center marginalized and oppressed points of view to generate stronger and more nuanced understandings of issues in society. As Collins argues, "it is impossible to separate the structure and thematic content of thought from the historical and material conditions shaped by the lives of its producers."[60] In a similar vein, Sandra Harding argues that "Knowledge claims are always socially situated, and the failure by dominant groups critically and systematically to interrogate their advantaged social situation and the effect of such advantages on their beliefs leaves their social situation a scientifically and epistemologically disadvantaged one for generating knowledge."[61] That is, only by better engaging with minoritized perspectives is it possible to generate better and more robust knowledge.

Further developing this line of thinking, black feminist theorist Jennifer C. Nash explains that "Marginalized subjects have an epistemic advantage, a particular perspective that scholars should consider, if not adopt, when creating a normative vision of a just society"[62] Proximity is important. We need to center the marginalized and those with situated expertise in fields to develop and advance visions for the future of cultural-memory institutions.

On a practical level, this means that cultural-memory institutions need to prioritize creating space and bandwidth for staff who engage directly with their end users and the communities they are intended to serve to lead work on strategy and planning activities. At the same time, cultural-memory institutions also need to center the voices and perspectives of the most marginalized and underprivileged communities they serve. All kinds

60. Patricia Hill Collins. "Learning from the Outsider Within: The Sociological Significance of Black Feminist Thought." *Social Problems* 33, no. 6 (1986), 14–32.

61. Sandra Harding, "Rethinking Standpoint Epistemology: What Is 'Strong Objectivity?'" *Centennial Review* 36, no. 3 (1992), 437–70.

62. Jennifer C. Nash, "Re-Thinking Intersectionality," *Feminist Review* 89, no. 1 (June 2008), 1–15.

of cultural-memory institutions—public libraries, local historical societies, galleries and museums, and academic and national libraries—should provide services to a wide range of communities, including people who are unhoused, disabled, queer, black and other people of color, the indigenous, uncompensated care workers, children, the elderly, and non–English language speakers. Asking the underprivileged to volunteer to provide this kind of input won't cut it. In the absence of a universal basic income policy, many underprivileged people need multiple jobs just to make ends meet. In that context, the luxury of being able to volunteer one's time to serve on an advisory board or committee is something that only the privileged can do. It's necessary to figure out how to compensate these people for their valuable time and expertise.

When cultural-memory institutions do engage in strategic planning activities and measurement and evaluation work, staff in the organization and community members should be charged with and supported in leading that work. External consultants do not have access to secret magical knowledge or the power to see the future. The people best positioned to do that are the people in the institution and the community.

Meaningful Goals over Measurable Goals

The insistence on setting easy-to-count and easy-to-measure goals recalls the streetlight effect.[63] In this imagined situation, you find someone searching for their lost keys under a streetlight. When asked if this is where they lost their keys, they inform you, that no, they lost them in the park, but they are looking for them here because this is where the light is. To have any hope of finding our metaphorical keys, to find and achieve things that genuinely matter, we must delve into the much harder work needed to set genuinely meaningful goals. In good news, we have a wealth of thoughtful, robust, and holistic ways to go about that work, methods anchored in rigorous ways of thinking. I'll briefly describe two examples, Blue Marble Evaluation and Systems Thinking for Social Change.

Building on a decades of scholarship, experience leading evaluation research at the University of Minnesota, and experience as a former president of the American Evaluation Association, Michael Patton's *Blue Mar-*

63. David H. Freedman, "Why Scientific Studies Are So Often Wrong: The Streetlight Effect," *Discover Magazine*, December 9, 2010, https://www.discovermagazine.com/the-sciences/why-scientific-studies-are-so-often-wrong-the-streetlight-effect

ble Evaluation: Premises and Principles offers a comprehensive approach to designing and developing evaluations for organizations and programs based in "knowing and facing the realities of the Anthropocene."[64] Approaches like those advocated in books like *Measure What Matters* take for granted that "what matters" is rapid growth of a service to accomplish very narrowly focused cancer-like goals. By contrast, Patton's approach starts from the reality that the dramatic challenges brought by climate change will require all organizations to think systematically and work toward the transformations necessary for the survival of individuals, communities, and cultures. Building on the same kind of logic that data feminism works from, this approach focuses attention on supporting individuals embedded in the context close to the problems as the key stakeholders and the best experts in advancing solutions. Patton's approach also recognizes that, in terms of the problems facing the world as a result of the Anthropocene, there is considerable expertise in more sustainable ways of working and living in indigenous communities around the globe. Given that the problems of the Anthropocene are the result of extractive, exploitive, and colonialist thinking and practices, the way toward better and more sustainable ways of working involves recognizing the wisdom and knowledge of indigenous communities and looking for ways to both respect that wisdom and to apply it to reshape and change world institutions.

Similarly, respecting the complexity of enacting results that make a positive social impact, *Systems Thinking for Social Change: A Practical Guide to Solving Complex Problems, Avoiding Unintended Consequences, and Achieving Lasting Results* offers an approach grounded in knowledge gleaned from complexity science and decades of work on systems thinking to offer perspectives for how individuals across organizations can come together to set goals and track progress.[65] As a key example in this book, while an individual running a homeless shelter might rightly want to advocate to expand the shelter, the system-level goal of helping end homelessness would result in an end state in which there would be no need for homeless shelters. In that context, work on goal setting for organizations that prioritizes their own persistence can be at odds with the broader social goals that organizations exist to serve.

64. Michael Quinn Patton, *Blue Marble Evaluation: Premises and Principles* (New York: Guilford Press, 2020), 19.

65. David Peter Stroh, *Systems Thinking for Social Change: A Practical Guide to Solving Complex Problems, Avoiding Unintended Consequences, and Achieving Lasting Results* (White River Junction, VT: Chelsea Green Publishing, 2015).

In summary, metrics fixation has resulted in substantial harm to people and our planet. Its primary function is to perpetuate the idea that analysts and data experts are the ones who have the objective answers, and it is resilient to critique in large part because it feigns having responded to that critique while still pushing the same message. In this we see an alignment between big-data hucksterism from Silicon Valley and management faddism put forward by consulting firms and many business schools. The same groups have played a similar role in another arena, how we define our own self-worth and the value in our work. The next chapter explores how the idea that we should all do what we love and advance our personal brands as people who approach our lives with entrepreneurial hustle; this approach similarly undermines the ability of organizations to support good work and of individuals to have good stable careers and live fulfilling lives.

CHAPTER 4

Why Memory Work Doesn't Work

In 2010, historians Dan Cohen and Tom Scheinfeldt invited scholars from around the world to contribute to the open-access book *Hacking the Academy*. One of the prompts in their call for participation was "Can Twitter replace a scholarly society?" At the time, at least for me, it felt like the answer might be yes. I had established a social media presence, primarily through Twitter, and found community and connection with a wide range of historians, digital humanities scholars, librarians, archivists, and museum professionals. That network was far more important to me professionally than what I had found in the American Historical Association, the American Library Association, or the Society of American Archivists. In contrast to slow-moving bureaucracies of formal professional organizations, I found the open online communities of blogs and social media at the end of the 2000s to be timely, generous, supportive, and fun.

The sentiments about Twitter from *Hacking the Academy* have not aged well. While Twitter gave me a way to get my name out there and make connections, I now see the way it functions as part of a draining, always-on, attention economy. The laissez-faire heart of technolibertarianism that animates social media platforms also makes them places where women and people of color face near constant harassment. This chapter explores the effects of ideas about social media, personal brands, and the "entrepreneurial self" on the careers of memory workers and on the institutions that employ them.

I start the chapter with reflections on my experience growing up professionally in academic-hustle culture doing precarious grant-funded, term-based work at a digital humanities center. Reflecting on my personal

journey, I see less a "I made it and so can you" story and more an "I was really lucky and came into this with a lot of privilege" story. With that as a starting point, I work through historical context on the emergence of "do what you love" and vocational awe as particularly problematic ideologies that contribute to an increasingly broken cultural-memory job market and work cultures that result in overwork and burnout. I end the chapter with some suggestions about how we can think about more balanced ways of designing jobs for cultural-memory work. Ultimately, cultural-memory institutions can only serve their functions when they are staffed by workers who are well-enough supported to do their work and manage the handoffs required to ensure enduring access to the cultural record.

Brand-Name Scholars on Blogs and Twitter

From 2006 to 2010 I worked at the Center for History and New Media (CHNM). It felt like a whole new way of doing history was emerging. As historian Adam Crymble observes in *Technology and the Historian: Transformations in the Digital Age*, I had come into CHNM at a specific moment in "the rise and fall of the scholarly blog."[1] I was twenty-one. I had a BA in history and the history of science from the University of Wisconsin, and I'd recently relocated to DC after graduation and was looking for work. In the haze of applying for five to ten jobs a day that I would find posted on craigslist, idealist.org, and monster.com, I found a posting for a job called "technology evangelist" at the Center for History and New Media. It sounded like an amazing opportunity, and it was.

The job posting explained that "The technology evangelist will be responsible for building alliances with scholarly organizations and libraries, encouraging scholars to try Zotero, developing and maintaining user documentation, and building awareness of this next-generation research tool." On one level it seemed perfect—I had a history background, I was good with technology. At the same time, I was concerned that I was potentially underqualified. In the interview, I talked a bit about the work I had done as an outreach intern for the Games Learning and Society Conference, which led to a conversation about some research I had done on the video game *Civilization*. I brought my twelve-inch Mac PowerBook to the interview to take notes, and observed that everyone on the interview panel had a Mac laptop, too. I got the job. I started working for $32,000 a year.

1. Adam Crymble, *Technology and the Historian: Transformations in the Digital Age* (Urbana: University of Illinois Press, 2021), 149.

I loved it. I got to be the hype man for an open-source reference management tool. I could play Mario Kart with my coworkers at lunch. As a university employee, I also could take nine credits a year as a benefit. I was able to work on an MA in history while I worked full-time at CHNM. This was one of the most important breaks I've received in my career to date.

Between 2004 to 2006, a lot of folks working at CHNM had started personal blogs. As Crymble notes, this had the effect that our "watercooler conversations made their way into print, extending the experience of working at CHNM to the wider world as never before."[2] I would read posts from senior colleagues like Tom Schienfeldt's "Brand Name Scholar," where he would note that though "scholars may not like it," in "the 21st century's fragmented media environment, marketing and branding are key to disseminating the knowledge and tools we produce." Furthermore, he noted that "This is especially true in the field of digital humanities, where we are competing for attention not only with other humanists and other cultural institutions, but also with titans of the blogosphere and big-time technology firms."[3] As we started Twitter accounts, largely to continue the same kinds of conversations we were having on our blogs, a seemingly new kind of scholarly ecosystem was emerging, one in which, in scholar Dave Perry's terms, we all needed to "Be Online or Be Irrelevant."[4] Through blogs and Twitter we could all be writing in the open for both an academic and broader public audience. In this world of scholarly blogs, I had found a community of generous and supportive colleagues connecting to each other in real time. This was a marked contrast to the harsh and at times genuinely cruel responses I received to my writing from formal double-blind peer review of my work from scholarly journals. Central in all of this was a notion that we could take ownership of our own scholarly brands.

Unconferences and Hacking the Academy

Where blogs were going to replace, or even disrupt, the slow pace of scholarly journals, there was an opportunity to similarly disrupt the academic conference. In 2008, I was able to assist my colleagues Dave Lester and

2. Adam Crymble, *Technology and the Historian: Transformations in the Digital Age* (Urbana: University of Illinois Press, 2021, 149.

3. Tom Scheinfeldt, "Brand Name Scholar," Found History (blog), February 26, 2009, http://www.foundhistory.org/2009/02/26/brand-name-scholar/

4. Dave Perry, "Be Online or Be Irrelevant," *Academhack: Thoughts on Emerging Media and Higher Education* (blog), January 11, 2010, https://web.archive.org/web/20161114014524/http://academhack.outsidethetext.com:80/home/2010/be-online-or-be-irrelevant/

Jeremy Boggs to host the first THATcamp (The Humanities and Technology Camp). THATcamp went on to become a worldwide series of unconference events. Based on Barcamp and other tech events, it worked as an "unconference"—folks made up the program on the spot and then had somewhat spontaneous, unstructured discussions. Google Docs were new at that point, and it was a rush to hop in an IRC channel, post a link to a doc, and watch as a room full of smart folks started adding in links and notes to collaboratively sketch out all kinds of ideas about the digital future of history and the humanities.

In the beginning, an unconference felt almost magical. Reserve some space on campus. Set up a Wordpress instance. Buy some coffee and donuts. Let folks sign up to propose things they wanted to talk about. Then show up, and suddenly a whole conference was happening. I remember seeing full professors taking notes from undergraduate students who had sorted out a way to use some interesting digital tool. It felt like established academic hierarchies were being flattened. It was like the network of bloggers emerging online could all get together in person to hash out the things we were blogging about. I made a whole bunch of new connections and became aware of a range of other projects that I was interested in.

Around the third THATcamp, Dan Cohen turned part of the event into a book sprint to produce "Hacking the Academy." It largely riffed on the same themes, with the somewhat provocative set of prompts, "Can an algorithm edit a journal? Can a library exist without books? Can students build and manage their own learning management platforms? Can a conference be held without a program? Can Twitter replace a scholarly society?" I remember first reading that prompt and being excited. Un-All-The-Things! Turn the old stuffy academic institutions upside down and inside out with the power of the web and social media.

Looking back now, a decade later, reading those prompts stirs different feelings. Can an algorithm edit a journal? No! People need to do that, and they need to get paid to do that. Can Twitter replace a scholarly society? No! What seemed like a fun place to share ideas and grow one's professional network grew into a hate machine for actual Nazis, and a global disinformation platform. Also, it's a platform that is generally terrible for women and people of color as they are easily targeted for harassment. Beyond those points, ideally a scholarly society functions through modes of governance within a field, something that a technology platform like Twitter was never going to do. Problems with Twitter are even more evident in the chaos that emerged after Elon Musk's purchase of the plat-

form. All this being noted, it is important to not be overly technologically deterministic in considering a platform like Twitter, or any of the other platforms discussed in this chapter. Notably, despite the harm the platform has done, it has also provided the context in which expansive cultural forms and practices, such as Black Twitter, have emerged. As André Brock argues in *Distributed Blackness: African American Cybercultures*, the ways in which cybercultures like Black Twitter emerge through technology use go beyond simple narratives of resistance and control.[5]

At the time, I thought this was part of an amazing new way for work and careers to operate. By 2011, I was thinking about this as the "DIY" humanities.[6] Despite the fact that I had a precarious, term-based, grant-funded job, I had set up my own blog, and leveraged my job into giving a lot of talks at conferences; CHNM was able to support the travel from the grants that paid my salary. I put in a ton of hours outside of work for graduate studies. I started trying to publish in journals and edited volumes. After staying afloat on money from grant to grant for a few years, that experience got me a job at the Library of Congress that nearly tripled my salary. I felt incredibly lucky, but it also felt like, despite the problems facing memory workers, the system that was coming together had worked. At least it had worked for me.

In hindsight, I've come to understand this experience as one of both massive luck and privilege. Getting to work at CHNM gave me credibility when I posted things online. It also put me in the center of a group of very well networked folks who would draw attention to my work. In being hired as a technology evangelist, I'd landed in a job that, while not coming with great pay, basically paid me to network with people in the field. I'd also graduated in a brief period when it was relatively easy to get a job out of college, between the dot-com bubble bursting at the beginning of the decade and the 2008 financial collapse. Along with all of that, the idea of the blog-based academic community came undone in the early 2010s. By the middle of the 2010s, THATcamps had lost their sheen, and they were ultimately completely shuttered in 2020. I've also come to appreciate the extent to which much more critical work in new media studies, like Lisa Nakamura's 2002 *Cybertypes: Race, Ethnicity, and the Internet*, and Wendy Chun's 2005 *Control and Freedom: Power and Paranoia in the Age of Fiber*

5. André L. Brock, *Distributed Blackness: African American Cybercultures*, Critical Cultural Communication (New York: New York University Press, 2020).

6. Trevor Owens, "The Digital Humanities as the DIY Humanities," *Trevor Owens* (blog), July 23, 2011, http://www.trevorowens.org/2011/07/the-digital-humanities-as-the-diy-humanities/

Optics, had been largely absent from the focus of the new media boosterism I had been involved in.[7] I very much appreciate and have learned from the work of scholars like Natalia Cecire, Moya Bailey, Roopika Risam, and Alex Gil, who have advanced a more critically engaged, global, and postcolonial set of perspectives for digital humanities initiatives.[8] Similarly, I very much appreciate work from Kim Gallon and others, who have demonstrated a black digital humanities "as a digital episteme of humanity that is less tool-oriented and more invested in anatomizing the digital as both progenitor of and host to new—albeit related—forms of racialization."[9] Significantly, these critical perspectives go beyond simple narratives of resistance to control and illustrate how, despite the intentions of the platform providers and creators, creative, thoughtful, and powerful critical work continues to proliferate across these networks. Over time, those much more critical perspectives have proven to be invaluable in helping me better understand the stakes and issues at hand in Silicon Valley–style thinking. I now read my experiences from this time as fitting in with the last gasp of the "Wired Imagination," the vision of the creative class of knowledge workers who could hop from gig to gig following the dream of "doing what you love."

From Knowledge Workers to the Creative Class

The work of cultural memory, the work of librarians, archivists, curators, historians, etc., is as old as the memory institutions themselves, tracing back more or less as far as we can trace the history of professions. In the twentieth century, various kinds of cultural-memory work, along with a

7. Lisa Nakamura, *Cybertypes: Race, Ethnicity, and Identity on the Internet* (New York: Routledge, 2002); Wendy Hui Kyong Chun, *Control and Freedom: Power and Paranoia in the Age of Fiber Optics* (Cambridge, MA: MIT Press, 2005)

8. See Alex Gil, "Nimble Tents: Xpmethod, #tornapart, and Other Tensile Approaches to the Forth Estate" (MITH Digital Dialogue, University of Maryland, College Park, November 6, 2018), https://mith.umd.edu/dialogues/dd-fall-2018-alex-gil/; Natalia Cecire, "When Digital Humanities Was in Vogue," *Journal of Digital Humanities* 1, no. 1, accessed January 9, 2022, http://journalofdigitalhumanities.org/1-1/when-digital-humanities-was-in-vogue-by-natalia-cecire/; Moya Bailey, "All the Digital Humanists Are White, All the Nerds Are Men, but Some of Us Are Brave," *Journal of Digital Humanities* 11, accessed January 9, 2022, http://journalofdigitalhumanities.org/1-1/all-the-digital-humanists-are-white-all-the-nerds-are-men-but-some-of-us-are-brave-by-moya-z-bailey/; Roopika Risam, *New Digital Worlds: Postcolonial Digital Humanities in Theory, Praxis, and Pedagogy* (Evanston, IL: Northwestern University Press, 2019).

9. Kim Gallon, "Making a Case for the Black Digital Humanities," in *Debates in the Digital Humanities* (Minneapolis: University of Minnesota Press, 2016), 42–49.

range of other areas of work, were integrated into broader notions of information and knowledge work. As notions of "knowledge work" emerged midcentury, and ultimately developed into a broader set of ideas about the emergence of a "creative class," memory workers could increasingly find themselves involved in a broader set of discussions about the economy and workforce that was being changed by information technology. Revisiting notions of how work was supposed to change for the better in these frameworks draws attention to how these visions for the future of work failed to come to fruition.

In 1969, Peter Drucker, twenty years into his professorship in management at New York University, popularized the idea of the "knowledge worker." In *The Age of Discontinuity: Guidelines to Our Changing Society*, he argued that the transformation that technology was bringing to the economy meant that in almost every "branch of knowledge," "there are more opportunities for productive, rewarding, and well-paid work than there are men and women available to fill them."[10] This narrative fit well with the development of work cultures associated with computing technologies, as explored in the previous chapter. The promise from this story was clear; knowledge work was a growing industry, and it was going to provide good, engaging jobs. The stories Stewart Brand was telling about the hacker ethic in Silicon Valley were part of this imagining of the future of knowledge work.

Fast forward three decades to 2002, and just as the dot-com bust would seem to undermine any notion of a vibrant future for knowledge work, another hit business book came out arguing the contrary. As many people employed as freelancers or on staff in creative roles in the tech industry lost their jobs, Richard Florida's book *The Rise of the Creative Class* argued that jobs like "university professors, poets and novelists, artists, entertainers, actors, designers and architects," along with "nonfiction writers, editors, and cultural figures," were becoming the center of a prosperous new class in society.[11] Florida doubled down on this story in 2012 in *The Rise of the Creative Class Revisited*. For Florida, one of the biggest priorities for this new creative class wanted in their careers was flexibility.

In the preface of the 2012 book, Florida acknowledges that "the great promise of the Creative Age is not being met."[12] Specifically, in reference to the "economic meltdown of 2008," he notes that this could have worked to

10. Peter F. Drucker, *The Age of Discontinuity: Guidelines to Our Changing Society* (New York: Harper & Row, 1969), 273.
11. Richard L. Florida, *The Rise of the Creative Class* (Basic Books, 2002), 38.
12. Richard L. Florida, *The Rise of the Creative Class* (Basic Books, 2002), xi.

"derail or reverse the trends" about the creative class, but from his perspective, they "have only become more deeply ensconced.[13]" While it's possible to believe that creativity is a great component of the future of work, and that more and more jobs are framed as needing creative work, the goal posts have clearly moved dramatically from the promises Drucker made about knowledge work in 1969. It is not the case that there are lots of great, well-paid creative jobs out there that can't be filled.

At the turn of the twenty-first century, it was also fashionable to imagine that these creative knowledge workers were changing the terms of how they would do their work. In *Free Agent Nation*, another popular business book from 2001, Daniel Pink asserted that "One-fourth of the American workforce has declared its independence from traditional work." These free agents were "free from the bonds of a large institution, and agents of their own future." They were "the footloose, independent worker, the tech-savvy, self-reliant, path-charting micropreneur," and they represented "the new archetypes of work in America."[14] In hindsight, this looks less like a declaration of independence than an attempt at a positive spin on pushing people out of stable jobs into the increasingly precarious gig economy. Returning to the *Creative Class*, Florida observed that "workers have come to accept that they are completely on their own—that the traditional sources of security and entitlement no longer exist, or even matter."[15] It's one thing to accept a reality that job security is no longer there for most workers. It's not at all clear why that wouldn't "even matter." Again, this is a huge drift from what Drucker prognosticated in 1969. Knowledge work did not manifest as a glut of permanent jobs in a wide range of industries.

In *After the Future*, Bernardi offers a different explanation of the realities of the knowledge worker and the creative class. From his perspective, after the general defeat of labor movements in the 1980s, the default social ideology became the idea that every person needs to be their own entrepreneur. In Bernardi's words, "we should all consider life as an economic venture, as a race where there are winners and losers."[16] This entrepreneurial self is part of the story that Pink and Florida spun about how perpetual gig work could be "footloose" and liberating, but in practice it helped create

13. Richard L. Florida, *The Rise of the Creative Class: Revisited* (New York: Basic Books, 2012), viii.
14. Daniel H. Pink, *Free Agent Nation: The Future of Working for Yourself*, new edition (New York: Warner Books, 2002), 14.
15. Richard L. Florida, *The Rise of the Creative Class* (Basic Books, 2002), 99.
16. Franco Berardi, *After the Future* (Oakland, CA: AK Press, 2011), 66.

a situation where knowledge workers are perpetually pitted against each other to make less and less while they do more and more.

In what follows I explore how a narrative of "do what you love" that was a cornerstone of the creative class story worked to undermine good jobs in general, and specifically those for memory workers. From there, I suggest the ways that "hope labor" and the belief that work for cultural-memory institutions functions as a calling has undermined the ability to support good jobs. For those who do make it through layers of hope labor as interns or low-paid temporary workers, the same logic then functions as part of a system that pushes more and more work onto the few people that make it into permanent employment. The culmination of this overview of the realities of work in cultural memory presents significant challenges for developing a better future of cultural-memory work. I conclude by offering recommendations for how to turn around the ideology of the entrepreneurial self, how we must work field-wide to shift the narrative from "lovable jobs" in cultural memory to one of "good jobs," and I describe some tangible practices that can help to support that shift.

Betrayed by Doing What You Love

Ideas about work and identity in the United States changed significantly in the later part of the twentieth century. While there had been a long-standing belief system in the United States around the moral value of work, part of that moral value came from drudgery. At the beginning of the century, in 1905, in *The Protestant Ethic and the Spirit of Capitalism*, Max Weber had made the case that the austerity of Protestantism was itself a key element in the development of capitalism.[17] Drawing on work like Ben Franklin's *Necessary Hints to Those That Would Be Rich* from 1736, he drew out themes about the inherent moral good of doing good work and being a good worker.[18] This is to say that the moral value of doing good work has been noted as a key part of American culture since before the United States was a nation. However, that moral imperative previously did not require people to chase after work that they love.

17. Max Weber and Talcott Parsons, *The Protestant Ethic and the Spirit of Capitalism* (Mineola, NY: Dover Publications, 2003).

18. Benjamin Franklin and Bliss Perry, *Benjamin Franklin: Selections from Autobiography, Poor Richard's Almanac, Advice to a Young Tradesman, The Whistle, Necessary Hints to Those That Would Be Rich, Motion for Prayers, Selected Letters*, Little Masterpieces, edited by Bliss Perry (New York: Doubleday & McClure Co., 1898).

The sentiment behind Marsha Sinetar's 1989 hit book, *Do What You Love, the Money Will Follow: Discovering Your Right Livelihood* illustrates the kind of transformation that occurred about the moral nature of work in America in the later twentieth century.[19] In Sinetar's popular framework, "work is a way of being."[20] The book argues that, based on "the teachings of the Buddha," people can develop the "right livelihood" for themselves. When you found the right livelihood, the "rewards that follow are inevitable and manifold."[21]

Throughout the book, readers are told about how people with the right tenacity and work ethic are "sure to be materially successful soon."[22] When someone isn't having that success, they are supposed to look inward. In her words, "If we are not earning a sufficient amount for our efforts, then it is up to each of us to find out why. Usually, all other things being equal, the problem lies in our own expectations or in the level of energy we are willing to put into the job at hand."[23]

That "all things being equal" part is carrying a lot. All things are effectively never equal when it comes to the resources people have, the money someone can make in a given field, or the way that privilege functions as a gatekeeper determining who has access to what opportunities. This is a key point in understanding how books like *Free Agent Nation* and *Rise of the Creative Class* can keep selling the idea that great new jobs are there for the folks who want them. In the logic of this ideology, the people who aren't succeeding just aren't trying hard enough. In Sinetar's framework, the reason something isn't working out is always some kind of personal failing. There is zero space in this framing to ask questions about any kind of society-level issues. The fact that some people are making it is presented as evidence that if anyone just wanted it more or worked harder for it, they could get it too.

Sinetar's book leads up to the key notion from the title: the role of love in the future of work. The final chapter of the book, titled "Vocational

19. Marsha Sinetar, *Do What You Love, the Money Will Follow: Discovering Your Right Livelihood* (New York: Dell, 1989).
20. Marsha Sinetar, *Do What You Love, the Money Will Follow: Discovering Your Right Livelihood* (New York: Dell, 1989), 12.
21. Marsha Sinetar, *Do What You Love, the Money Will Follow: Discovering Your Right Livelihood* (New York: Dell, 1989), 11.
22. Marsha Sinetar, *Do What You Love, the Money Will Follow: Discovering Your Right Livelihood* (New York: Dell, 1989), 120.
23. Marsha Sinetar, *Do What You Love, the Money Will Follow: Discovering Your Right Livelihood* (New York: Dell, 1989), 135.

Integration: Work as Love, Work as Devotion," clarifies these points. Work ultimately comes to completely define us in this framework. Work is how "the individual finds a place in the world, belongs to it, takes responsibility for himself and for others." It becomes "his way of giving of himself." It "provides him with a way of dedicating himself to life." Work becomes "a radical transformation of duty into love, fascination or pleasure." Because "he has committed his heart, attention and intention to doing the work" he is "thus able to give his all to the job at hand."[24]

The use of the term "vocation" in this context, and the direct and explicitly religious and spiritual frame of discussing work, makes clear how dramatically the stakes of work and self have been raised. In Sinetar's words, "The individual who achieves vocational integration is thus able to fully focus on what he is at the core."[25] Ultimately, "While the actualizing person may also receive status, adulation, power or security from his working life, these are not his main concerns nor are they his primary reason for working." The reason to work is "because he is in love with what he does and because he senses in an intuitive, strange way that the work loves him too, opens itself up to him, shows him its special rules and secrets and requirements."[26] Ultimately, *Do What You Love* reads more like a religious tract of affirmations than a business book. The points presented here are less grounded in argument than in a belief system. As an aside, most of the business books explored throughout this whole book start to make more sense if you approach them less as arguments based on evidence and more as ostensibly sacred texts of the contemporary belief system of our age, a belief system in which loving one's work is totalizing for understanding one's sense of self and one's place in the world.

While there is a long tradition of a moral imperative for work, as Miya Tokumitsu observes in the 2015 book *Do What You Love: And Other Lies about Success and Happiness*, Ben Franklin's ideas about "punctuality, frugality, and industry all require the diminishment of the self to some extent," and "passion for the tasks of work was irrelevant."[27] In many cases, the idea

24. Marsha Sinetar, *Do What You Love, the Money Will Follow: Discovering Your Right Livelihood* (New York: Dell, 1989), 177.

25. Marsha Sinetar, *Do What You Love, the Money Will Follow: Discovering Your Right Livelihood* (New York: Dell, 1989), 196.

26. Marsha Sinetar, *Do What You Love, the Money Will Follow: Discovering Your Right Livelihood* (New York: Dell, 1989), 203.

27. Miya Tokumitsu, *Do What You Love: And Other Lies about Success and Happiness* (New York: Regan Arts, 2015), 11.

that work could be drudgery, or boring, could have been part of the moral good that it did. Work could be a way to develop patience or perseverance, whether or not one enjoyed a given task. In Tokumitsu's analysis, the "rhetoric of hope and love" in contemporary beliefs about work serves a disciplinary function. They enable the market "to extract cheap work from a labor force that embraces its own exploitation."[28]

The source of this change in our moral theory of work connects to hacker cultures that were emerging around the development of the computing industry in the mid-twentieth century. In the late 1950s, psychologists at Lockheed had found that there was a key personality type that thrived in the R&D work environments they managed. They found workers who "devoted every waking hour to it, usually to the exclusion of non-work relationships, exercise, sleep, food, and even personal care."[29] In short, the "sci-tech personality," which became the basis of the hacker ethic, is also the template for how deeply problematic relationships with work were promoted in a wide range of other fields of knowledge work.

The imperative to love what one does as work creates a vicious race to the bottom in terms of compensation and sustainable jobs. This was on some level already evident in the claims that Sinetar put forward in *Do What You Love*. While the subtitle explicitly asserted "the money will follow," by the time you get to the end of the book, you find out that the money was in fact never the point. In the end you would do what you love as work for whatever anyone was willing to pay you, because the framework had made it impossible for you to conceive of doing anything else. As journalist Anne Helen Petersen explains, "The desirability of 'lovable' jobs is part of what makes them so unsustainable: So many people are competing for so few positions that compensation standards can be continuously lowered with little effect. There is always someone just as passionate to take your place."[30] For better, and more so for worse, the jobs that make up cultural-memory work are largely the kinds of jobs that one might "love." The result has had significantly detrimental effects on the state of memory work.

28. Miya Tokumitsu, *Do What You Love: And Other Lies about Success and Happiness* (New York: Regan Arts, 2015), 8.

29. Miya Tokumitsu, *Do What You Love: And Other Lies about Success and Happiness* (New York: Regan Arts, 2015), 127.

30. Anne Helen Petersen, *Can't Even: How Millennials Became the Burnout Generation* (Boston: Houghton Mifflin Harcourt, 2020), 70.

Concerted Cultivation and Hope Labor

The moral imperatives for work changed while the availability of good and indeed lovable jobs was drying up. As a result, the levels of work required to be competitive in society keep escalating. Children need to start building their CVs or résumés from an early age. As sociologist Annette Lareau noted in the early 1990s, middle-class parents began shifting their focus to the "concerted cultivation" of their children.[31] Where children had once engaged in free play, nearly every activity from playing on the soccer team to going to violin lessons became part of building out one's résumé for college and their eventual future career.

As Anne Helen Petersen documents in *Can't Even: How Millennials Became the Burnout Generation*, millennials, now well into their careers, recall feeling really busy as early as age seven, and report feeling "stressed when I'm not doing something" or feeling "guilty just relaxing."[32] In the logic of concerted cultivation, children are "trained to become good networkers, good employees, good multitaskers. Every part of a child's life, in other words, can be optimized to better prepare them for their eventual entry into the working world. They become mini-adults, with the attendant anxiety and expectations, years before adulthood hits."[33]

Young people strive to get the right grades in high school to get into the right college. That striving continues in college to get into the right grad school or land the right internship. All of that is pursued in the hope that it could pan out into something that might become the basis of a secure and steady paid job in the future. But that hope is itself part of the problem.

As discussed earlier in the chapter on platforms, a core tenet of the Silicon Valley platform ideology is that content, and information, are supposed to be free and functionally valueless. It's the platforms as infrastructure that are valuable. That was in effect Shirky's argument in *In Here Comes Everybody: The Power of Organizing without Organizations*.[34] The clerks were done away with by the printing press, and the journalists would be done away with by the platform that is the web. Shirky extends

31. Annette Lareau, *Unequal Childhoods: Class, Race, and Family Life* (Berkeley: University of California Press, 2003).

32. Anne Helen Petersen, *Can't Even: How Millennials Became the Burnout Generation* (Boston: Houghton Mifflin Harcourt, 2020), 21.

33. Anne Helen Petersen, *Can't Even: How Millennials Became the Burnout Generation* (Boston: Houghton Mifflin Harcourt, 2020), 25.

34. Clay Shirky, *Here Comes Everybody: The Power of Organizing without Organizations* (New York: Penguin Books, 2009).

this argument further in *The Wisdom of Crowds: Why the Many Are Smarter Than the Few and How Collective Wisdom Shapes Business, Economies, Societies and Nations*. A core idea in that context is that with the gatekeepers gone, everyone could be a journalist or an author. Significantly, the idea that content and information should be free depends on the notion that otherwise gainfully employed people were going to be able to create content for those platforms in their free time. This creates its own trap. Much of the lovable work that we are morally compelled to seek out in the *Do What You Love* framework is "content production"—exactly the kind of work that the platform monopolies insist should now be done for free. Significantly, studies of the people reviewing restaurants on Yelp or writing for free online sports blogging platforms demonstrate how wrong some of these assumptions are.

For the "wisdom of crowds" notion to work, it requires that the people working on these online platforms do so just for the satisfaction of it. In practice, many are engaging in what media studies scholars Kathleen Kuehn and Thomas Corrigan describe as "hope labor." Their interviews with people writing free reviews for Yelp or engaging in sports blogging on the site SB Nation (SportsBlog Nation) show that people were clearly aspiring to leverage the work into jobs where they could get paid to do that kind of writing. For them, hope labor represents "un- or under-compensated work carried out in the present, often for experience or exposure, in the hope that future employment opportunities may follow."[35]

While much of the focus around user-generated content has stressed the freeing power of these platforms, given that they have become places for people to engage in hope labor, they clearly work more broadly as part of an ever-expanding range of areas in which people are expected to perform their entrepreneurial brand selves in the hope that they might turn into opportunities to do work they love for a living. As Jenny Odell observes in considering the ever-expanding nature of the attention economy, "In a situation where every waking moment has become time in which we make our living, and when we submit even our leisure for numerical evaluation via likes on Facebook and Instagram, constantly checking in on its performance like one checks a stock, monitoring the ongoing development of our personal brand, time becomes an economic resource that we can no longer

35. Kathleen Kuehn and Thomas F. Corrigan, "Hope Labor: The Role of Employment Prospects in Online Social Production," *The Political Economy of Communication* 1, no. 1 (May 16, 2013), https://polecom.org/index.php/polecom/article/view/9, 21.

justify spending on nothing."[36] In this context, the imagined freedom to be able to create and share things on online platforms ends up being part of an expanding zero-sum game in which concerted cultivation pushes everyone to perpetually hustle to find work that can both sustain them financially and define them personally and socially.

Hope labor isn't just something for the kind of free work that people do creating content for online platforms. Researchers studying cultural-memory work, like art curation, have identified the value in looking at the kinds of free work that individuals attempting to break into cultural work do to try and get their foot in the door.[37]

When you look across the range of cultural-heritage jobs, it becomes clear that hope labor is now central to the function of these systems. In Tokumitsu's terms, these hope labor roles largely function as elements of tiered employee statuses in organizations. For careers in libraries, archives, and museums, it's now largely the case that beyond requiring advanced degrees for work, new professionals are expected to work a series of low-paid or unpaid internships in the hopes of getting closer to a permanent job. The comments of one intern interviewed in Ross Perlin's *Intern Nation: How to Earn Nothing and Learn Little in the Brave New Economy* is exactly the kind of thing I've heard from students looking to break into cultural-memory careers: "every entry-level job seemed to require two or three years of experience. How does that work? Where are you supposed to get it?"[38] In the case of careers in cultural-heritage organizations, it's largely the case that individuals need to string together unpaid or low-paid internships to build a résumé that starts to make them potentially competitive to apply for jobs that will probably have as many as a hundred similarly qualified applicants. Beyond navigating strings of internships, many early-career cultural-heritage professionals then end up competing for short-term positions, like my first job at CHNM, that are funded by term-based grants or other kinds of limited project-based funding.

When we turn to another core area of cultural-memory work, faculty positions for historians and a wide range of humanities fields, we see the

36. Jenny Odell, *How to Do Nothing: Resisting the Attention Economy* (Brooklyn, NY: Melville House, 2019), 15.

37. Ewan Mackenzie and Alan McKinlay, "Hope Labour and the Psychic Life of Cultural Work," *Human Relations* 74, no. 11 (November 1, 2021), 1841–63, https://doi.org/10.1177/00 18726720940777

38. Ross Perlin, *Intern Nation: How to Earn Nothing and Learn Little in the Brave New Economy* (Brooklyn, NY: Verso Books, 2011), 28.

same kind of tiered work problems on an even larger scale in the form of temporary adjunct faculty positions. Over the last decade, "the number of instructors who worked part-time consistently outpaced the number who worked full-time, as adjunctification—higher education's version of the gig economy—took hold."[39] At this point half of higher education instructors are part-time, or adjuncts, and a full 75 percent of instructors are not on the tenure track, which is functionally the process by which they would gain permanent employment status and job security.[40]

In summary, hope labor is now central to the ability to have a career in memory work. The results of this are problematic in myriad ways. First, it takes a fair bit of privilege to engage in this kind of unpaid hope labor. Just living in the twenty-first century is expensive. Early-career professionals often need to move around the country to run a gauntlet of low-pay or unpaid jobs. It takes a lot of privilege to be able to pull that off. That ends up meaning that the serious lack of racial diversity in cultural-memory professions is effectively sustained by the tiered labor system. Along with that, as Tokumitsu notes, "one of the most dispiriting things about tiered work systems is that they fragment workforces and encourage divisiveness." In practice they are both "self-perpetuating and self-validating." The people who find themselves in stable jobs in cultural-memory institutions have a survivor bias. "Because the system worked for them, it works, period and because those graduates are in relative positions of power they often consciously or unconsciously continue the bifurcated organization in their sectors."[41] As a result, the system can grind on. The demand for all that hope labor is hurting the ability of memory workers to live more sustainable, well-supported lives. Significantly, the key reason for all that hope is a belief that memory work is a calling. Memory workers are largely trapped in a logic of vocational awe for the work.

Vocational Awe in Memory Work

When work is framed as a calling, it sets workers up to deprioritize their compensation and their well-being. Sinetar's insistence that the best kind

39. Doug Lederman, "The Faculty Shrinks, but Tilts to Full-Time," *Inside Higher Ed*, November 27, 2019, https://www.insidehighered.com/news/2019/11/27/federal-data-show-proportion-instructors-who-work-full-time-rising

40. New Faculty Majority, "Facts about Adjuncts," accessed November 14, 2021, https://www.newfacultymajority.info/facts-about-adjuncts/

41. Miya Tokumitsu, *Do What You Love: And Other Lies about Success and Happiness* (New York: Regan Arts, 2015), 116.

of work resulted from treating work as a vocation or a calling directly hurts the ability of that work to be properly compensated. Key examples of the problem of treating work as a calling or vocation are often drawn from specific areas of memory work. For example, a study on zookeepers, who play an essential role in caring for living collections in zoos, underscores how their relationship to their work as a calling undermines their ability to be paid well. Stuart Bunderson and Jeffery Thompson found that "in spite of the apparent lack of economic and status or advancement incentives associated with zookeeping, many people are so eager to work in the profession that they volunteer for months or years before securing a position."[42] The zookeepers clearly identified their love of animals as the factor that convinced them that zookeeping was their calling.

The love of zookeepers for caring for animals set them up in the logic of "do what you love," with the inescapable conclusion that, whatever hardships they might face, they needed to do everything in their power to pursue this passion. While this does mean that zookeepers get a lot of meaning and satisfaction from their work, they receive very low pay, in many cases taking a second job to make ends meet. Significantly, this sets up a situation where they feel "hardwired for particular work and that destiny has led [them] to it." In that context, this line of work is not something they could just walk away from. That is, "rejecting that calling would be more than just an occupational choice; it would be a moral failure, a negligent abandonment of those who have need of one's gifts, talents, and efforts."[43] When leaving your job would result in a feeling of moral failure, you aren't in a very good position to negotiate for better hours or pay.

A similar kind of relationship emerges around the work of other memory workers, such as librarians. In an analysis of librarianship, Fobazi Ettarh articulated the notion of vocational awe as "the set of ideas, values, and assumptions librarians have about themselves and the profession that result in beliefs that libraries as institutions are inherently good and sacred, and therefore beyond critique."[44] Ettarh's approach has been widely cited in a range of fields, but has found particular resonance across the work of

42. J. Stuart Bunderson and Jeffery A. Thompson, "The Call of the Wild: Zookeepers, Callings, and the Double-Edged Sword of Deeply Meaningful Work," *Administrative Science Quarterly* 54, no. 1 (2009), 36.

43. J. Stuart Bunderson and Jeffery A. Thompson, "The Call of the Wild: Zookeepers, Callings, and the Double-Edged Sword of Deeply Meaningful Work," *Administrative Science Quarterly* 54, no. 1 (2009), 42.

44. Fobazi Ettarh, "Vocational Awe and Librarianship: The Lies We Tell Ourselves," *In the Library with the Lead Pipe*, January 10, 2018, http://www.inthelibrarywiththeleadpipe.org/2018/vocational-awe/

librarians, archivists, and curators, who often take exactly this view on the nature of the cultural-memory institutions they work for. The belief in this work as a calling is directly related to how and why memory workers are undercompensated and prone to burnout, and how and why work in professions like librarianship is also prone to job creep, being given ever-greater responsibilities over time.

It's Not You, It's Work

Those privileged and lucky enough to climb their way up the hope labor ladder toward a permanent job face another set of challenges. Expectations about level of effort and quality of work have risen significantly for the remaining permanent jobs. As a result, burnout is a major problem for cultural-memory workers. Even the temporary jobs that librarians work while in graduate school have been identified as beginning the cycle of burnout in library jobs.[45] For librarians working in the field, a 2018 survey using a standardized psychological instrument for tracking burnout found that roughly half of academic librarians are experiencing job burnout. That instrument asked questions like "Do you feel worn out at the end of the working day? Are you exhausted in the morning at the thought of another day of work? Is your work emotionally exhausting?[46] With that noted, talking about burnout can also make it seem like an issue of individuals rather than systems. To that end, it's been argued that it may be better to focus on the ways that overwork and under-resourcing in the sector are directly demoralizing.[47] The result is that, for those lucky enough to make it into permanent careers in cultural-memory work, a plurality, if not a majority, will find themselves working in jobs that are actively demoralizing and burning them out.

In the logic of vocational awe, it's on the worker to figure out how to cope with whatever is piled on them to respond to their calling. This fits with a

45. Jade Geary and Brittany Hickey, "When Does Burnout Begin? The Relationship Between Graduate School Employment and Burnout Amongst Librarians," *In the Library with the Lead Pipe*, October 16, 2019, http://www.inthelibrarywiththeleadpipe.org/2019/when-does-burnout-begin/

46. Barbara A. Wood et al., "Academic Librarian Burnout: A Survey Using the Copenhagen Burnout Inventory (CBI)," *Journal of Library Administration* 60, no. 5 (July 3, 2020), 512–31, https://doi.org/10.1080/01930826.2020.1729622

47. David Stieber, "America's Teachers Aren't Burned Out. We Are Demoralized," *EdSurge News*, February 14, 2022, https://www.edsurge.com/news/2022-02-14-america-s-teachers-aren-t-burned-out-we-are-demoralized

broader social trend: we are continually asked to turn our attention inward to figure out what is wrong with us, instead of looking outward at what is wrong with our society. Research on the history of time-management self-help literature is useful in underscoring this point. In *Counterproductive: Time Management in the Knowledge Economy*, Melissa Gregg unpacks how self-help books on time management turn a lack of time and resources into failings of self-discipline. As she observes, "The actual content of texts references a fairly unchanging cluster of tried-and-true methods (ranked and refined To Do lists; daily affirmations; time logs; single handling; delegation; embracing seclusions).[48] Books like *How to Systematize the Day's Work* from 1911, which acted much like advertising material for the newly invented vertical file cabinet, explained how filing systems could give their users "an auxiliary brain" and "a second memory for the desk man."[49] The same kind of ideas appear again and again, in titles such as James McKay's *The Management of Time* (1959) through *How to Get Control of Your Time and Your Life* (1973), and more recently, David Allen's *Getting Things Done: The Art of Stress-Free Productivity* (2001). In these books, the idea is that you can always find a way to improve your personal process for tracking and accomplishing work. This has the effect of displacing the problems of overwork from being organizational problems to issues of personal discipline. Task management takes on a kind of athleticism for doing more and more work in less time.

In Gregg's analysis, it becomes clear that the goal of time-management self-help is to provide "a form of training through which workers become capable of the ever more daring acts of solitude and ruthlessness necessary to produce career competence."[50] While there is a long history of time-management self-help, it is worth underscoring that "The initial wave of mass-market productivity titles bears close relation to the first flush of corporate downsizing in North America in the 1970s."[51] Time-management books focus on a minor area where individual workers can attempt to control their employability, and at the same time they make problems of overwork into failures of individuals rather than organizations. If everyone

48. Melissa Gregg, *Counterproductive: Time Management in the Knowledge Economy* (Durham, NC: Duke University Press, 2018), 55.
49. The System Company, *How to Systematize the Day's Work* (System Company, 1911).
50. Melissa Gregg, *Counterproductive: Time Management in the Knowledge Economy* (Durham, NC: Duke University Press, 2018), 54.
51. Melissa Gregg, *Counterproductive: Time Management in the Knowledge Economy* (Durham, NC: Duke University Press, 2018), 55.

would just get better at managing their time, then it would be possible to do more and more with less.

This becomes an important context for broadly understanding self-help books, books on mindfulness, and books like *Do What You Love* that offer career advice. As William Davies documents in *The Happiness Industry: How the Government and Big Business Sold Us Well-Being*, in the early history of psychology it was understood that the goals of psychology were to study the mind to understand how to improve individuals and how to improve society to work better for individuals. In practice, a range of areas in psychology works to pathologize what are clearly necessary adaptations to deal with precarity and the push to define oneself in moral terms based on the kind of work you do, when there are fewer opportunities to do that kind of fulfilling work for a living.

It makes a lot of sense that people are increasingly anxious and depressed in a world that provides fewer opportunities for them to fulfill what has been defined as their moral purpose. In Davies's words, "The hope is that a fundamental flaw in our current political economy may be surmounted, without confronting any serious political-economic questions. Psychology is very often how societies avoid looking in the mirror."[52] In this context, the promotion of mindfulness and meditation also function under the logic of athleticism that governs time management. Anne Helen Petersen frames the problem similarly. "This isn't a personal problem, it will not be cured by productivity apps, or a bullet journal, or face mask skin treatments" From her perspective, "We gravitate toward those personal cures because they seem tenable, and promise that our lives can be recentered, and regrounded, with just a bit more discipline, a new app, a better email organization strategy, or a new approach to meal planning." The problem, though, is that "all these are merely band-aids on an open wound. They might temporarily stop the bleeding, but when they fall off, and we fail at our newfound discipline, we just feel worse."[53] Which is exactly where we find ourselves in memory work.

Young people rack up debt for a chance to do enough hope labor to climb a ladder to get one of the handful of good jobs, and those lucky enough to get one are disciplined to accept overwork based on the logic that their career is a calling. If they were ever to walk away, based on the

52. William Davies, *The Happiness Industry: How the Government and Big Business Sold Us Well-Being* (London: Verso, 2015).

53. Anne Helen Petersen, *Can't Even: How Millennials Became the Burnout Generation* (Boston: Houghton Mifflin Harcourt, 2020), xxvi.

logic of the culture, they are effectively turning their backs on the essence of their self-worth and identity. This cycle needs to stop, and people in leadership roles across the field and in professional associations are the ones in the position to start resetting expectations.

Forget Lovable Memory Jobs, Let's Make Good Memory Jobs

On the surface, the idea that librarians, archivists, curators, historians, and other memory workers approach their work as a calling is a huge asset. There are so many people who want to do memory work that when cultural-memory institutions need to hire more workers, they get a flood of applications. Through my work teaching graduate students in public history at American University and librarians and archivists at the University of Maryland, I know firsthand just how bright, thoughtful, creative, and eager the cohort of people aspiring to work in cultural memory is. With that noted, the belief system around work in contemporary culture undermines the viability of cultural-memory careers.

The hope labor required to get into one of those lovable jobs functions as a multitiered filter that requires both a lot of luck and a good bit of privilege to make it through. For those who do make it through, the lovable nature of those jobs sabotages that work to become unsustainable and sends workers on a path that leads directly toward burnout. The future of memory institutions is very much the future of memory workers, so it's not just an ethical responsibility of leaders in cultural memory to do right by the next generation of workers, it's critical to the very future viability of those institutions.

Given these challenges, I've concluded that the only way forward is for us to consciously work to shift our field from "lovable jobs" to what management and organizational theory scholar Zeynep Ton calls "good jobs."[54] In the 2014 book *The Good Jobs Strategy*, Ton identifies a set of key issues in job design, operational models, and staffing that enable organizations to create good jobs and as a result deliver better products and services. Written primarily about retail, the key concepts in the framework relating to building teams, defining services, and supporting and empowering staff are also relevant to cultural-memory institutions. Two of Ton's principles—offer less, and operate with slack—are particularly critical for the future

54. Zeynep Ton, *The Good Jobs Strategy: How the Smartest Companies Invest in Employees to Lower Costs and Boost Profits*, illustrated edition (Boston: New Harvest, 2014).

of memory work. Along with that, we need to start by acknowledging and clarifying that workaholism is a vice and not a virtue. We also need to shift away from promoting jobs for "rock stars," the "brand name scholar" phenomena that supports a culture of celebrity, and toward the development of sustainable and maintainable memory institutions.

Say No to Personal Brands, "Unicorns," "Rock Stars," and "Magic"

In 2009, the idea of the "brand name scholar" from Schienfeldt's post made a lot of sense to me. In practice, it is an accurate guide for navigating hustle culture toward better job opportunities. I'd seen it work for a number of colleagues, some of whom were moving between digital humanities labs, libraries and archives, and tech-sector employers like Apple, Twitter, and Netflix. However, its effects on the field of cultural-memory work are clearly negative. As people are encouraged to raise their profile as individuals, to push for their own personal brands, the system ends up further promoting a tiered caste system of jobs. As discussed earlier, Vinsel and Russel note that the tiered nature of "innovation" in any number of work cultures creates different tracks for different classes of work. In this framework, the workers with the best personal brands pursue unsustainable innovation projects while the rest of the staff is saddled with maintenance work.

Under vocational awe, anyone posting a memory-work job can be sure that however high they set the bar for applicants and however low they set the pay, they will still receive dozens of applications. The net result is that, when an organization gets to post a job, it often posts it for what has been described as a "messianic unicorn: a person who singularly can immediately" bring the institution up to speed in a range of areas at once.[55]

In technology organizations it's become customary for some jobs to be described as opportunities for "rock stars" or "ninjas" or "unicorns." This language plays directly into problematic ideas about celebrity and orientalism, and notions that skill with technology is in some way magical or mystical. These perspectives have come to be rightly ridiculed. First, betting the future of an institution on a newly made-up job for a savior is a terrible idea. Beyond that, given that these opportunities usually don't come with the resources necessary to do this kind of transformative work,

55. Bobby Smiley, "From Humanities to Scholarship: Librarians, Labor, and the Digital," in *Debates in the Digital Humanities 2019*, ed. Matthew K. Gold and Lauren F. Klein (Minneapolis: University of Minnesota Press, 2019), 413–20, https://doi.org/10.5749/j.ctvg251hk.38

the reasonable thing for someone in this kind of job to do is to rack up a few cool, probably unsustainable flashy digital projects for their CV before the long-term costs of sustaining or maintaining that work become clear. People in such jobs need to hustle up the rungs of organizational hierarchy, often leaving for some other organization before the digital projects whose screenshots feature prominently in their conference-presentation and job-talk slide decks stop working. The result of this process is that when the "unicorn" or "rock star" leaves, either because they are burned out or because they found a way to get a promotion somewhere else, everyone left behind at the organization needs to figure out how to keep various special projects running in the future.

Issues around what kind of work gets recognition and appreciation inevitably play into existing problematic dynamics around privilege. Sharon Leon, one of the key leaders of CHNM during the time I worked there, has documented the range of ways that work in digital history has failed to recognize the leadership of women in work in the field over the last three decades. In her essay "Complicating a 'Great Man' Narrative of Digital History," she notes that, among a range of reasons that work on digital history has focused on the work of men, "women's work on digital history projects can get buried if researchers only pay attention to the founders and the individuals who are listed as principal investigators."[56] She also notes that while many leaders in digital history organizations wrote extensively on their projects, that opportunity was only afforded to people who had particular kinds of job status. As she observes, "For contingent faculty and staff being paid out of grant funding that requires the assignment of all of their labor to particular projects with no latitude for their own exploratory work, producing these kinds of peer-reviewed articles can be nearly impossible to do given the timescales and constraints of project deliverables." As a result, "Unless the analytical writing is built into the grant or the project plan, it is extraordinarily difficult to fit in, and the review and revision cycles for traditional scholarly publishing can outlast the period of performance for the project." Here again we see the how the different tiering of job status, and requirements associated with contingent labor, work against the need to acknowledge and support the full range of

56. Sharon M. Leon, "Complicating a 'Great Man' Narrative of Digital History in the United States," in *Bodies of Information: Intersectional Feminism and Digital Humanities*, ed. Jacqueline Wernimont and Elizabeth Losh, accessed November 14, 2021, https://dhdebates.gc.cuny.edu/read/untitled-4e08b137-aec5-49a4-83c0-38258425f145/section/53838061-eb08-4f46-ace0-e6b15e4bf5bf#ch19

work and collaborations required to sustain cultural-memory work. We can work to change what kinds of work is recognized and to create more equitable approaches to job design.

Recognize Workaholism as a Vice, Not a Virtue

The people who make it into leadership roles in cultural-memory organizations and institutions, myself included, need to recognize that we have a survivor bias. The fact that we made it into our jobs is not affirmation that the system works, it's an affirmation that through privilege and luck we were able to make it. It's also the case that many of the characteristics we might think are our virtues, such as working long hours or prioritizing work over other parts of life, are in fact our vices.

The result may well be that the senior leaders of memory institutions such as libraries, archives, museums, and history centers really do love to do their work and want to work after hours or on weekends when they are off. If this is something that you do, you need to recognize you are now part of the problem. You could do many things that would do you and the world some good and also help address the stress and anxiety that come from putting too much of your life and your energy into work. For even the most workaholic among us, it is worth underscoring that research on leadership has demonstrated that centering work too much in your life creates cycles of self-sacrifice that make it harder and harder to be an effective organizational leader. We all need cycles of renewal to be able to be in the right headspace to respond to the challenges and complexities of our work.[57] If you can't resist the compulsion to send a work email on the weekend, at the very least set up your email client to delay sending the message until Monday. Whatever happens, make sure that the people working in your organization understand that good jobs come with boundaries, and that you want everyone you work with to start respecting those boundaries.

I write all of this as someone who is in fact writing the first draft of this chapter at 7:00 PM on a Saturday. I put in a full day of writing on a book that isn't directly related to the actual requirements of my library day job.

57. Richard E. Boyatzis and Annie McKee, *Resonant Leadership: Renewing Yourself and Connecting with Others through Mindfulness, Hope, and Compassion* (Boston: Harvard Business School Press, 2005).

I am one of those millennials who was raised in concerted cultivation who finds themselves driven to work in cultural heritage with feelings that it is a calling. I now understand this compulsion more as a vice than a virtue.

With that noted, I'm also happy to share that I did a lot of other things today. I made tofu scramble breakfast tacos for me and my wife Marjee. I took our dogs Iggy and Bowser on three walks around our neighborhood. Marjee and I went on a bike ride down the Hyattsville Trolley Trail and around Lake Artemesia, where we took in the colors of the changing leaves. Marjee and I also talked a bunch about the book she is writing. She had several great ideas for it, and I was excited to hear about them. I talked to my mom on the phone. We are coordinating plans to stay at a cabin in Luray out in the Blue Ridge Mountains for New Years. Besides this, I didn't do any writing on the book last weekend, when Marjee and I went back to Madison for my cousin's paebaek ceremony, where I got to see many of my relatives who I hadn't seen for two years because of COVID-19, and at which my uncle, who runs my grandfather's farm and recently turned sixty, shared the advice that it's important to slow down and treasure every moment, because life only keeps moving faster.

I realize my last paragraph might seem like a digression, but it's worth remembering that in the world of the attention economy we only see the parts of each other's lives that are performed in particular venues. To that end, I think it's useful for us all to sometimes get more into the habit of sharing parts of our lives that aren't directly work related. It's critical to resist the "do what you love" philosophy's push to reduce all we love into the confines of what we do for work. Our lives and worlds exist beyond the boundaries of our work.

Through ongoing attention and effort, I've even been able to not work on things and to genuinely relax, at least for brief periods. This is to say, I speak to the challenges and contradictions of attempting to disassociate the whole of myself from my work. I do so in the way that any addict copes with what they know to be an addiction they will live with for the rest of their life. That said, this book is, in fact, also my hobby. Unlike jobs at research libraries in higher education, my work for the federal government does not ask or require me to do any kind of external publishing or research. I am genuinely doing this as a thing that I love to do, but in my case, it isn't hope labor. I mean, I hope you find this book interesting and useful, but I'm not working on this book in the hope that it can get me a different job or advance my career. I can write like this on the weekend

because I want to, and not out of any sense that I need to. That is of course possible because the federal government has a range of good guardrails in place about what the expectations are for employees.

Memory Institutions Need to Offer Less, Not More

In Ton's research on companies that are successful with "a good jobs strategy," one of the key things she observes is that those organizations categorically offer less.[58] They offer fewer products and services. They are open fewer hours. They run fewer promotions. In Ton's words, "What retailers do not realize is how much each additional product, each additional promotion, and each additional holiday they choose to stay open increases the complexity of their business. . . . More product variety and promotions also increase the likelihood of errors and operational problems."[59] While it might seem off to compare retail positions to cultural-memory jobs, I think it's worth underscoring that this is itself part of the problem. The fact that memory workers often believe their calling to be somehow above other kinds of work is one of the attitudes that undermines workers' ability for workers to advocate for better working conditions. Beyond that, in Ton's terms, if a good jobs strategy can work in industries like low-cost retail, which are explicitly known for providing particularly bad jobs, then places like memory work that ostensibly provide lovable jobs have a lot to learn from those industries.

Ton underscores that a series of cascading valuable effects come from the operational decision to offer less. "Offering less makes operations more efficient and accurate, which in turn improves customer service and hence sales. Since improving operations helps employees do a better job—sometimes in ways that customers can see with their own eyes—employees feel greater pride and joy in their work."[60] In the retail context, offering less allows an organization and its workers to focus on optimizing resources and generating the most value from the time and energy their higher-paid workforce brings to the work. Significantly, in the retail context, decisions

58. My discussion of Ton's work here draws from parts of Trevor Owens, "A Good Jobs Strategy for Libraries," *Library Leadership & Management* 35, no. 3 (November 15, 2021), https://doi.org/10.5860/llm.v35i3.7486

59. Zeynep Ton, *The Good Jobs Strategy: How the Smartest Companies Invest in Employees to Lower Costs and Boost Profits* (Boston: New Harvest, 2014), 77.

60. Zeynep Ton, *The Good Jobs Strategy: How the Smartest Companies Invest in Employees to Lower Costs and Boost Profits* (Boston: New Harvest, 2014), 96.

about how many products to provide relate directly to sales and to revenue, but it's worth underscoring that the effects of offerings in contexts that don't relate to additional revenue present different kinds of problems. That is, when libraries, archives, and museums offer more, it's not generally the case that they can thereby generate more resources. In general, cultural-memory institutions like libraries operate from a spend plan on a fixed budget provided by a city, municipality, or nonprofit organization; the library operates on a largely fixed sum of funds in an endowment. So, when a library decides to offer more, by doing so it doesn't generally have a possibility to gain more resources to operate on.

If one were to describe the offerings of memory organizations like public and research libraries in the last several decades, they would probably be best characterized as the opposite of "offer less." I think it's fair to say that across different kinds of library sectors, the current operating theory is "offer more." Research libraries are providing growing lists of services, such as digital scholarship, research-data management, open-access publishing services, digitization, and digital repository functions.[61] Public libraries offer a wide range of varied digital content and services to their users, provide access to new kinds of services such as "maker spaces," and are increasingly being called on to play key roles as social service providers for the unhoused, as first responders with Narcan for drug overdoses, and as providers of a wide array of social work services.[62] Every new offering or

61. For digital scholarship services, see Robin Chin Roemer and Verletta Kern, eds., *The Culture of Digital Scholarship in Academic Libraries* (Chicago: ALA Editions, 2019). For research and data management services, see Carol Tenopir et al., "Research Data Management Services in Academic Research Libraries and Perceptions of Librarians," *Library & Information Science Research* 36, no. 2 (2014), 84–90. For open access publishing services see Katherine Skinner et al., "Library-as-Publisher: Capacity Building for the Library Publishing Subfield," *Journal of Electronic Publishing* 17, no. 2 2014. For digitization services see Karim Tharani, "Collections Digitization Framework: A Service-Oriented Approach to Digitization in Academic Libraries," *The Canadian Journal of Library and Information Practice and Research*, 7, no.2, 2012. For digital repository services see Dorothea Salo, "Innkeeper at the Roach Motel," *Library Trends* 57, no. 2 (2008), 98–123.

62. For maker spaces, see Erica Halverson, Alexandra Lakind, and Rebekah Willett, "The Bubbler as Systemwide Makerspace: A Design Case of How Making Became a Core Service of the Public Libraries," *International Journal of Designs for Learning* 8, no. 1 (2017). For services for the unhoused see Vikki C. Terrile, "Public Library Support of Families Experiencing Homelessness," *Journal of Children and Poverty* 22, no. 2 (2016), 133–46. For support for individuals overdosing on drugs, see Anne Ford, "Saving Lives in the Stacks," *American Libraries* 48, no. 9–10 (2017), 44–49. For social work services see Patrick Lloyd, "The Public Library as a Protective Factor: An Introduction to Library Social Work," *Public Library Quarterly* 39, no. 1 (2020), 50–63.

service a library provides creates more operational complexity to manage. This is particularly problematic given that, for the most part, the growth in these kinds of services has come in a period in which budgets have been either stagnant or shrinking, when costs of things like e-journal subscriptions continue to skyrocket, and in which, by and large, all the existing functions and services of libraries around management of print collections and long-standing services persist.[63] In practice, this has resulted in a situation where "the number of support staff is in fairly inexorable decline."[64] Much of this is a self-imposed problem. Organizational leaders make decisions about how thin they can spread their staff, and they need to stop pushing them to do more and more with less and instead focus on what work really needs to be prioritized.

Design Permanent Jobs with Slack

Ton's last principle for a good jobs strategy is that organizations need to design jobs with an explicit focus on creating slack. In her words, "Model retailers cut waste everywhere they can find it except when it comes to labor. There, they like to err on the side of too much labor—or over staffing—which would be seen as a fatal mistake anywhere else. It's not even a matter of 'erring'; model retailers deliberately build slack into their staffing."[65] She stresses that this is the most critical component of the good jobs strategy she documents.

Ton explains that this provides two essential benefits, first by "preventing the operational problems that come from understaffing. Second by allowing employees to be involved in continuous improvement in the form of waste reduction, efficiency, and safety improvement, and product and process innovation."[66] Central to this concept is that workers who are pushed to the limit of what they can do have no capacity to think about how to do the work better. Further, workers who are pushed to the limit

63. Glenn S. McGuigan, "Publishing Perils in Academe: The Serials Crisis and the Economics of the Academic Journal Publishing Industry," *Journal of Business & Finance Librarianship* 10, no. 1 (2004), 13–26.

64. Liam Sweeney and Roger Schonfeld, "Inclusion, Diversity, and Equity: Members of the Association of Research Libraries" (Ithaka S+R, August 30, 2017), https://doi.org/10.18665/sr.304524

65. Zeynep Ton, *The Good Jobs Strategy: How the Smartest Companies Invest in Employees to Lower Costs and Boost Profits* (Boston: New Harvest, 2014), 154.

66. Zeynep Ton, *The Good Jobs Strategy: How the Smartest Companies Invest in Employees to Lower Costs and Boost Profits* (Boston: New Harvest, 2014), 155.

are going to get burned out, stressed, and fatigued, and will be less and less effective in their ability to do the work. Operating with slack is, in her words, the "ultimate expression of putting employees at the center of a company's success." Relating to the previous chapter, this slack is essential to create the time and space for those closest to the work to identify and articulate strategies and plans for the future.

This principle seems to be the one that is the most at odds with the lived experience of memory workers across higher education, libraries, archives, and museums. Understaffing has been directly identified as a key factor creating low morale in libraries.[67] This is particularly problematic when paired with the fact that instead of offering less, they continue to attempt to offer more and more services with fewer workers and resources. If in fact cultural-memory institutions want to follow a good-jobs strategy, it is essential for leaders of cultural-heritage organizations to step back and reflect on what they are offering to begin to identify what things don't need to be done. Given that we probably aren't in situations where large amounts of additional core funding can be generated, the central issue for memory institutions is to identify what services they can offer with the staff they have, and then to think even harder about how to offer fewer services so that they can give staff the bandwidth to think about how to improve processes and work.

Central to the good-jobs strategy is an understanding that it's essential to provide stability and consistency to workers in terms of both ongoing employment and scheduling and hours. In this respect, organizations need to be very deliberate about how and when they create term-based positions. Notably, many libraries, archives, museums, and cultural-heritage jobs in higher education organizations have attempted to grow their services and offerings by creating precarious term-based jobs that place considerable responsibilities and stress on temporary workers funded with external grant funds or short-term project funds. People in these roles are often in their dream jobs, but are deeply stressed by both their inability to plan for their own futures and the likelihood that because of the temporary nature of their employment and funding, their work is probably going to be unsustainable in the long run for their organizations.[68] Further, "inse-

67. Kaetrena Davis Kendrick, "The Low Morale Experience of Academic Librarians: A Phenomenological Study," *Journal of Library Administration* 57, no. 8 (November 17, 2017): 846–78, https://doi.org/10.1080/01930826.2017.1368325

68. Courtney Dean et al., "UCLA Temporary Librarians," June 11, 2018, https://docs.google.com/document/d/1h-P7mWiUn27b2nrkk-1eMbDkqSZtk4Moxis07KcMwhI/mobilebasic

cure employment affects both the diversity of the profession and the cadre of early career professionals who often fill term roles."[69] This emphasizes that the issues drawn out here compound challenges to efforts to center diversity, equity, and inclusion in the future of cultural-memory work. The stress that comes from precarious funding and staffing in support of what should be developed into core ongoing programs has been identified as a major source of job dissatisfaction for early and mid-career memory workers.[70] In this context, library organizations would do well to develop clear plans for how term-based funding fits into the development of core services, and to be sure that when it is necessary to create term-based positions, they review and engage with best practices for this kind of work, as identified in resources like the "Guidelines for Developing and Supporting Grant-Funded Positions in Digital Libraries, Archives, and Museums."[71]

When I look back at the twenty-one-year-old me that started as the "technology evangelist" at the Center for History and New Media, I have a lot of fond memories. It was a fun place to work. I was lucky to have the support and guidance of generous mentors. I remember setting up my blog. I remember hopping on Twitter and getting connected with a network of historians, archivists, and librarians. I remember meeting with folks face-to-face when we started throwing THATcamp events. It all felt like a new, less-hierarchical, more open future for cultural-memory work was coming together. At that point, I felt like anyone could be scrappy and hustle your way through things and end up with a great career. I see that as partly my youth and naïveté regarding my privilege, but I also recognize it as a key problem in the broader cultural zeitgeist of the *Wired* imaginary of that moment in the ascendance of Silicon Valley–style thinking. It was in that spirit that in 2011 I wrote a post about "the digital humanities as the

69. Chela Scott Weber, "Research and Learning Agenda for Archives, Special, and Distinctive Collections and Research Libraries" (Dublin, OH: OCLC Research, 2017), 10.25333/C3C34F.

70. Karl Blumenthal et al., "What's Wrong with Digital Stewardship: Evaluating the Organization of Digital Preservation Programs from Practitioners' Perspectives," *Journal of Contemporary Archival Studies* 7, no. 1 (August 17, 2020), https://elischolar.library.yale.edu/jcas/vol7/iss1/13; Stephanie Bredbenner, Alison Fulmer, Meghan Rinn, Rose Oliveira, and Kimberly Barzola, "'Nothing About It Was Better Than a Permanent Job': Report of the New England Archivists Contingent Employment Study Task Force," New England Archivists Inclusion and Diversity Committee, February 2022. https://newenglandarchivists.org/resources/Documents/Inclusion_Diversity/Contingent-Employment-2022-report.pdf

71. Hillel Arnold et al., "Do Better—Love(,) Us: Guidelines for Developing and Supporting Grant-Funded Positions in Digital Libraries, Archives, and Museums," January 2020, https://dobetterlabor.com

DIY humanities" that got a great response.[72] It felt like all you needed was a lot of tenacity and grit and you could invent the kind of career that you wanted for yourself.

Looking back on that Trevor from a decade ago, I see someone who was mildly clueless about the wide range of privilege and luck that had come together to make it possible for him to have the kind of success he did. In no way, shape, or form did I "do it myself." I was only able to get that job because when we moved out to DC, Marjee had a well-paying job that let me keep applying for jobs until I got one that I really wanted. I was lucky to end up at a place like CHNM, which despite providing short-term temp jobs was full of people who enthusiastically and wholeheartedly supported me as someone who could participate in work beyond the specifics of the project-based nature of my job.

I share this reflection in part to model the kind of thinking that more of us who have stable, good-paying jobs in cultural-memory organizations should do. At this point, if you are in one of those stable jobs, congratulations. To some extent, you have won the lottery. I've now been on enough job search panels to report that for every open position, there were generally a dozen or more highly qualified people who would have been great. The only way we can make work in cultural-memory institutions better is if those of us who made it into the field really start to own up to the fact that we didn't get these jobs because we were better, or we worked harder. A lot of it had to do with whatever levels of privilege we had, and with luck. That realization should spark action. It's critical that we work together to make all the jobs in cultural-memory organizations into good jobs, and advocate for the policies and practices that will help make that a reality.

72. Trevor Owens, "The Digital Humanities as the DIY Humanities" (2011), http://www.trevorowens.org/2011/07/the-digital-humanities-as-the-diy-humanities/

PART TWO

Three Ways Forward

The first half of this book largely worked to diagnosis a set of ideological problems affecting memory work and memory institutions. Along with diagnosing the problems, I've offered some ideas about how we can counteract the worst of those ideologies, but so far, we have still been starting from and reacting to ideas emerging from those frameworks. Resisting and reframing those problematic ideologies is important, but we also need to find a different place to start from. The rest of this book is an attempt to do that.

The second half of the book works to draw out how three interrelated ideas—maintenance, care, and repair—can serve us as fundamental replacements for disruption, metrics obsession, and hustle culture. Throughout these chapters I try to balance key theoretical and conceptual work about maintenance, care, and repair with practical examples of how and where cultural-memory workers manifest these ideological frames in action. With that said, my main goal here is not to provide a how-too book, or to offer simple answers. One problem with disruptive innovation is its facile engagement with complexity and nuance and its solutionist bent, attempting to jump to answers before we even fully understand the nature of our problems in context.

In keeping with the standpoint epistemology described in the first half of the book, I am consciously focusing attention on the work and voices of those who have been othered and intentionally left out of futures envisioned by venture capitalists and Silicon Valley. I engage in this with open eyes about my own positionality as a cisgender white man who lives and works in and around centers of power in Washington, DC.

My hope is that I can use my relative privilege and power to draw further attention to a wide range of leading feminist, black, indigenous, queer, and majority world thought leaders that cultural-memory institutions should be paying more attention to. With that noted, I am wary of the realities of how privilege and power work through appropriation of ideas, and with a direct recognition with potential problems of appropriation and reductiveness that can emerge when someone with my positionalities attempts to engage in this kind of work. To that end, through the rest of the book I have attempted to build more in-depth engagement with thinkers and authors working in these spaces. In many cases I have tried to balance how much I center my own voice and to center other voices over my own. I accept that some readers may have preferred a simpler, clearer, more definitive set of takes about exactly how the future should work. But that kind of command-and-control ideology is itself at odds on some level with the kind of transformation I am advocating for. My hope is that you can find the ideas that follow generative and fruitful in developing your own reflective practice to engage in memory work.

CHAPTER 5

The Maintenance Mindset

In 1969, artist Mierle Laderman Ukeles wrote the *Maintenance Art Manifesto*. It was, in part, a proposal for a museum exhibition titled *Care*. The proposed exhibit would "zero in on pure maintenance" and "exhibit it as contemporary art." It was to be organized in three sections: "personal, general, and Earth maintenance."[1] For the personal part, she would live in the museum as if it were her home. She would "sweep and wax the floors, dust everything, wash the walls, cook, invite people to eat, clean up, put away, change light bulbs." The general part would exhibit typescripts of interviews with fifty people in maintenance occupations, including mailmen, librarians, teachers, nurses, and museum directors. Interviewees would explain what they think maintenance is and "the relationship between maintenance and life's dreams." For the third part, on Earth maintenance, garbage from a sanitation truck, polluted air, polluted water from the Hudson River, and polluted soil would be brought into the museum daily. As part of the exhibit, she, along with a series of experts, would work on this garbage and polluted earth and air until it was "purified, depolluted, rehabilitated, recycled, and conserved."[2] Ukeles proposed this exhibition to the Whitney Museum of American Art and the American Craft Museum. The museums were uninterested. However, she also sent a copy of the mani-

1. Mierle Laderman Ukeles, "Manifesto for Maintenance Art 1969! Proposal for an Exhibition 'CARE,'" 1969. Queens Museum, https://queensmuseum.org/wp-content/uploads/2016/04/Ukeles-Manifesto-for-Maintenance-Art-1969.pdf
2. Mierle Laderman Ukeles, "Manifesto for Maintenance Art 1969! Proposal for an Exhibition, 'CARE,'" 1969. Queens Museum, https://queensmuseum.org/wp-content/uploads/2016/04/Ukeles-Manifesto-for-Maintenance-Art-1969.pdf

festo to art critic Jack Burnham. Burnham published an excerpt of it in *Artforum*, where it came to play a significant role in shaping ideas about maintenance and care in contemporary art practice and beyond.[3]

Building out from that manifesto, over the next four decades Ukeles engaged in a wide range of creative work under the banner of maintenance art. Notably, she became the artist-in-residence at the New York City Waste Management Program. In 2017, the Queens Museum mounted a major exhibition of maintenance art she produced across her career, evidence of the success and resonance of her work. In the book published alongside the exhibition, curator Patricia Phillips asserts that the manifesto is "an active summons that remains a point of origin for endless departures and returns—both for the artist and for successive generations who look to her independent, social, and contextual work as a source of inspiration and a model of courage, generosity, and freedom."[4] As Phillips observes, "Although *Care* was never staged in its entirety . . . the *Manifesto* is an epistemological prompt that has challenged and altered conventional conceptions of art and artists. It still lives provocatively in the world."[5] In that spirit, I take the manifesto, and its presentation and exhibition in the Queens Museum, as a provocation for the second half of this book.

The *Maintenance Art Manifesto* has become an important document in advancing feminist notions of maintenance and care. Before delving into the description of activities she would engage in for the *Care* exhibition, Ukeles opens the manifesto with a description of what she identifies as the dichotomy between a death and a life instinct in society. The death instinct is focused on "separation, individuality, Avant-Garde par excellence; to follow one's own path—do your own thing." In contrast, the life instinct is about "unification, the eternal return; the perpetuation and MAINTENANCE of the species; survival systems and operations, equilibrium." She further explains that the death instinct is anchored in "pure individual creation; the new; change; progress, advance, excitement, flight or fleeing." In contrast, the life instinct prompts one to "keep the dust of the pure individual creation; preserve the new; sustain the change; protect prog-

3. Jack Burnham, "Problems of Criticism IX: Art and Technology," *Artforum*, January 1971, https://www.artforum.com/print/197101/problems-of-criticism-ix-art-and-technology-38921

4. Patricia C. Phillips, ed., *Mierle Laderman Ukeles: Maintenance Art* (New York: DelMonico Books/Prestel, 2016), 25.

5. Patricia C. Phillips, ed., *Mierle Laderman Ukeles: Maintenance Art* (New York: DelMonico Books/Prestel, 2016), 40.

ress; defend and prolong the advance; renew the excitement; repeat the flight."[6] Ukeles's descriptions of the death instinct largely describe the central themes of the last three chapters. The stories of disruptive innovation, of hustle culture, of Moneyball statistical thinking are anchored in the new, in individuality, and in runaway growth. In that regard, the problems of the first half of the book can all be framed as problems of this death instinct. The rest of this book is, functionally, an attempt to distill and advance notions related to the life instinct for cultural-memory work.

I've become increasingly convinced that themes around the life instinct are central to envisioning a better future for cultural memory. The second half of this book focuses on drawing out three related but distinct concepts in that life instinct: maintenance, care, and repair. I believe that these concepts can serve as positive counter-frameworks for building a better future for cultural-memory work and institutions. As is evident in Ukeles's manifesto, notions of maintenance, care, and repair are so closely related that in many cases they flow in a litany and blur together. I insist that it is important to understand the work that each of these concepts can do independently, while also observing how they relate and connect to each other.

To that end, over the next three chapters I explore these concepts individually. I approach maintenance as more of a technical or engineering concept. I draw on work about both the value of preventive maintenance and the importance of engineering more reliable and sustainable infrastructures and systems.

Building on work in feminist theory, I approach care largely through scholarship on an ethic of care and its relationship to work in disability justice. This work reframes the basis of our obligations and relationships to each other and our communities as relations of care and interdependence. This includes interdependence between people, animals, and the environment.

I approach repair as a critical concept to address foundational problems of settler colonialism, patriarchy, and white supremacy. I pair it with two other "re" words, revision and return. If memory institutions are to support freedom and justice, core aspects of their structure and function require explicit action to repair and address injustices. Similarly, we must revise the stories we tell of the past, return looted objects and culture, and seek ways

6. Mierle Laderman Ukeles, "Manifesto for Maintenance Art 1969! Proposal for an Exhibition 'CARE'" (Intellect Ltd., 1969), Queens Museum, https://queensmuseum.org/wp-content/uploads/2016/04/Ukeles-Manifesto-for-Maintenance-Art-1969.pdf

to repair the harm and violence that memory institutions have participated in and perpetrated over time. In contrast to disruption, this chapter draws on notions such as Jenny Odell's concept of manifest dismantling and explores the extent to which intentional work needs to happen to change the function and practices of memory institutions to enable a more just and equitable future.

In each of these cases, there are strong, clear connections between maintenance, care, and repair that I will attempt to draw out, but I intend to do so while respecting what is distinct and significant about each of the three concepts. The rest of this chapter is focused on maintenance.

The title of this chapter, "The Maintenance Mindset," comes from historians Lee Vinsel and Andrew Russell's work on innovation and maintenance. In much the way that disruptive innovation works as a frame of mind for thinking about the present and the future, so too can we develop maintenance as a framework for centering our work and practice.[7] This chapter starts by considering general points about what is necessary to support and sustain this maintenance mindset. I then shift to focus more directly on recent scholarship on establishing more maintainable and durable digital infrastructure for cultural-memory and knowledge work. I then consider the way the Haudenosaunee notion of seventh-generation thinking can operate as a framework for thinking about the maintainability and sustainability of work in memory organizations.

Collectively, this chapter offers a way forward for cultural memory where we begin to center maintenance over innovation—or, to state it less antagonistically, where we need to reframe what it means to be innovative. We need creative, novel ways to envision more resilient systems and ways to live outside of obsessive pursuit of growth. We can shift our resources and our thinking away from novelty. At the same time, we need to make sure that a focus on maintenance doesn't become maintenance of the status quo.

Three Maintenance Mindset Principles

There are three components to what Vinsel and Russell identify as the maintenance mindset. Each component is relevant to cultural-memory work and institutions. First, they argue that maintenance sustains success.

7. Lee Vinsel and Andrew L. Russell, *The Innovation Delusion: How Our Obsession with the New Has Disrupted the Work That Matters Most* (New York: Currency, 2020), 141.

Second, they argue that maintenance depends on culture and management. Third, they argue that maintenance depends on constant care. I will give a brief overview of each of these points and relate them to issues in the work of cultural-memory institutions.

The idea that maintenance sustains success is useful as a sales pitch regarding the value that the maintenance mindset provides to those who may be unconvinced. Studies of the value of maintenance in commercial real estate have found that resources invested in preventive maintenance programs resulted in a 545 percent return on investment.[8] Maintenance pays huge dividends. The better we understand the value that comes from that kind of proactive investment, the stronger the case we can build for maintenance work. As organizations decide how to invest their limited resources, there will continually be competition: resources could go to support some novel initiative or project or to support forms of preventive maintenance. Every new innovative initiative brings about its own aftermath as well. Novel initiatives either need to be wound down and decommissioned, which takes time and effort to do well, or they end up being added to the overall maintenance burden an organization carries. To that end, it's critical to be able to explain the value provided by resources invested in maintenance work.

The second point in the maintenance mindset is that maintenance depends on culture and management. What gets prioritized in an organization and what is supported and celebrated in its culture is evident in the organization's rituals and structures—everything from its salary structures, strategic plans, allocations of office space, and the rhythms and cadence of its meetings. Given that there is such a focus on metrics in data-driven approaches to work, it is worth noting that shifting from growth-oriented metrics to metrics that track reliability and demonstrate the impact of investments in maintenance can work to bend organizational metrics obsessions in a positive direction. Reliability metrics, such as tracking how often systems fail to produce quality results, how expensive it is to maintain a system or process, or measures of system uptime, are all things that can be observed and tracked. Within the cultural-memory community, advancements like the OCLC report on the total cost of collections stewardship are valuable for helping to shift some of the planning mindset around cul-

8. Wei Lin Koo and Tracy Van Hoy, "Determining the Economic Value of Preventive Maintenance" (Jones Lang LaSalle, 2002), http://cdn.ifma.org/sfcdn/docs/default-source/default-document-library/determining-the-economic-value-of-preventative-maintenance.pdf?sfvrsn=2

tural heritage collections.⁹ If we are going to have key metrics to track in support of our work, we can shift them to look at factors such as projecting costs and the environmental impacts of decisions well out into the future. While memory institutions often track and report on how much money they spend on acquiring collections and the extent of those collections, they have historically not done well in accounting for the total costs to process, maintain, and sustain those collections. As an example, the Association of Research Libraries annual statistical report provides a number of rank-ordered lists where one can see where a given research library ranks in total spending on new acquisitions, total new items acquired, and the total number of volumes held. All of the lists are ordered to suggest that first place goes to whoever has the biggest collection. The ranked lists of who spends the most and who has the most inherently privilege growth and expansiveness.

We can well imagine those kinds of metrics being replaced by such factors as the reliability and uptime of core digital systems, or the results of standardized surveys of staff burnout, or the differential between the highest- and lowest-paid members of staff, or counts of which institutions have the largest unprocessed backlogs, or measures of the library's carbon footprint, or measures of how accurate and complete an organization's inventory is. In short, it's entirely possible to identify different measures for memory institutions. In this context, developing maintenance-centered metrics could help shift priorities to what is going to be required to maintain and sustain access to those resources into the future. That said, it's also worth recognizing that the metrics obsession is still a problem in its own right, but we all have to keep working in the world that is instead of the world as it should be; at least pivoting the metrics toward maintenance centered measures can shift our systems toward patterns that focus resources and attention on maintenance work.

Vinsel and Russell's third observation is that maintenance depends on constant care. For them, care is about the kind of attention and focus required of professionals who are responsible for doing maintenance work in organizations. They identify a set of key factors that motivate "maintainers," people who both do maintenance work and exhibit what they call a maintenance mindset. In their words, "Maintainers are most effective when they can focus on their work, improve and refine their

9. Chela Weber et al., "Total Cost of Stewardship: Responsible Collection Building in Archives and Special Collections," 2021, https://doi.org/10.25333/ZBH0-A044

methods, and apply their innate curiosity and ingenuity."[10] While that might be broadly true of work in a range of areas, it's worth underscoring that maintainers find the work of maintenance itself to be engaging and motivating. To this end, they tend to be primarily interested in having the time and space to do that maintenance work well. This point relates directly back to a series of issues raised in the previous chapter on burnout in memory-work careers. A key part of the maintenance mindset requires us to change what work is celebrated and what kinds of feedback and support staff receive for their work.

Staff involved in maintenance work need the time and space to do their work, but they also need slack to be able to identify ways to improve and make systems more resilient and maintainable. That need for slack exists for all workers' roles in an organization. Ultimately, the work of cultural-memory institutions depends on having well-supported cultural-memory workers in place to manage and sustain operations. An organization that works from a maintenance mindset must focus on supporting its workers. Precarious forms of employment for workers at memory institutions are unsustainable and unmaintainable. If we understand the work of memory institutions to be about ensuring maintainable long-term functions, it's important to build and support teams of staff in long-term jobs that align with that long-term vision. It's similarly critical that we work to establish and sustain systems and processes that work to carry forward operations beyond the time horizons of individual workers' time with organizations.

A key aspect of this last point is that when organizational and work cultures prioritize the kinds of facile notions of disruptive innovation explored in the first chapter of this book, they end up perpetuating deeply dysfunctional cultures that are diametrically opposed to cultivating and sustaining a maintenance mindset. As previously discussed, this ends up producing caste systems between the work of maintainers and innovators in nearly every area of activity in an organization. Given how strongly the ideologies around disruptive innovation came bundled with computing technologies, it is not surprising that some of the most unsustainable and least maintenance-oriented thinking can be found in the areas of cultural-memory organizations focused on implementing and managing digital technologies. To this end, it is particularly useful to focus attention on the growing literature that draws out a maintenance mindset for

10. Lee Vinsel and Andrew L. Russell, *The Innovation Delusion: How Our Obsession with the New Has Disrupted the Work That Matters Most* (New York: Currency, 2020), 153.

approaching digital technologies in cultural-memory institutions from a maintenance mindset.

Maintainable and Durable Digital Knowledge Infrastructure

The places where disruptive innovation finds its strongest foothold, in the digital operations of institutions, are often the least maintenance-oriented parts of organizations. To this end, digital humanities centers, digital library programs, and digital and IT departments in museums and archives are the sites most in need of a maintenance mindset intervention. It's worth noting that these areas are often related to or embedded with technical services functions such as cataloging or collection management, which have in large part been hollowed out and underfunded as workflow automation practices were implemented during the '60s, '70s, '80s, and '90s. During that period, many organizations saw reductions in staffing in those technical services areas of as much as 50 to 80 percent. This is particularly critical as, in the words of tech evangelist Marc Andreessen, "software is eating the world."[11] As nearly every part of an organization that might have previously relied on paper forms and filing transitions to depend on complex digital workflow applications, it becomes more critical to learn lessons about how digital operations can become sustainable and maintainable.

From the late '90s through the '00s, an exciting and diverse array of digital collections, digital archives, and digital humanities initiatives burst onto the web. In my work at the Center for History and New Media and through the network of THATCamp (The Humanities and Technology Camp) events, I got to know much of this work from colleagues at the Scholars Lab in the University of Virginia Library, the Maryland Institute for Technology in the Humanities, and the MATRIX Center for Digital Humanities & Social Science at Michigan State University. Some were anchored in academic humanities departments, other in units in an academic library. At the same time, I got to know a number of folks working on digital initiatives and projects in other parts of libraries, archives, and museum organizations. At that point in time, it felt exciting to be able to spin up an instance of open-source software like WordPress or Omeka and rapidly develop and publish a website or digital collection.

As those projects accumulated and people transitioned through differ-

11. Marc Andreessen, "Why Software Is Eating the World," *Wall Street Journal* 20, no. 2011 (2011): C2.

ent jobs over time, it became clear that all of this was unsustainable. It's one thing to launch some novel project with an initial set of startup funds from a grant. It's entirely different to coordinate the ongoing maintenance and patching of those digital resources into the foreseeable future. In short, the project-based funding that let so many interesting projects flourish was a direct contributor to the unsustainability of digital projects and initiatives of cultural-memory organizations.

The idea of the "project," in the language of project management, is supposed to be a time-limited engagement. A core concept in project management is that a project is a "temporary endeavor," and "the temporary nature of projects indicates that a project has a definite beginning and end."[12] The one thing that is supposed to be true of all projects is that they end. But when it came to digital humanities projects, it seemed like they were, in large part, being built with little consideration of who would need to maintain them in the future and where the resources to support that maintenance would come from. If these projects are in fact intended to operate as ongoing programs, they need to be reconceived and resourced as work that requires ongoing and direct programmatic support and resources.

Indeed, in the later part of the '00 decade, digital humanities practitioners began to delve more deeply into the question of when and if a digital humanities project is ever really "done." In the introduction to a special issue of *Digital Humanities Quarterly* on the topic, Matthew Kirschenbaum asked, "How do we *know* when we're done? What does it mean to 'finish' a piece of digital work?" Further, he asked "What is the measure of 'completeness' in a medium where the prevailing wisdom is to celebrate the incomplete, the open-ended, and the extensible?"[13] Indeed, as Anne Burdick, Johanna Drucker, Peter Lunenfeld, Todd Presner, and Jeffrey Schnapp would argue in the 2012 book *Digital_Humanities*, it was increasingly the case to think of "the project as [the] basic unit" of work in the digital humanities. In their terms, "a project is a kind of scholarship that requires design, management, negotiation, and collaboration. It is also scholarship that projects, in the sense of futurity, as something which is not yet."[14] Already in this defini-

12. Project Management Institute, *A Guide to the Project Management Body of Knowledge/ Project Management Institute*, 6th ed, PMBOK Guide (Newtown Square, PA: Project Management Institute, 2017), 5.

13. Matthew G. Kirschenbaum, "Done: Finishing Projects in the Digital Humanities," *Digital Humanities Quarterly* 003, no. 2 (June 18, 2009).

14. Anne Burdick, Johanna Drucker, Peter Lunenfeld, Todd Presner, and Jeffrey Schnapp, *Digital_Humanities*, (Cambridge: MIT Press, 2012), 124.

tion, we see a bit of a departure from the notion of projects as temporary to projects as something projecting indefinitely into the future. As they go on to explain, a project "is extensible in the double sense of allowing for seemingly unlimited scale and of being process- rather than product-based. When a book goes to print, it stabilizes in an edition that has to be reissued in order to be revised; a digital artifact can be altered." The lack of durability, the potential to continue to forever add to and extend digital projects, is exciting. However, in the long run, perpetual changeability becomes an expensive cost to carry. As the authors of *Digital_Humanities* stress, much of the work on digital humanities projects has been funded through external project-based grants, and those grants inevitably require those proposing the projects to put forward their sustainability plans. Making assertions about sustainability to win a grant, assertions that are really only evaluated before the funds are awarded and are not ever really checked up on as part of the close-out of a grant project, tend to be of limited value when it comes to what work is genuinely sustainable. As evaluation expert Michael Patton observes on grant funding, "Those receiving grants pretend that they have a viable strategy for sustaining funding. Those making the grants pretend to believe them."[15] Notably, in many cases, project sustainability plans are effectively plans to continue to seek bigger and better grants, which inevitably result in even bigger projects that come with larger ongoing costs for operations and maintenance.

Before digital projects, the prevailing practices around cultural-memory work produced outputs that were relatively durable or understood to be inherently temporary. An archive, once arranged and described, could be served up as part of the ongoing operations of a repository. If a set of materials was microfilmed, copies of the reels could be readily reproduced from negatives, and if stored in the right environmental conditions, those reels could be readable for as much as a thousand years. A scholar working on a critical edition or a team working to publish a set of personal papers would produce bound volumes printed on acid-free paper that could be stored, managed, and retrieved from a library collection for a century or more. The same is true for an exhibition catalog or other museum publications. While a specific physical museum exhibit would come and go, the scholarship and arguments made in that exhibition would become durable in the form of these publications. If a cultural-memory organization produced a

15. Michael Quinn Patton, *Blue Marble Evaluation: Premises and Principles* (New York: Guilford Press, 2020), 82.

documentary film, copies of that film on good film stock could be copied, distributed, and held as items in library collections in a stable state for long periods of time. In short, there was a clear demarcation on what represented the "done" state of various cultural-memory projects before digital media became central to them.

The net effect of a few decades of spinning up project after project on various software platforms, each of which requires patching, updating, migration, and maintenance, is a growing maintenance burden to those left with the responsibility to keep it all running. Those who end up inheriting portfolios of numerous groundbreaking projects find themselves reeling from the challenge of sorting through what to do with what are often rapidly degrading digital platforms. Many organizations are now, rightly, prioritizing a shift to more of a maintenance mindset for working with digital platforms and projects. The 2019 *Digital Humanities Quarterly* article, "Managing 100 Digital Humanities Projects: Digital Scholarship & Archiving in King's Digital Lab," distills the kind of hard-won wisdom that memory workers inheriting these sets of legacy projects and systems are developing in trying to rationalize and programmatize these inherited portfolios of projects. The team at King's College went through a major multiyear project to review the status of all the projects in their portfolio. In that process, they documented a wide range of sites running on outdated software platforms that had security vulnerabilities and needed either to be upgraded and migrated or archived and spun down. They also needed to identify all the stakeholders for any given project and establish agreements with them about the plan for resourcing and managing their projects. As a result, they developed an overall program that established how they would manage and sustain these and any future projects. This kind of work is essential, and requires thinking about what constitutes acceptable loss and or how to support graceful degradation of systems and resources.[16] If we are to continue to appreciate the flexibility and value that come from having a project-based approach to work in digital cultural-memory organizations, that work can only become maintainable and sustainable if core resources are invested in overarching programs to manage those projects in this kind of portfolio approach.

In good news, work like the King's College article exemplifies the ways that a maintenance mindset is becoming increasingly important when

16. Bethany Nowviskie, "Digital Humanities in the Anthropocene," *Bethany Nowviskie* (blog), July 10, 2014, https://nowviskie.org/2014/anthropocene/.

thinking about digital cultural-memory projects and initiatives. However, even within this turn to maintenance, aspects of caste systems between innovators and maintainers can persist. In a 2021 article, "Sustainability and Complexity: Knowledge and Authority in the Digital Humanities," Johanna Drucker set out to advance thinking about sustainability and maintenance in digital humanities initiatives.[17] While the article intended to further consideration of how to approach sustainability in digital humanities projects, it was read by many who work to maintain and manage digital projects in libraries, archives, museums, and digital humanities centers as a set of complaints about how the maintainer caste wasn't up to the challenge of sustaining the great innovative projects that Drucker had left behind over her time at the academic institutions that had previously employed her. Librarian Andromeda Yelton drew out a number of these issues in a blog post, "'Just a Few Files': Technical Labor, Academe, and Care."[18]

When she left the University of Virginia for UCLA, Drucker explained that the ArtistsBooksOnline project she had led was left in the care of staff at the University of Virginia. In her words, those left with the project at UVA "tired of care-taking, even though this involved little more than continuing to host the project files on a server." In reaction to that point, Yelton underscores that this kind of project would not require "just hosting some files on a server." A server needs upgrades and maintenance, the project's databases need management, files may need to be migrated to other formats, and all of that is very much real work that needs to be planned for and managed. Reflecting on her own experience, Yelton notes that she had at one point been part of a team of six who were, among other things, tasked with maintaining 243 of these "just a few files" sorts of projects for a university library. This underscores the value of the approach that Kings College took and modeled for their suite of digital projects. At the same time, those 243 "just a few files" projects underscore just how hard it is to really transition into a maintenance mindset for digital project work.

Drucker wrote her article out of a desire to draw attention to the importance of sustainability and maintenance work. Reflecting the level

17. Johanna Drucker, "Sustainability and Complexity: Knowledge and Authority in the Digital Humanities," *Digital Scholarship in the Humanities* 36, supplement 2 (October 1, 2021): ii86–94. https://doi.org/10.1093/llc/fqab025

18. Andromeda Yelton, "'Just a Few Files': Technical Labor, Academe, and Care," *Andromeda Yelton* (blog), December 3, 2021, https://andromedayelton.com/2021/12/03/just-a-few-files-technical-labor-academe-and-care/

of interest in the topic, the article had started its life as an invited conference keynote at the major digital humanities international conference. It is a big deal that the profile of discussion of maintenance is being raised like this in scholarly discourse. However, while maintenance in this context has come into vogue intellectually, her exploration of maintenance issues failed to resonate with those involved in doing actual maintenance work in cultural-memory institutions. It's possible to celebrate or muse about the importance of maintenance as an idea, while still fundamentally misreading the costs, nature, and extent of the work required to really run digital infrastructure programs to support maintainable work. For the maintenance mindset to be genuine, to be something beyond its own new fad in thinking for conference keynotes, it's essential that it not simply be an interesting topic of discussion, but something that is used to reshape what work is valued, credited, and recognized. A genuine shift to a maintenance mindset will require genuine transfers of authority, power, credit, and decision rights to maintainers.

I write this as someone who has both left institutions holding the bag for one-off projects I've made, and who has now spent years trying to untangle a wide range of legacy digital collections projects that others had left behind for me and my colleagues in my current work. In the former case, while at the Center for History and New Media I built out a class project called Playing History, which ran on an instance of Omeka that I spun up on CHNM's servers. I won an award for that class project, but I know that it now lives on in a zombie state, as one of perhaps over a hundred such projects that CHNM has been working to develop a portfolio-based approach to, as was outlined in the Kings College article. In my current context, my team has spent a meaningful portion of our time over the last five years trying to rationalize, modernize, and forward-migrate an array of what were very exciting, novel, and creative digital collections projects created in the '90s and early '00s into something that can be managed and sustained going forward.

In good news, as we work to transition the digital parts of our institutions toward a maintenance mindset, we can learn from parallel work happening in other technology sectors. The challenges with managing legacy software systems are not unique to cultural-memory work. Marianne Bellotti's observations in the book *Kill It with Fire: Manage Aging Computer Systems (and Future Proof Modern Ones)* are particularly useful in this context. The book focuses on "how to run legacy modernizations," which she notes

in the introduction is "a topic many software engineers regard as slow-moving career suicide, if not the prologue to a literal one."[19] The book distills hard-won wisdom from work on managing a wide range of modernization projects, the kind of work that is essential to ensure that legacy IT systems and projects continue to be usable. To Bellotti's point, this is not glamorous work, but it is essential. Indeed, much of her book focuses on the problems that come from not having a consistent maintenance mindset in working with systems.

Large organizations lose systems, literally forgetting they are running, and the more time goes by, the less likely it is that there is anyone around who might even know what that system is. Similarly, the longer maintenance is deferred, the more challenging and problematic it will be to modernize the system. Ultimately, she concludes the book by noting that "Future-proofing isn't about preventing mistakes; it's about knowing how to maintain and evolve technology gradually."[20] As she observes, "we get better at dealing with problems the more often we have to deal with them. The longer the gap between the maturity date of deteriorations, the more likely knowledge has been lost and critical functionality has been built without taking the inevitable into account."[21] All of this points toward both the inherent challenges and the essential need for work to shift into a maintenance mindset.

This becomes more critical as digital work in cultural-memory organizations continues to transition from being a discrete area of activity to becoming central to the operating infrastructure of nearly every aspect of an organization. At this point, for a major library, archive, or museum, the institution's web platforms are probably the primary method users use to interact with data about the institution's collections, and increasingly, digital surrogates of collection objects or the actual content of born-digital collection materials. Every aspect of collection management, from acquisitions, through processing, description, and access, is increasingly managed and mediated through software systems. Applications for jobs and fellowships; functions such as ticketing for events; the systems through which staff file their timesheets; the systems for receiving, processing, and approv-

19. Marianne Bellotti, *Kill It with Fire: Manage Aging Computer Systems (and Future-Proof Modern Ones)* (San Francisco: No Starch Press, 2021), xvii.

20. Marianne Bellotti, *Kill It with Fire: Manage Aging Computer Systems (and Future-Proof Modern Ones)* (San Francisco: No Starch Press, 2021), 195.

21. Marianne Bellotti, *Kill It with Fire: Manage Aging Computer Systems (and Future-Proof Modern Ones)* (San Francisco: No Starch Press, 2021), 204.

ing travel requests; the organization's records-management functions—all these activities are increasingly entangled with software systems that operate in their own software life cycles and dependencies. It's believed that these systems generate efficiencies that make it possible for work to be accomplished with less administrative staff, but in practice, the lack of user-centered design and the lack of investments in interfaces between these systems often create even more administrative work and burdens, which are often passed off to other stakeholders after the core staffing support for administrative staff has already been reallocated.

As this becomes the case, all the issues previously explored in relationship to digital humanities and similar projects become part of the portfolio-management problem of the IT infrastructure that is increasingly critical to the successful operation of a memory organization. That is, the sustainability of digital projects isn't just a problem for whatever the unit on the org chart has the word "digital" in its name. It's increasingly the case that problems of maintainability and sustainability of digital systems are central operational concerns to nearly all parts of the operations of memory organizations. To support and cultivate a maintenance mindset, it is increasingly important for us to embrace longer-term forms of thinking and planning. In this context, we would do well to learn from the notion of seventh-generation thinking that comes from the Haudenosaunee Confederacy.

Seventh-Generation Thinking

In the earlier chapter on data-driven decision making, a key tenet in books like *Measure What Matters*, is the insistence that the time frame for "what matters" is located entirely in the near term. That framework ends up being about driving growth at any cost, focused entirely on the next quarter of a year. When short-term growth is all that matters, everything about a maintenance mindset is irrelevant. Deferring maintenance beyond the next quarter is a perpetually reasonable and rational activity when your framework for thinking doesn't care about anything beyond this quarter. This way of thinking is directly at odds with sustainable, maintainable work.

For a fundamentally different perspective we can turn to one of the central enduring values of the Haudenosaunee Confederacy. As the Confederacy's website currently explains, "Among the nations of the Haudenosaunee is a core value called the Seventh Generation. While the Haudenosaunee encompass traditional values like sharing labor and maintaining a duty to their family, clan and nation and being thankful to nature and

the Creator for their sustenance, the Seventh Generation value takes into consideration those who are not yet born but who will inherit the world."[22] This seventh-generation principle illustrates what it means to take stewardship seriously: if we take the fundamentals of a maintenance mindset to the next level, we end up with something that resonates with seventh-generation thinking. Far beyond thinking about the next quarter, we can shift into a framework where we consider the weight of our decisions with a prospect on their potential impact 500 years out.

In *Braiding Sweetgrass: Indigenous Wisdom, Scientific Knowledge, and the Teachings of Plants*, Robin Wall Kimmerer, a distinguished professor of environmental biology and founder and director of the Center for Native Peoples and the Environment, explains the extent to which seventh-generation thinking resonates broadly across indigenous cultures in the notion of the honorable harvest. As she explains, "Collectively, the Indigenous canon of principles and practices that govern the exchange of life for life is known as the Honorable Harvest. They are rules of sorts that govern our taking, shape our relationships with the natural world, and rein in our tendency to consume—that the world might be as rich for the seventh generation as it is for our own." She notes that "The details are highly specific to different cultures and ecosystems but the fundamental principles are nearly universal among peoples who live close to the land."[23] When we zoom out from the engineering relationship between ourselves and systems that require maintenance, we start to bridge into a related context of what maintainable and sustainable relationships between ourselves and our ecosystems can look like.

The vision of braiding sweetgrass in Kimmerer's book is valuable for understanding how a maintenance mindset can be transformative, how it can move one from a scarcity mindset to an abundance mindset. She notes that a graduate student she was working with, Laurie, was interested in traditional practices around harvesting and managing sweetgrass. Laurie wanted to draw on indigenous knowledge and practices for harvesting the grasses, but Kimmerer's colleagues, with their ideas moored in more extractive ideas about agriculture, didn't believe that the practices she would explore from indigenous communities were particularly relevant. But Laurie persisted and studied the impact of an honorable harvest approach to cultivating sweetgrass. The results were dramatic.

22. Haudenosaunee Confederacy, "Values—Haudenosaunee Confederacy," accessed April 30, 2022. https://www.haudenosauneeconfederacy.com/values/

23. Robin Wall Kimmerer, *Braiding Sweetgrass: Indigenous Wisdom, Scientific Knowledge, and the Teachings of Plants* (Minneapolis: Milkweed Editions, 2020), 156–66.

With indigenous practices of cultivating and harvesting, the grasses flourished. When maintained through practices of the honorable harvest, the grasses grew better than if they were undisturbed. That is, instead of a zero-sum extractive game, the ecological network that approached the needs of plants and people together resulted in something more sustainable and maintainable.[24] The same kind of observations are evident in anthropologist Anna Tsing's research on matsutake mushroom cultivation in Japan.[25] Broadly, this underscores the fundamentally symbiotic relationships that emerge from the mentality of an honorable harvest, a topic we explore more extensively in discussions of care.

It is useful to explore the ways the seventh-generation principle has been deployed by memory workers to conceptualize the nature of memory work. In an article titled "Archaeology for the Seventh Generation" in *American Indian Quarterly*, archaeologists Sara L. Gonzalez, Darren Modzelewski, Lee M. Panich, and Tsim D. Schneider draw out how work to push back against colonialism in memory work in archeology can draw on seventh-generation thinking. In describing their work, they explain that "Collaboration was not a taken for granted process but rather a serious one that implicates future generations of archeologists and Kashaya people." They go on to explain that "Archaeology for the seventh generation, then, is concerned with not only the next seven generations of archeologists but also Indian people and their cultural heritage. It is an archaeology that seeks not just common ground but sustainability and longevity of cultural integrity and vitality." Here we can see how a maintenance mindset is not simply relevant to the maintenance of systems and functions, but much more broadly a central concern of the very function of memory work as a whole. Memory work itself is fundamentally concerned with the maintenance and continued usability of culture. To that end, while the maintenance mindset is broadly relevant to a wide range of fields, it should be fundamental to the very nature of memory work and memory institutions.

It's worth noting that pockets of long-term thinking have also emerged in the tech sector, which could be valuable to build connections with. For example, the Long Now Foundation in the Bay Area has worked to support a range of exploratory projects focused on thinking on a 10,000-year time scale about the future. With that noted, in many cases, when tech-sector

24. Robin Wall Kimmerer, *Braiding Sweetgrass: Indigenous Wisdom, Scientific Knowledge, and the Teachings of Plants* (Minneapolis: Milkweed Editions, 2020), 182.

25. Anna Lowenhaupt Tsing, *The Mushroom at the End of the World: On the Possibility of Life in Capitalist Ruins.* (Princeton: Princeton University Press, 2015).

thinkers tackle questions like this, there is a tendency to further double down on unsustainable and extractive modes of thought. That is, instead of focusing on hard and enduring problems related to ecological sustainability or justice, we get ideas about mining asteroids, geo-engineering the Earth with satellites, building bases on the moon, terraforming Mars, or looking toward some point when a computer-based AI singularity changes everything. We need to be suspicious of a lot of "futurist" modes of thinking that fall more into hucksterism, tech boosterism, and solutionism. At the core, if someone is pitching that the way out of the devastating impact of extractive and depletive late capitalism is even more extreme forms of extraction, we need to call out that mode of thinking.

Sustainable Thinking in Unsustainable Times

When we accept the importance of a maintenance mindset for practicing memory work, when we start to think ahead seven generations of memory workers and institutions, the only rational response is to be deeply concerned. The twentieth century brought with it something far more novel than the emergence of digital media. It brought the ability for humanity to radically alter our world to the point that it could become completely inhospitable to us. We have entered a new age, the Anthropocene. On astrobiologist David Grinspoon's terms, it's not entirely clear whether the Anthropocene will be an era, an epoch, or an event. Will we come to recognize the power of technology and science and become stewards of our fragile, pale blue dot? Or will we haphazardly continue along a collision course toward our own potential near extinction?[26] Only time will tell, but in general, the outlook does not look so good.

The use of "we" in this context, as well as the idea that it's all of "anthropos" that is responsible for the current age, is itself problematic. Arguably, a much more apt name for our era would be the Capitalocene, as the dramatic problems facing the Earth are not a result of the actions of all of humanity, but rather the direct result of the carbon-fueled growth of extractive capitalism.[27]

Anthropogenic global climate change is happening. The science is settled. In the next half century, we are going to see dramatic changes to our

26. David Grinspoon. *Earth in Human Hands: Shaping Our Planet's Future* (New York, Grand Central Publishing,) 2016.

27. Donna Haraway, "Anthropocene, Capitalocene, Plantationocene, Chthulucene: Making Kin," *Environmental Humanities* 6, no. 1 (2015): 159–65.

global environment, and the results of this will have sweeping impacts on all sectors of society, cultural heritage institutions included. For context, just in the United States, more than half of the major cities are less than ten feet above sea level. Many cultural heritage institutions may be literally under water in the next century.

Librarians, archivists, and museum professionals are responding to this issue proactively through initiatives such as Archivists Responding to Climate Change, and Keeping History above Water.[28] It's worth noting that, more than a decade ago, the National Parks Service issued guidance on scenario planning for historical sites, which is a useful tool for any cultural heritage institution to plan for continuing your mission in the face of a changing environment.[29] Throughout this work, it remains clear that we are likely to see more and more natural disasters around the world, which makes it all the more critical for cultural heritage institutions to develop plans to respond to disasters in their communities, and ideally how to lend a hand in disasters that occur elsewhere.[30]

In this context, it becomes increasingly important for cultural-heritage institutions to explore ways to become more environmentally sustainable. The revolving cast of ever-sleeker new computing gadgets in the privileged minority world is predicated on deeply problematic labor conditions in the majority world and the unsustainable exploitation of natural resources.

Beyond that, it's not just the problems of producing computing technologies, but also the problems of where they end up when they have been quickly discarded. E-waste is having detrimental effects on human health in the majority world, in countries like China and India. In this context, it is important for memory workers to commit to establishing green practices. In good news, recent scholarship is helping to better document the extent of carbon footprints for the full life cycle of resources required to

28. Archivists responding to climate change, "PROJECT_ARCC—Archivists Responding to Climate Change," *Project_arcc* (blog), June 7, 2015, https://projectarcc.org/about-us/. Newport Restoration Foundation, "ABOUT—History Above Water," 2016, https://history-abovewater.org/about/

29. Matthew Rose and Jonathan Star, "Using Scenarios to Explore Climate Change: A Handbook for Practitioners," *US National Park Service, Climate Change Response Program*, 2013, http://Www.Nps.Gov/Subjects/Climatechange/Resources Htm https://www.nps.gov/subjects/climatechange/upload/scenarioshandbook-july2013-508compliant-smaller.pdf

30. T. Mazurczyk, N. Piekielek, E. Tansey, and B. Goldman, "American Archives and Climate Change: Risks and Adaptation," *Climate Risk Management* 20 (January 2018): 111–25, https://doi.org/10.1016/j.crm.2018.03.005

support management of cultural-memory collections.[31] With that noted, there needs to be much more exhaustive explorations of the environmental costs of memory work. As we better understand the environmental impacts of cultural-memory institutions, we can make more informed decisions about stewarding memory in ways that are more sustainable. As we learn more about the environmental impacts of digital technologies, there will be more opportunities to connect with digital humanities efforts such as minimal computing that start from the premise that much can be learned about how humanities scholarship can support creating and using computing technology that requires fewer resources and less energy.[32]

It will not be possible to innovate or grow our way out of these problems. As Mike Berners-Lee explains in *There Is No Planet B*, the only way to bend the curve on carbon emissions to an extent necessary to keep life maintainable and sustainable is to begin a rapid transition to a situation where we leave the remaining oil in the ground.[33] In this context, struggles against the extraction of fossil fuels are literally struggles for the future persistence of life on Earth. They are struggles for the future of memory. That will only happen if we move beyond our cultural obsession with growth. Work to collectively support an alternative to the growth obsession in culture and society will be increasingly important. Economist Jason Hickel underscores that this will only be possible if we end up "shifting to a different kind of economy altogether—an economy that doesn't need growth in the first place." If we hope to persist as a culture capable of having a memory, we must "create an economy that is organized around human flourishing instead of around endless capital accumulation."[34] The idea that economies can and should grow in a "steady-state" rate of 3 percent is inherently unsustainable. That kind of compounding growth is cancerous. Invoking a backward glance from a memory worker in the future, economists Giorgos Kallis, Susan Paulson, Giacomo D'Alisa, and Federico Demaria argue that "to an archeologist in the future, this obsession with growth will seem as strange as Greeks worshiping twelve gods on a moun-

31. Keith L. Pendergrass, Walker Sampson, Tim Walsh, and Laura Alagna, "Toward Environmentally Sustainable Digital Preservation," *American Archivist* 82, no. 1 (March 2019): 165–206, https://doi.org/10.17723/0360-9081-82.1.165

32. Global Digital Humanities Working Group, "Minimal Computing," accessed April 2, 2017, http://go-dh.github.io/mincomp/

33. Mike Berners-Lee, *There Is No Planet B: A Handbook for the Make or Break Years*, revised edition (New York: Cambridge University Press, 2020), 58.

34. Jason Hickel, *Less Is More: How Degrowth Will Save the World* (London: William Heinemann, 2020).

tain top who masquerade as bulls to have sex and more deadly than the sacrifice of thousands of humans on Aztec pyramids."[35]

You might be questioning how and why we have zoomed out from discussion of what versions of software need to be upgraded to maintain a digital humanities project, to all the software that keeps a memory organization operating, and then out to questioning assumptions about growth at the heart of the global economic system. You might well question to what extent it's in bounds for me to be laying out a case about the inherent unsustainability of our social and economic system in a book about the future of cultural memory. In response, I would suggest that if we take seventh-generation thinking seriously, it becomes essential that memory workers start to advocate for a more maintainable and sustainable society. To do so is to advocate for a future for memory. An inclusive approach to memory work that also takes into consideration appropriate time horizons in generations both backward and forward draws into high relief how unsustainable the driving forces of contemporary societies are. If memory institutions and memory workers are to work as organs of memory in communities and societies, it is essential that we help our broader societies and communities understand the changes we must make to have a more just, sustainable, maintainable, and equitable future.

If we hope to carry forward the wisdom and knowledge of cultures, for them to even persist it is critical that we help those cultures adapt and evolve. To be clear, while there are often appeals for such memory workers as librarians and archivists to act as neutral figures in social or political concerns, it would be malpractice for memory workers to be neutral on issues that threaten the very core of the ability to maintain and carry forward memory, cultures, and societies. Memory work must push back against the death instinct and draw us all into deeper connection with the life instinct. In this regard, a maintenance mindset requires memory workers to organize their work and advance memory practices to support more durable and maintainable cultures. This point will become more pressing and clearer as it is further drawn out in the later chapters on care and repair.

My intention with this chapter was to draw out some context and background on what a maintenance mindset means and how it can and should become foundational to the function of memory work and institutions. To that end, I believe that the maintenance mindset outlined here

35. Giorgos Kallis, *The Case for Degrowth*, The Case for Series (Cambridge, UK; Polity Press, 2020), 27.

can become a core value for memory workers when we are confronted with the inherently illogical yearnings of disruptive innovation and metrics obsessions that focus narrowly on short-term goals for growth. Along with that, I believe that this maintenance mindset can be invaluable in helping us design jobs and workloads for memory workers that don't push them toward burnout. A memory institution built around a maintenance mindset would make sure that its staff has the slack they need to do their work and have time to think about how to make that work more maintainable and sustainable. Such an organization would be deliberate about planning to make sure that staff have the bandwidth they need to complete the projects that have been committed to, and it would eschew the inherently unsustainable nature of hope labor.

In this context, we can return to Mierle Laderman Ukeles's *Maintenance Art Manifesto* and observe how that work illustrates the kind of continual ripple that work in art and cultural memory can play in changing both our organizations and our impact on society. Ukeles's work draws our attention to questions and issues of maintenance and care. Notably, her manifesto was itself a proposal for a gallery exhibition in a memory institution. In this context, exhibitions, and the stories and narratives that cultural-memory institutions platform, are themselves vital in enabling and communicating a maintenance mindset. Beyond that, as her work has been echoed and carried forward through support and care from museums and through publications, her story continues to find resonance and audiences. The seventh-generation thinking of the Haudenosaunee Confederacy is a story of the strength and potential of cultural-memory functions to support more of a maintenance mindset in culture. Despite centuries of settler colonialism, racist and genocidal policy against indigenous peoples of the Americas their cultural memory and traditions persist. This is more than mere resistance and existence. Indigenous ways of thinking about memory are also powerful as the standard-bearers for resistance to the death instinct and support for the life instinct. Indigenous communities are teaching the world about what it means to stand up for life, a topic that will be central to issues raised in the next two chapters. Memory workers and memory institutions can and must build common cause with this life instinct and weave it into every aspect of the way we work and the stories and memories we feature and platform.

CHAPTER 6

Concentric Circles of Care

At the start of the COVID-19 pandemic, libraries, archives, and museums across the United States closed their doors to the public. Libraries and archives mostly shifted to remote work and/or providing contactless services. In contrast, museums engaged in an unprecedented mass layoff of museum workers. In many cases, museums with massive endowments, which pay their executives six- and seven-figure salaries, rapidly laid off their lowest-paid workers. As explained in the report "Cultural Institutions Cashed In, Workers Got Sold Out," 228 large museum institutions in the US reduced their workforces by more than 14,000 employees, or 28 percent.[1] Of the 69 museums for which financial data was available, all ended the year with operating surpluses. By and large, museums had the money to pay their staff, who could have done any number of things to advance their organizations' missions during the pandemic.[2] But museums, it seemed, just didn't really care that much about supporting their lowest-paid staff in a time of crisis.

COVID-19 is an ongoing global crisis of care. I write this at a time when many are acting like that this crisis is over, and that is itself part of the crisis. The virus continues to mutate and infect people around the globe. Many affected by long COVID face huge, long-term care needs. With that noted, we can already look back on how the early phases of the pandemic played out to explore and understand the extent to which our societies

1. AFSCME Cultural Workers United, "Cultural Institutions Cashed In, Workers Got Sold Out," AFSCME CWU, October 2021, https://report.culturalworkersunited.org/
2. AFSCME Cultural Workers United, "Cultural Institutions Cashed In, Workers Got Sold Out," AFSCME CWU, October 2021, https://report.culturalworkersunited.org/

and institutions met the challenge of care the pandemic presented. A sober evaluation of the results is not promising. In the case of those museum institutions, they abandoned their most precarious staff in a time of crisis, when many still had plenty of money that could have gone to support staff in a time of need. Furthermore, if we believe that there is important value in the services of organizations like museums, those staff could have provided valuable online programs and events for their user communities while people were in lockdown seeking learning opportunities.

Despite receiving substantial funding through the CARES Act, which eponymously put the name "care" in all caps, it seemed to many working in museums that these institutions just did not care for their workers. How would that have turned out differently if the museum executives and trustees on their boards had thought that a cornerstone of their work and goals was to enable more caring relations in the world? How differently would the pandemic have played out if the museum leaders' highest priority was to care for the staff, who in turn care for their collections and for the communities they serve? This question of prioritization and the centrality of care in the work of cultural memory is the central question of this chapter.

Historically, in library, archives, and museum literature, the topic of care has been discussed primarily in terms of "collections care." Broadly, collections-care literature is the body of scholarship and work on how best to ensure long-term access to and use of materials in cultural-heritage collections. The 1991 Museums Charter published by the UK-based Museums Association stresses that "caring for collections" is a central concern of their function, and specifically, that "Museums should care for their collections to a high standard and should have policies for their management and development."[3] Similarly, the core values statement of the Society of American Archivists (SAA) has long included mention of the role that archivists and archives play in caring for records.[4] Notably, when the SAA revised their values statement in 2020, it was updated to note that archivists "should root their work in an ethic of care."[5] Indeed, work on the impor-

3. Museums Association, "The Museums Charter," in *Museum Provision and Professionalism*, edited by Gaynor Kavanagh, Leicester Readers in Museum Studies (New York: Routledge, 1994).

4. Society of American Archivists, "SAA Core Values Statement and Code of Ethics," 2011, https://www2.archivists.org/statements/saa-core-values-statement-and-code-of-ethics

5. Committee on Ethics and Professional Conduct, "Recommended Revisions to SAA Core Values Statement and Code of Ethics," Society of American Archivists, August 3, 2020, https://www2.archivists.org/sites/all/files/0820-IV-A-CEPC-CodeRevisions_0.pdf

tance of a feminist ethics of care in archives is receiving increased attention in archival scholarship.[6] In drawing the notion of an "ethic of care" into the core values of archivists, the SAA values now connect the practice of cultural-memory work into a broader dialog with work in feminist theory advancing the concept.

This chapter is about exploring the implications of centering care as a core value of memory work. This reorientation of our work requires us to trace and map concentric circles out from the objects of memory in collections into various people's lives. We need to consider how institutions of memory enable relations of care between the people they employ, the peoples documented in their collections, the communities they serve, and their broader memory function in societies. Beyond that, as anthropogenic climate change increasingly affects our ability to care for, and be cared for by, the whole Earth system, it becomes critical to see that whole system as the broadest of those circles of care that memory work participates in. As an ethic of care becomes one of the guiding values of cultural-memory work, memory workers must engage with decades of feminist scholarship on the concept. Much of that scholarship operates in direct opposition to many of the default assumptions that organizations operate on as outlined in the first half of this book.

Individualism and the ideal of individual responsibility are central to contemporary thinking about people and organizations in the United States and other colonial countries. Stories about "disruptive innovation" prominently feature singular individuals like Steve Jobs as change makers. When people do or don't succeed in developing their career, under the logic of "do what you love" explored earlier, it is on them to review what more they could have done to succeed in a competitive marketplace. This social Darwinist story about hypothetical independent, rational actors engaging in competition is so central to contemporary ways of thinking in the United States that it is difficult to step outside of it and see it for what it is. It's a fiction, not a fact, and that fiction is increasingly useless in describing or explaining the realities of the world we operate in. Individualism isn't just a fiction, it's increasingly clear from a range of perspectives that it's a misleading and pernicious one. The reality of our lives and our worlds is one of interdependence, and interdependence is increasingly best understood through the framework of relations of care.

6. Michelle Caswell and Marika Cifor, "Revisiting a Feminist Ethics of Care in Archives: An Introductory Note," *Journal of Critical Library and Information Studies* 3 (June 11, 2021), https://journals.litwinbooks.com/index.php/jclis/article/view/162

This chapter explores some key concepts necessary to understand how and why the individualism of innovation discourse fails to explain the realities of a world better understood by mapping relationships of the interdependence of care. In good news, in parallel with the development of innovation rhetoric, feminist scholarship has developed and advanced an ethics and politics better attuned to the realities of the world we find ourselves in—the politics and ethics of care.

At its heart, a politics of care transposes the interdependence that exists in our individual relationships with each other as a basis for reimagining social, political, and institutional structures and systems. Much of the language of innovation draws on social Darwinist survival-of-the-fittest metaphors. Those competition-based metaphors are proving less and less useful in explaining natural history and the natural world. We have an opportunity to learn from what is replacing those survival-of-the-fittest stories. Ecosystems and evolution are now increasingly understood not primarily in terms of struggle and dominance, but in terms of symbiosis, and sympoiesis (making with). Processes of both intra- and interspecies collaboration and cooperation offer models to draw from for enacting this politics of care. They also offer more robust models for thinking about the relationship between peoples, cultures, and the natural world.

Care is valuable in helping us reinvent the very language of adaptation and change. Discussions of maintenance still largely summon images of masculine notions of construction, engineering, and the built environment. In contrast, notions of care draw attention to personal interdependencies and offer up metaphors such as "gardening," which suggest ways to think about cocreation and ecological systems perspectives. Indeed, as we increasingly move into a world that exists "after nature," it's essential that we transition away from metaphors that position "makers" in contrast to "materials."[7] That is, the effects and impact of human societies and technology on the natural world are so significant that it is increasingly untenable to believe in a separation of the engineered worlds of towns and cities and notionally pristine set-apart natural places. The whole of the biosphere is an increasingly interconnected set of systems. When we start from care, we set fundamentally different kinds of goals for fundamentally different kinds of results. If we succeed in this endeavor, when the next pandemic comes, or when this one reasserts itself, we can again

7. Jedediah Purdy, *After Nature: A Politics for the Anthropocene* (Cambridge, MA: Harvard University Press, 2015).

evaluate our institutions by the extent to which they facilitate, provide, and sustain care. Experience with COVID-19 suggests that there is a lot of room for improvement.

A Feminist Ethic of Care and Interdependence

Over the last four decades feminist scholars developed and advanced the ethics and politics of care as a framework for rethinking much of the basis of moral and political philosophy. I can't do this entire body of work justice in this chapter, but I will try to elucidate what making care central to memory work might entail. My hope is to open the door to this growing body of work and encourage cultural-memory workers to use it as a jumping-off point to further engage with this work and center it in library, archives, and museum scholarship going forward.

In 1984, educational philosopher Nel Noddings published *Caring: A Feminine Approach to Ethics and Moral Education*, asserting that to work from an ethic of care is to "always act so as to establish, maintain, or enhance caring relations" and "to meet the other as one-caring."[8] This involves striving to advance the ends of others on their terms. Central to this concept is that care can only function and operate relationally. One cares for another. One is cared for by another. In 1990, Bernice Fischer and Joan Tronto argued that care should be understood as "a species of activity that includes everything that we do to maintain, continue, and repair our 'world' so that we can live in it as well as possible."[9] Their framing of care illustrates how quickly notions of maintenance and repair become entangled in notions of care. They identify four steps in the processes of care: (1) caring about, where a person or group identifies an unmet need for care; (2) caring for, in which a person or group takes responsibility to ensure those needs are met; (3) caregiving, in which the actual work to provide care is done; and (4) care receiving, in which the response from the one cared for is observed and acknowledged. Subsequently, they identified "caring-with" as a fifth phase of care that "requires that caring needs and the ways in which they are met need to be consistent with democratic commitments to justice, equity, and

8. Nel Noddings, *Caring: A Feminine Approach to Ethics & Moral Education*, 2nd ed. (Berkeley: University of California Press, 2003), 17.

9. Joan Tronto and Bernice Fischer, "Toward a Feminist Theory of Caring," in *Circles of Care: Work and Identity in Women's Lives*, edited by Emily K. Abel and Margaret K. Nelson. SUNY Series on Women and Work (Albany: State University of New York Press, 1990).

freedom for all."[10] Collectively, this framework is useful for identifying distinctions between intentions or observations of needs for care apart from taking responsibility to provide the care, and ultimately following through and ensuring that care work is provided and received on the terms needed. All those aspects are necessary for effective and just caring relations.

Care, as a feminist framework, has become transformational for rethinking our relationships to each other and to institutions. In *The Ethics of Care: Personal, Political, and Global*, Virginia Held stresses that "the focus of the ethics of care is on the compelling moral salience of attending to the needs of the particular others for whom we take responsibility."[11] In Tronto's terms, "the world consists not of individuals who are the starting point for intellectual reflection, but of humans who are always in relations with others. To make sense of human life requires a relational perspective."[12] All people and institutions find themselves enmeshed in webs of interdependent relationships, and as such a relational perspective is necessary for mapping and understanding individual parts of those wholes.

On some level, it is widely understood that every person depends on others. We are born incapable of taking care of ourselves. We grow old and depend on care from others. But in the middle, at some points, many people imagine themselves to be genuinely independent. Those who imagine themselves to be independent by and large are not. Almost no one lives a kind of Robinson Crusoe existence. We persist in this belief largely by using the market to change how we frame care relationships. Think of all the services and dependencies that enable us to live our lives—the work of cooking meals, collecting the trash, maintaining the sewer system, providing childcare and elder care, providing medical care, ensuring access to running water and electricity, and so on. All of it is based on networks of need and dependency. Recognizing this, both psychological and economic theory are similarly shifting to a more interdependent ecological model.[13] At every level, people, organizations, and nations are not islands. All come into the world from the start entangled in relations of care.

10. Joan C. Tronto, *Caring Democracy: Markets, Equality, and Justice* (New York: New York University Press, 2013), 23.

11. Virginia Held, *The Ethics of Care: Personal, Political, and Global* (Oxford: Oxford University Press, 2006), 10.

12. Joan C. Tronto, *Caring Democracy: Markets, Equality, and Justice*. (New York: New York University Press, 2013), 36.

13. For examples see Hutchins, Edwin, *Cognition in the Wild* (Cambridge, MA: MIT Press, 1995); Andy Clark, *Supersizing the Mind: Embodiment, Action, and Cognitive Extension* (Oxford: Oxford University Press, 2008).

A feminist ethic of care has a different starting point than the independent, rational-actor, Adam Smith story. As Tronto explains in the 2013 book *Caring Democracy: Markets, Equality, and Justice*, at first "individuals are conceived of as being in relationships"; "it makes little sense to think of individuals as if they were Robinson Crusoe, all alone making decisions." By contrast, we understand that "all individuals constantly work in, through, or away from relationships with others, who in turn, are in different states of providing or needing care from them." A second principle is "all humans are vulnerable and fragile." While we are vulnerable over time, in particular when we are very young, elderly, or ill, "people are constantly vulnerable to changes in their bodily conditions that may require they rely on others for care and support." A third principle is "all humans are at once both recipients and givers of care." While many might think of care as being something that only some people need, in fact all people "receive care from others, and from themselves, every day."[14]

If we take these principles as foundational, then it is no longer possible to think of ourselves as autonomous rational actors. This has significant implications for how social institutions should function. Based on these principles, Tronto prompts those working with institutions to begin their work by "thinking about how people's interdependence can best be organized through caring institutions that take everyone's equal capacity both for care and for freedom."[15] For Tronto, this is a basis for rethinking our societies. In her words, "democratic politics should center upon assigning responsibilities for care, and for ensuring that democratic citizens are as capable as possible of participating in this assignment of responsibilities."[16]

How would your assessment of any cultural heritage organization change if you were to start that assessment from questions of care and caring responsibilities? If you undertook a care audit of each cultural-memory organization, starting by exploring the extent to which they were or weren't focusing their time, energy, and resources on enabling and supporting caring relations between people and the broader natural world, what would the results be? My hunch is that the results for most organizations would not look great. That said, I think we are in the early days of really unpack-

14. Joan C. Tronto, *Caring Democracy: Markets, Equality, and Justice* (New York: New York University Press, 2013), 30.
15. Joan C. Tronto, *Caring Democracy: Markets, Equality, and Justice* (New York: New York University Press, 2013), 45.
16. Joan C. Tronto, *Caring Democracy: Markets, Equality, and Justice* (New York: New York University Press, 2013), 30.

ing what a shift like this would entail, but it is already clear that mapping the concentric circles of care that memory institutions participate in will be a key place to start.

Centering Disability Justice in Care Work

The imperative "nothing about us without us" has been a key concept from the disability justice movement. It is also of broad relevance to understanding the nature of doing care work well.[17] Work in disability justice is a particularly critical context in which the theory and practice of care has been developed and advanced. In *Care Work: Dreaming of Disability Justice*, Leah Lakshmi Piepzna-Samarasinha positions experiments around creating and sustaining collective access communities as critical work toward creating better futures. She asks us, "What does it mean to shift our ideas of access and care (whether it's disability, childcare, economic access, or many more) from an individual chore, an unfortunate cost of having an unfortunate body, to a collective responsibility that's maybe even deeply joyful?"[18] This work is anchored in the value of "Solidarity not charity—of showing up for each other in mutual aid and respect."[19] All too often, the assumption of any kind of social or cultural service is anchored in notions of charity, which come with their own deeply embedded paternalism. When we start from the realization that all of us need care and that the provision of care to all is a central concern of our societies, we can get to fundamentally different positions on how we support and sustain that care.

Care is also entangled with basic notions in health and medicine about dichotomies between sickness and wellness. As Piepzna-Samarasinha notes, "Mainstream ideas of 'healing' deeply believe in ableist ideas that you're either sick or well, fixed or broken, and that nobody would want to be in a disabled or sick bodymind."[20] When we appreciate the extent to which all of us require and depend on care from each other, we can also appreciate the extent to which dichotomies between sick and well, able and disabled,

17. David. Werner, *Nothing About Us Without Us: Developing Innovative Technologies For, By, and With Disabled Persons* (Palo Alto, CA: Healthwrights, 1998).

18. Leah Lakshmi Piepzna-Samarasinha, *Care Work: Dreaming Disability Justice* (Vancouver: Arsenal Pulp Press, 2018), 33.

19. Leah Lakshmi Piepzna-Samarasinha, *Care Work: Dreaming Disability Justice* (Vancouver: Arsenal Pulp Press, 2018), 44.

20. Leah Lakshmi Piepzna-Samarasinha, *Care Work: Dreaming Disability Justice* (Vancouver: Arsenal Pulp Press, 2018), 103.

and fixed and broken are all major oversimplifications of the realities of our entangled existences. As more and more of personality and neurodiversity has been medicalized as disorders, we are left with narrower and narrower notions of what constitutes "normal." Significantly, much of the function and practice of psychology itself has become an instrument for diagnosing and medicating anxieties and stresses as problems of individuals instead of recognizing and working to address how precarity, social insecurity, and overwork are the actual sources of problems.[21] When the burdens and dysfunction of our societies are diagnosed as the personal failings of individuals, our social system will declare more and more of us to be unwell.

Where do we find expertise relevant to these concerns of ability/disability and care? What Piepzna-Samarasinha calls "crip skills" or "crip science" is of key importance for rounding out our notions of care. She observes that "sick and disabled folks have many superpowers: one of them is that many of us have sophisticated, highly developed skills around negotiating and organizing care."[22] This line of thinking leads to "a radical disability justice stance that turns the ableist world on its ear, to instead work from a place where disabled folks are the experts on our own bodies and lives, and we get to consent, or not."[23] Here we return to earlier considerations of the importance of standpoint epistemology. Work in disability justice anchored in the lived experiences of people with various disabilities is important not simply as perspectives of "users" of various services, but because various crip communities have significant experience and expertise in both providing and receiving good care. This is not about charity; it is about deferring to the experts, those living and experiencing their reality. Furthermore, when we genuinely embrace the notion that care is tied up in interdependence, the idea of "users" starts to break down in general. There aren't "providers" and "users," but instead an entanglement of relationships and responsibilities that are a part of enabling and sustaining caring relations.

All too often, institutions that work to provide care start from a deficit model of understanding people dependent on care, but in fact, individuals in the crip communities are some of the world's best experts on the

21. William Davies, *The Happiness Industry: How the Government and Big Business Sold Us Well-Being* (London: Verso, 2015).
22. Leah Lakshmi Piepzna-Samarasinha, *Care Work: Dreaming Disability Justice* (Vancouver: Arsenal Pulp Press, 2018), 144.
23. Leah Lakshmi Piepzna-Samarasinha, *Care Work: Dreaming Disability Justice* (Vancouver: Arsenal Pulp Press, 2018), 145.

nature and functions of care. In this context, a guiding principle of the Allied Media Conference's Healing Justice Practice Space is relevant. They start their work by "Centering the genius and leadership of disabled and chronically ill communities, for what we know about surviving and resisting the medical industrial complex and living with fierce beauty in our sick and disabled bodies" and noting the critical importance of "working from a place of belief in the wholeness of disability, interdependence and disabled people as inherently good as we are."[24] Instead of starting from a deficit mindset in imagining services needed by the disabled, it is possible for the whole cultural-memory community to turn to crip communities as the nexus of expertise on what centering caring relations in our work and our institutions would entail. That recognition needs to come with resources, too. It's not enough to acknowledge that expertise, it's also essential to provide resources to support legitimate engagement with those experts.

Expanding Circles of Care

For many, the idea of care seems like something personal, something that exists outside the market-based relationships that tend to define things like the jobs and economic functions of consumerism. Work on an ethic of care rejects this notion. In large part, through the functions of patriarchy, the work of care has been discounted and undervalued as work that women are socialized to believe is their sole responsibility and duty. An ethic of care requires us to center, respect, and account for all the activities and work required to provide and sustain care, and this also requires an active struggle against the functions of patriarchy in societies. When we take the broad view of care and the central role that interdependence plays in our lives, it becomes possible to map webs or circles of interdependence and care. Interdependence through care becomes the basis for thinking through our obligations to each other.

In the terms of *Care Manifesto: The Politics of Interdependence*, Chatzidakis et al. make the case for how we extend more local notions of care to become the basis for understanding and organizing our institutions. In their words, "Only by multiplying our circles of care—in the first instance, by expanding our notion of kinship—will we achieve the psychic infrastructures necessary to build a caring society that has universal care as its

24. Bad Ass Visionary Healers, "Healing Justice Principles: Some of What We Believe," October 19, 2012, https://badassvisionaryhealers.wordpress.com/healing-justice-principles/

ideal."[25] Anchored in this perspective, they suggest the need to consider and map how caring relations extend from kinship networks, to local communities, out to the formation and function of states, into economies and ultimately to a broad framework for thinking about the entire relationship between humanity, animals, and our environment. Significant to our situation, each of those levels also sustains cultural-memory institutions, from family historian networks, out to community groups in a local library or historical society, through to a wide range of groups such as community archives. As noted in the beginning, a key care component of those circles is the kind of belonging that people find when they see themselves as part of the memory traditions of their communities. Of key relevance to the work of memory institutions, the *Care Manifesto* specifically draws attention to the community level—"we need localized environments in which we can flourish; in which we can support each other and generate networks of belonging."[26] As they note, "local libraries remain one of the most powerful examples of non-commodified local space and resource-sharing. They enable us to read widely, and can also work as community hubs, providing internet access and meeting space for people to learn and connect."[27] Memory institutions in this context can be evaluated by the extent to which they provide localized environments where we can flourish, based on the extent to which they support and sustain networks of belonging. The same is true of our relationships with state, national, and international institutions of memory. That kind of zooming in from global to local is useful, but it is also critical to explore other relationships that are essential to flows of caregiving and care receiving around cultural-memory work.

Responsibilities of care also encompass the full life cycle of objects and materials that come into cultural-memory institutions. As Michele Caswell and Marika Cifor have argued, for memory workers such as archivists, to genuinely transition to anchor their work in an ethic of care, it is essential to start to see them "not only as guardians of the authenticity of the records in their collections, but also as centerpieces in an ever-changing web of responsibility through which they are connected to the records' creators, the records' subjects, the records' users, and larger communities." In this

25. Andreas Chatzidakis, Jamie Hakim, Jo Littler, Catherine Rottenberg, and Lynne Segal, *The Care Manifesto: The Politics of Interdependence* (London: Verso Books, 2020), 33.
26. Andreas Chatzidakis, Jamie Hakim, Jo Littler, Catherine Rottenberg, and Lynne Segal, *The Care Manifesto: The Politics of Interdependence* (London: Verso Books, 2020), 45.
27. Andreas Chatzidakis, Jamie Hakim, Jo Littler, Catherine Rottenberg, and Lynne Segal, *The Care Manifesto: The Politics of Interdependence* (London: Verso Books, 2020), 52.

way, we start to see archivists and other memory workers "more as caregivers, bound to records creators, subjects, users, and communities through a web of mutual responsibility."[28] This kind of thinking represents a marked departure from thoughts about care that center collections to models that center the people and communities represented in those collections.

In *Information Maintenance as a Practice of Care*, a collective of librarians, archivists, humanities scholars, and others drew out a key set of points for considering the function of care in information work.[29] They specifically argue that work with information needs to be active in cultures of empathy. It needs to be collective, involving interconnection between those providing and receiving care. It needs to be organized and sustained through the design and function of institutions. It needs to be scalable, working out from direct circles of care to broader networks, and it is inherently interdisciplinary and inherently intergenerational.

When we take seriously the call for centering care in cultural-memory work, we start from an understanding like what McCracken and Hogan advocate for in their work on residential school archives. As they argue, "Archivists have a responsibility to the people documented in the records they care for, and this includes an obligation to Indigenous and colonial people documented by nation-states."[30] The obligations of care radiate out in every direction from memory organizations, from the communities documented in collections, to the staff working with them, to their users.

Care and Servant Leadership

I realize that the set of ideas I'm drawing out here, related to reorienting work and organizations to be anchored in caring relations, is rather radical. On some level they are radical, but at the same time, currents of thought already exist in organizational thinking and business scholarship that center aspects of care, although they have not been genuinely engaged with or widely adopted. It is worth returning to some fundamental questions about the nature and purpose of organizations. There is a body of business and

28. Michelle Caswell and Marika Cifor, "From Human Rights to Feminist Ethics: Radical Empathy in the Archives," *Archivaria* (May 6, 2016): 23–43.

29. D. Olson, J. Meyerson, M. A. Parsons, J. Castro, M. Lassere, et al., "Information Maintenance as a Practice of Care," June 17, 2019, https://doi.org/10.5281/zenodo.3251131

30. Krista McCracken and Skylee-Storm Hogan, "Residential School Community Archives: Spaces of Trauma and Community Healing," *Journal of Critical Library and Information Studies* 3, no. 2 (2021), https://doi.org/10.24242/jclis.v3i2.115, 25.

management scholarship that can help us map the circles of care that need to exist inside an organization.

Why do organizations exist? The default answer for publicly traded companies is often something like "to maximize shareholder value." For memory organizations, one can often look to a mission statement or a statement in its founding nonprofit paperwork. For example, the Smithsonian Institution asserts its purpose is to "increase and diffusion of knowledge."[31] Harvard Library's purpose is to "champion curiosity for the betterment of the world."[32] The U.S. National Archives mission is to "drive openness, cultivate public participation, and strengthen our nation's democracy through public access to high-value government records."[33] Across these contexts, the default assumption tends to be that all of these organizations exist to first and foremost serve a purpose for their patrons, users, or clients. Robert Greenleaf offered a fundamentally different approach to how we should answer this kind of question. One might think that ideas about organizations and management have become more people-centered and progressive over time, but Greenleaf's work on servant leadership from the 1970s illustrates how, in large part, the opposite is the case. Born in 1904, Greenleaf played a key role in shaping work at one of the world's largest organizations. He started his thirty-eight-year career at AT&T in 1926, in a period when it was the largest information organization in the world. He eventually became the director of management development. After leaving AT&T in 1964, he went on to publish on the idea of servant leadership, first in an essay in 1970 and in a full-length book in 1977. His ideas in this work are an interesting mixture of both an old-school mindset about work and radical ideas percolating in the '60s and '70s. His ideas offer a context to draw out the role that care can and should play in articulating the purposes of all kinds of organizations.

For Greenleaf, the heart of a servant leadership approach is that "The servant-leader is servant first." Central to this idea is a notion of care—specifically that "the care taken by the servant-first to make sure that other people's highest priority needs are being served." In this regard, he notes that "the best test" of whether a leader or organization is doing well is to

31. Smithsonian Institution, "Purpose and Vision," Smithsonian Institution, accessed May 9, 2022, https://www.si.edu/about/mission

32. Harvard Library, "About Harvard Library," Harvard Library, accessed May 9, 2022, https://library.harvard.edu/visit-about/about-harvard-library

33. National Archives, "Mission, Vision and Values." National Archives, August 15, 2016, https://www.archives.gov/about/info/mission

answer the questions, "Do those served grow as persons? Do they, while being served, become healthier, wiser, freer, more autonomous, more likely themselves to become servants? *And*, what is the effect on the least privileged in society; will they benefit, or at least, not be further deprived?"[34] Of critical importance, the main constituency he was concerned with was not only the users of the products or services an organization provides, but also how an organization cares for and supports its employees.

His view from the 1970s is itself a powerful corrective to any notions that we have developed a more enlightened or advanced set of ideas about the role and function of work in society. In 1977, he argued that "We are well on the way to accepting that the world owes every person a living. The next step may be to acknowledge that every person is entitled to work that is meaningful in individual terms, and that it is the obligation of employers in toto, to provide it."[35] The world we find ourselves in is far from that vision.

For Greenleaf, the value of an organization is always bidirectional and relational. In his words, "The business exists as much to provide meaningful work to the person as it exists to provide a product or a service to a customer."[36] Within the servant leadership framework, any manager in an organization practicing servant leadership, asked what business they are in, should respond, "I am in the business of growing people—people who are stronger, healthier, more autonomous, more self-reliant, more competent. Incidentally, we also make and sell at a profit, things that people want to buy so we can pay for all of this."[37]

This is all to say that the idea that care for people can and should be a central purpose of an organization and institutions is not particularly novel. Central to Greenleaf's ideas on servant leadership is the notion that "Caring for persons, the more able and the less able serving each other, is the rock upon which a good society is built."[38] In short, there is work in organizational theory, such as servant leadership, which we can draw on

34. Robert K. Greenleaf, *Servant Leadership: A Journey into the Nature of Legitimate Power and Greatness* (New York: Paulist Press, 1977), 14.
35. Robert K. Greenleaf, *Servant Leadership: A Journey into the Nature of Legitimate Power and Greatness* (New York: Paulist Press, 1977), 146.
36. Robert K. Greenleaf, *Servant Leadership: A Journey into the Nature of Legitimate Power and Greatness* (New York: Paulist Press, 1977), 142.
37. Robert K. Greenleaf, *Servant Leadership: A Journey into the Nature of Legitimate Power and Greatness* (New York: Paulist Press, 1977), 147.
38. Robert K. Greenleaf, *Servant Leadership: A Journey into the Nature of Legitimate Power and Greatness* (New York: Paulist Press, 1977), 49.

and return to for better centering care in how we think about work and organizations.

From Survival of the Fittest to Symbiosis, Sympoiesis, and Making Kin

Both the lowest and the broadest levels of circles of care are at their root biological and ecological. The organelles in our cells are part of circles of care; so are entire food webs in ecosystems, and ultimately entire global cycles throughout the biosphere. Attending to and understanding caring relations in these systems and processes helps to fully map the circles of care that memory institutions participate in. Notions of rugged individualism and competition that are at the core of the bankrupt ideas explored in the first half of this book are anchored in out-of-date ideas of social Darwinism that present competition and survival of the fittest as seemingly natural explanations for how our social worlds work. Significantly, in parallel to the development of the ethic of care in philosophy, work in ecology and biology has changed how scientists understand cooperation and collaboration in the natural world. This is important in that biology and ecology are where many of our metaphors for describing growth, change, and development come from. To that end, it is useful to go back to ecology and biology to update the source of our metaphors. It's also critical that our entanglements and obligations of care extend beyond relations between people to also include relations between animals, plants, and the entirety of our world.[39] Our networks of interdependence aren't limited to people, but to these whole sets of interconnected ecosystems. The broadest of the concentric circles of care we all participate in is at the whole-biosphere level, so it's important that we understand how our institutions do and do not support caring relations with all living things that make up the biosphere.

Biologist Lynn Margulis's work is a key starting point for resetting our baseline understanding of metaphors for life and nature. From Margulis's work, and the work of others developing this line of thinking, we now understand that in shaping the development of life on Earth, symbiosis has been as powerful as competition, or even more powerful. In *Symbiotic Planet: A New Look at Evolution*, Margulis explains, "All organisms large enough for us to see are composed of once-independent microbes, teamed up to become larger wholes. As they merged, many lost what we in retro-

39. María Puig de la Bellacasa, *Matters of Care: Speculative Ethics in More than Human Worlds* (Minneapolis: University of Minnesota Press, 2017).

spect recognize as their former individuality."[40] Margulis argues that "most evolutionary novelty arose, and still arises, directly from symbiosis."[41] Even our own idea of bodily integrity is a fiction. As Margulis argues, each individual person is "a kind of baroque edifice" that is "rebuilt every two decades or so by fused and mutating symbiotic bacteria." For Margulis, this prompts a reminder of our humility—"Our strong sense of difference from any other life form, our sense of species superiority, is a delusion of grandeur."[42] At whatever level we look—at cells, organs, bodies, families, neighborhoods, watersheds, cities, states, biospheres, nations, and the whole planet—we find the same recurring patterns of interdependence.

The implications of these biological facts underscore the shift in thinking necessary to grapple with relationality and interdependence as the basis for understanding our world. In *Staying with the Trouble: Making Kin in the Chthulucene*, Donna Haraway unpacks the implications of this way of understanding life on Earth. As she explains, "Neither biology nor philosophy any longer supports the notion of independent organisms in environments."[43]

In *Braiding Sweetgrass: Indigenous Wisdom, Scientific Knowledge and the Teachings of Plants*, Robin Wall Kimmerer looks toward a future "when the intellectual monoculture of science will be replaced with a polyculture of complementary knowledges."[44] As previously discussed, Kimmerer's approach to the notion of the honorable harvest illustrates the significance of indigenous science as an invaluable resource for advancing our collective ability to survive and thrive in symbiosis with plants and animals. As she notes, "The traditional ecological knowledge of Indigenous harvesters is rich in prescriptions for sustainability. They are found in Native science, philosophy, in lifeways and practices, but most of all in stories, the ones that are told to help restore balance, to locate ourselves once again in the circle."[45] In this context, it's essential to approach partnerships around

40. Lynn Margulis, *Symbiotic Planet: A New Look at Evolution* (New York: Basic Books, 1998), 33.

41. Lynn Margulis, *Symbiotic Planet: A New Look at Evolution* (New York: Basic Books, 1998), 33.

42. Lynn Margulis, *Symbiotic Planet: A New Look at Evolution* (New York: Basic Books, 1998), 98.

43. Donna Jeanne Haraway, *Staying with the Trouble: Making Kin in the Chthulucene* (Durham, NC: Duke University Press, 2016), 33.

44. Donna Jeanne Haraway, *Staying with the Trouble: Making Kin in the Chthulucene* (Durham, NC: Duke University Press, 2016), 139.

45. Donna Jeanne Haraway, *Staying with the Trouble: Making Kin in the Chthulucene* (Durham, NC: Duke University Press, 2016), 179.

sustaining indigenous memory and knowledge, both because of its vitality as part of networks of care, and because that knowledge is proving to be a vital body of rigorous wisdom in understanding of the natural world with a much more balanced and caring notion of reciprocity with nature. That is, agriculture for the Anthropocene is likely to be much better for all parties involved if the epistemic hegemony of Western science is increasingly displaced to respect and acknowledge the significance, power, and value of indigenous science. As Kimmerer observes, "Each of us comes from people who were once Indigenous. We can reclaim our membership in the cultures of gratitude that formed our old relationships with the living earth."[46]

The notion of kinship here broadly resonates with indigenous approaches to understanding relationships and care as well. As Nick Estes argues in *Our History Is the Future: Standing Rock versus the Dakota Access Pipeline, and the Long Tradition of Indigenous Resistance*, "perhaps the answers lie within the kinship relations between Indigenous and non-Indigenous and the lands we both inhabit. There is a capaciousness to Indigenous kinship that goes beyond the human and that fundamentally differs from the heteronuclear family or biological family."[47] In the words of Dakota scholar Kim TallBear, "Making kin is to make people into familiars in order to relate. This seems fundamentally different from negotiating relations between those who are seen as different—between 'sovereigns' or 'nations'—especially when one of those nations is a militarized and white supremacist empire."[48] This more capacious approach to kinship can be helpful in mapping and enriching our relations of care.

Paternalism's Pretenses of Care

As we explore care, it is essential that we also reflect on how the language of care has been mobilized through paternalistic language to advance oppression and control. As Uma Narayan identified in an analysis of colonialism in India, "the colonizing project was seen as being in the interests of, for the good of, and as promoting the welfare of the Colonized."[49] A

46. Donna Jeanne Haraway, *Staying with the Trouble: Making Kin in the Chthulucene* (Durham, NC: Duke University Press, 2016), 377.

47. Nick Estes, *Our History Is the Future: Standing Rock versus the Dakota Access Pipeline, and the Long Tradition of Indigenous Resistance* (London: Verso, 2019), 256.

48. Kim TallBear, "Annual Meeting: The US-Dakota War and Failed Settler Kinship," *Anthropology News* 57, no. 9 (2016): e92–e95, https://doi.org/10.1111/AN.137

49. Uma Narayan, "Colonialism and Its Others: Considerations on Rights and Care Dis-

key insight from this is that "that care discourse can sometimes function ideologically, to justify or conceal relationships of power and domination." Indeed, much of the looting of cultural heritage artifacts from Egypt in the nineteenth century was justified through the racist and paternalist notion that it was the only way to preserve and care for those artifacts.[50] The same is true for patently false narratives about the looting of the artifacts from Benin.[51] As Andrew McClellan argues in *Inventing the Louvre: Art, Politics, and the Origins of the Modern Museum in Eighteenth-Century Paris*, establishing the museum in the 1790s was a way for France to portray "itself as a politically and culturally superior nation . . . uniquely qualified to safeguard the world treasures for the benefits of mankind."[52] In this regard, it becomes critical to recognize and consider the role that cultural-memory institutions, and discourses of care, have played in substantiating claims of cultural superiority.

Significantly, much of the work and theory of care has emerged from feminized professions such as education, nursing, and librarianship. The history of those professions is itself entangled with complex, layered issues of power and domination directly related to coercive notions of care that Narayan identified. Feminist historian Dee Garrison's book, *Apostles of Culture: The Public Librarian and American Society, 1876–1920* (1979), is still an invaluable resource for reminding ourselves about the multiple levels of paternalism involved in the development of librarianship as a profession in the United States. When Melvil Dewey focused on professionalizing librarianship as women's work, that approach was anchored in a notion of white womanhood as a civilizing influence. In this regard, problematic notions of care are central to the idea of librarians as "apostles of culture" who were to civilize and enculturate the poor and immigrants. To this end, many cultural-memory institutions still have far to go to move from being feminized professions created as part of a system of intellectual control to being intersectional feminist professions that work to ensure freedom, liberation, and justice. Here it becomes essential to return to the relational

courses," *Hypatia* 10, no. 2 (1995): 133–40, https://doi.org/10.1111/j.1527-2001.1995.tb01375.x

50. Donald M. Reid, *Whose Pharaohs? Archaeology, Museums, and Egyptian National Identity from Napoleon to World War I* (Berkeley: University of California Press, 2002).

51. Dan Hicks, *The Brutish Museums: The Benin Bronzes, Colonial Violence and Cultural Restitution* (London: Pluto Press, 2020), 142.

52. Andrew McClellan, *Inventing the Louvre: Art, Politics, and the Origins of the Modern Museum in Eighteenth-Century Paris* (Cambridge: Cambridge University Press, 1994), 7.

nature of care. At the heart of it, the only way to understand if care is good or effective is to trust and value both the perspective of those receiving care and those providing care.

A major force for the development of public libraries in the US was tied up in notions of "urban reform." In the 1870s, as reformers made the case for the value of the libraries, they contended that the library was "a direct rival to the saloon and would help prevent crime and social rebellion."[53] The role of the librarian was to "be the literary pastor of the town" and "gradually elevate their taste." Librarians were to function as "missionaries of literature."[54] Melvil Dewey would note in an 1877 *Library Journal* editorial that "Light is always the one cure for darkness, and every book that the public library circulates helps to make railroad rioters impossible."[55] That is, library books were to function to suppress a desire for fair wages and pay. Similarly, a key function of the public library in the United States was "the Americanization of the adult immigrant."[56] It is in this context that Dewey established a vision for a feminized labor force of librarians who would work to improve and refine the moral character of growing urban immigrant populations who were deemed to not be "American" enough. As Garrison explains, in the late nineteenth century, "the newly formed feminized professions sought to use their organizations to mend the moral and cultural fabric of a society that was unraveling into mass diversity."[57] In this context, librarianship became a method by which white women of the right class and standing could become civilizing missionaries supporting the right kinds of thinking and reading. As such, the origins of librarianship are tied up in both the control of women through the development of the role of librarians and the control of populations prone to considering more radical ideas.

In a paternalistic framework, care is about knowing better than those who are being infantilized and conceptually turned into children. This is a core part of how patriarchy, white supremacy, and ableism operate. In this regard, it's of the utmost importance that we work to root out these coer-

53. Dee Garrison, *Apostles of Culture: The Public Librarian and American Society, 1876–1920* (New York: Macmillan Information, 1979), 36.

54. Dee Garrison, *Apostles of Culture: The Public Librarian and American Society, 1876–1920* (New York: Macmillan Information, 1979), 37.

55. M. Dewey, "Editorial notes." *American Library Journal* 1, no. 11 (1877): 395.

56. Dee Garrison, *Apostles of Culture: The Public Librarian and American Society, 1876–1920* (New York: Macmillan Information, 1979), 217.

57. Dee Garrison, *Apostles of Culture: The Public Librarian and American Society, 1876–1920* (New York: Macmillan Information, 1979), 202.

cive notions of care. In these examples of colonial power and its corrupt use of the discourse of care, we find some of the most central and vexing issues for cultural-memory institutions. As instruments of state power and social power, over much of their history, memory institutions have clearly functioned as a force for oppression.[58] In the next chapter I draw out the ways that ideas of repair have become central to anticolonial thinking in cultural-memory work.

Toward Circles of Care in Memory Work

Returning to the questions of care and memory work raised at the start of this chapter, we can reflect on how institutions of memory that centered care in their work might have responded differently to the COVID-19 pandemic. First, the need for memory organizations to care for their workers would keep them from engaging in mass layoffs. Beyond that, in looking for safe work for their staff, they would also want to seek out where the greatest crisis of care was emerging that was relevant to the nature and expertise of their organizations.

As an ethics of care comes to be considered important by memory institutions and professions, it is critical that this involve more than just talking about care. As is evident in the problematic entanglements between the rhetoric of care and paternalism, we must also question uses of the rhetoric of care that in fact merely reframe oppression and domination. My hope is that the points I have raised here can help staff at all levels of memory organizations ask critical questions about how their institutions work to support and sustain caring relations between their staff, the peoples documented in their collections, the communities they serve, their broader functions in society, and their relationships with the entire planet as a system.

When it is time to rework a cultural-memory organization's mission, vision and values statement, or strategic plan, think about starting from care. Who is your organization responsible to provide care to? Whose care work is essential for your organization to succeed? Map out the circles of care your organization participates in, and build your goals and plans around how to help those relationships of care flourish. To give an example from my own experience: by making care an explicit value collectively defined by the Digital Content Management Section at the Library

58. N. De Jesus, "Locating the Library in Institutional Oppression," *In the Library with the Lead Pipe*, September 24, 2014.

of Congress, and by returning to and reflecting on that regularly, we can start to counter many of the default assumptions embedded in contemporary work cultures.[59] I think that the more we can learn from the disability justice movement, from feminist philosophy on care, and from a deeper understanding of the kinds of symbiosis that support life on Earth, the better we will be able to support our institutions' functions as nodes in networks of care.

59. Elizabeth Holdzkom, Mark Lopez, Trevor Owens, Camille Salas, and Lauren Seroka, "Beyond Good Intentions: Developing and Operationalizing Values in the Structure of Digital Library Programs," *Library Leadership & Management* 36, no. 2 (August 3, 2022), https://llm-ojs-tamu.tdl.org/llm/article/view/7533

CHAPTER 7

Repair, Revision, and Return

In 2018, student protesters at the Rhode Island School of Design demanded change. They sought repair. The Rhode Island School of Design Museum is one of the more than 160 museums and galleries in Europe and North America that possess bronzes looted in the genocidal sacking of the city of Benin by the British in 1897. The student protester's flier and website set the stakes for this protest as follows: "We are not demanding merely a physical transaction that displaces the object from our ownership to someone else's ownership, elsewhere. We are demanding public recognition of the symbolic and epistemic violence that our intellectual community helps perpetuate." The student protesters assert, "This is an opportunity to actualize repair."[1] This invocation of repair is the jumping-off point for a third key concept for the future of memory work.

Maintenance and care are invaluable concepts for helping transition to a more sustainable approach to memory work. However, those concepts do not draw our attention to the considerable harm that memory institutions have done as part of systems of oppression. Maintenance as a concept can carry a reactionary connotation. Work under the banner of maintenance must not be synonymous with "maintaining the status quo." At the same time, it's crucial to recognize that the language of care through rhetoric around security, protection, and paternalism has also been a core part of enacting unjust relationships.[2] Pairing maintenance and care with repair

1. "Unmake the Collection," *Unmake the Collection* (blog), November 6, 2018, https://unmakethecollection.wordpress.com/2018/11/06/unmake-the-collection/

2. Michelle Murphy, "Unsettling Care: Troubling Transnational Itineraries of Care in Feminist Health Practices," *Social Studies of Science* 45, no. 5 (2015): 717–37.

is necessary to draw our attention to the unjust state of the world and the complicity of memory institutions in bringing about and maintaining this state of injustice.

Major repair is necessary in our social, civic, and economic institutions. Toxic masculinity, white supremacy, and settler colonialism are central to the history and founding of major cultural-memory institutions. As a result, it is not surprising to find racism, ableism, ageism, sexism, xenophobia, transphobia, queer-phobia, and other forms of oppression endemic to memory work and institutions of cultural memory. This is true in the context of the possession and presentation of trophies of conquest like the Benin Bronzes, which will become a focal consideration of this chapter. It's true in the context of how a wide range of collections are organized and described. It's true in how access to collections is managed. It's true in the ways that the physical structures of memory institutions are inaccessible to people with disabilities. It's true in the myriad microaggressions faced by people of color working in memory organizations.[3] I offer this litany not in the sense that these injustices are commensurate in any way, but to illustrate how injustice abounds in memory work and memory institutions. In a wide range of contexts, concepts of repair are being developed and advanced in memory work, and I'm increasingly convinced that this needs to be at the center of how we enact and envision the present and future of the enterprise of cultural memory.

This chapter starts with an exploration of the development of "repair" as a key concept in information theory. From there, I work to unpack the idea of "revisionism," which is often invoked as some kind of nefarious activity. In contrast, I suggest that any legitimate claim to practice memory work should itself be based on an understanding of the need to continually revise our understanding of the past based on new facts and contexts. It is essential that we work to revise, update, and improve the accuracy of our understanding of the past. From there, I consider calls to change how we understand historical time and the presence of the past in our present. Synthesizing work in archival scholarship, as well as historical and curatorial research on the history of genocides of indigenous peoples in the United States and Benin, I draw out the ways that memory institutions bring atrocities from the past into the present. I briefly present a set of pos-

3. For a wide range of illustrations of microaggressions faced by library and information science workers, see LIS Microaggressions, "Microaggressions in Librarianship," accessed March 19, 2022, https://lismicroaggressions.com/.

itive examples of enacting repair in Yukatek Mayan cultural-memory work. I end the chapter by drawing on artist Jenny Odell's notion of manifest dismantling as a framework for enacting repair in cultural-memory work.

Memory work can and should be reparative. It can and should revise and update our understanding of the past based on what we know now. It can and should return objects, knowledge, agency, and control to those it has been taken from, to prevent the harm of that taking from persisting into the future. Before going further, I will offer a general content warning that this chapter engages with discussions of the history of racism, colonial violence, and death.

Rethinking Repair

In "Rethinking Repair," information science scholar Stephen Jackson asks us to "take erosion, breakdown, and decay, rather than novelty, growth, and progress, as our starting points in thinking through the nature, use, and effects of information technology and new media."[4] In contrast to the notions of disruptive and destructive innovation explored at the start of this book, this line of thinking leads us to focus on how communities have managed to respond, resist, and persist despite the harms enacted by disruptive innovation on people, animals, and the environment.

Through consideration of the ship-breaking industry in Bangladesh, Jackson demonstrates how a source of waste and detritus becomes a resource that is broken down to its parts and circulated back into the global economy. He calls this "broken-world thinking" and asks us to consider "the subtle arts of repair by which rich and robust lives are sustained against the weight of centrifugal odds, and how sociotechnical forms and infrastructures, large and small, get not only broken but restored, one not-so-metaphoric brick at a time."[5] In this framing, he also directly connects with notions of maintenance—how we sustain systems, and with discussions of an ethics of care, how we establish and maintain caring relations. Broken-world thinking shifts focus from "designers/creators" and "users/consumers" to the much more complex ecologies that emerge around the flow of

4. Steven J. Jackson, "Rethinking Repair," in *Essays on Communication, Materiality, and Society*, edited by Kirsten A. Foot, Pablo J. Boczkowski, and Tarleton Gillespie (Cambridge, MA: MIT Press, 2014).

5. Steven J. Jackson, "Rethinking Repair," in *Essays on Communication, Materiality, and Society*, edited by Kirsten A. Foot, Pablo J. Boczkowski, and Tarleton Gillespie (Cambridge, MA: MIT Press, 2014).

material and goods across the globe. We shift from imagining innovators as those who disseminate products and services to a view of the world in which, "Above all, repair occupies and constitutes an aftermath, growing at the margins, breakpoints, and interstices of complex sociotechnical systems as they creak, flex, and bend their way through time."[6] The creativity and ingenuity of sustaining our cultures and societies in this aftermath becomes the focal point for envisioning more resilient systems.

I find that focus on the aftermath to be compelling. Every day we wake up anew in the aftermath of ongoing historical processes. Along with maintenance and care, repair and related notions of revision and return provide valuable starting points for thinking about how to sustain people and institutions in more just ways. Indeed, much of the best work in historical scholarship in the last century has been explicitly about looking into the history of those margins, the people and communities that have been oppressed and marginalized; as the reality of that history has come to light, it has been critical to revise and update our understanding of mainstream historical narratives.

Revisionism as Repair

As I write this chapter, I read near-daily news stories about legislation advancing in several US states intended to stifle teachers and students from engaging in a robust and full exploration of the realities of US history. As an example, a bill in Kentucky prohibits teaching "the theory that racism is not merely the product of individual prejudice but is embedded in American society for the purpose of upholding white supremacy." The bill explicitly defines this and a range of other issues explored in contemporary historical scholarship as being "revisionist history."[7] The bill is intended to "ensure that no public school or public charter school offers any classroom instruction or discussion, formal or informal, or distributes any printed or digital materials, including but not limited to textbooks and instructional materials, that . . . [a]dvocate, inculcate, or promote bigotry, revisionist

6. Steven J. Jackson, "Rethinking Repair," in *Essays on Communication, Materiality, and Society*, edited by Kirsten A. Foot, Pablo J. Boczkowski, and Tarleton Gillespie (Cambridge, MA: MIT Press, 2014).

7. Brandon Reed, "An Act Relating to Education and Declaring an Emergency," Pub. L. No. HB487 (2022), https://trackbill.com/bill/kentucky-house-bill-487-an-act-relating-to-education-and-declaring-an-emergency/2225062/

history, or critical social justice."[8] The inherent contradictions in that language, probably created in bad faith, are difficult to make sense of. The explicit intention of work to revise and improve our understanding of the past is in fact part of an attempt to root out the bigotry inherent in many previous mainstream narratives of US history. While terms like "revisionism" and "revisionist" have long been used derisively, the use of such terms remains fundamentally incoherent as a critique. A cornerstone of memory work is the idea that one can contribute to advancing our understanding of the past. Anyone against revising and updating our understanding of the past is against the very idea of doing any kind of memory work other than disingenuous, sycophantic hagiography.

Given that "revision" in other contexts is generally a positive term, used to note that something has been updated or otherwise improved, an attack on revision is itself an attack on historical scholarship and memory work writ large. Wouldn't you want the most accurate, most up-to-date history? As explored in the first chapter of this book, history and memory are on some level always perspectival. Stories of the past that are shared in the present are always on some level also about the present. In this context, honest history must always be, on some level, a revisionist project. While history is often conceptualized as what happened in the past, it's better understood as the work done to make sense of records of the past to understand what happened in the past.[9] To that end, the work of historians and other memory workers can and should be oriented toward revising and improving our understanding of the past. This is particularly significant when we understand the importance and need for peoples of every community to find meaning and belonging in their own cultural memory and traditions.[10] In this regard, there is value in embracing the language of revision as itself part of work to enact repair. Peoples who have been systematically excluded and erased from histories should have the chance to see themselves and find belonging in their histories. Further, all of the kinds of people who have been excluded from producing

8. Brandon Reed, "An Act Relating to Education and Declaring an Emergency," Pub. L. No. HB487 (2022), https://trackbill.com/bill/kentucky-house-bill-487-an-act-relating-to-education-and-declaring-an-emergency/2225062/.

9. Richard A. Marius and Melvin E. Page, *A Short Guide to Writing about History*, 6th ed. (New York:Longman, 2006); L. J. Jordanova, *History in Practice*, 2nd ed. (London: Hodder Arnold, 2006).

10. Michelle Caswell, Marika Cifor, and Mario H. Ramirez, "'To Suddenly Discover Yourself Existing': Uncovering the Impact of Community Archives," *American Archivist* 79, no. 1 (June 1, 2016): 56–81, https://doi.org/10.17723/0360-9081.79.1.56

and disseminating their own histories should be supported in the work necessary to rectify their exclusion.

While historical argumentation is itself perspectival and partial, this should not be misconstrued as the idea that "anything goes." The production of histories always involves creative acts of storytelling, plot devices, and framing.[11] However, for any perspective or argument for a story about the past to be viable, it needs to make sense of the realities of the sources in the historical record.[12] Given brutal and uncontested facts, any account of the history of the United States that fails to start by recognizing and acknowledging its founding as part of a genocidal endeavor of European colonialism and the theft of the land of indigenous peoples is historically untenable. Similarly, any account of the history of the United States that fails to recognize that the nation was built and sustained by enslaved people is untenable. The central contradiction of the lofty values of the founding documents of the United States and the realities of these oppressive facts and many others demand revisions of many of the mainstream narratives of US history and of the apparatus of cultural memory and memory work that produces history.

In short, there isn't space to be neutral in the face of attempts to demonize revising our understanding of the past. Any honest, good-faith engagement with the historical record requires revision of mainstream historical narratives. That work of revision can serve as a context to enact repair for the ways that many institutions of memory and memory work grew out of and perpetuate acts of violence. To better understand this point and its implications, we consider some history of the United States and of British colonial violence in Nigeria as sites requiring revision, and we open questions about the complicity of memory institutions and workers in perpetuating the violence of the past into the present.

Grim Trophies of Conquest

In 1862, Taoyateduta, also known as Little Crow, and Dakota warriors opened conflict to expel white settlers from areas that treaties with the United States had clearly identified as Dakota land. At the end of a thirty-seven-day war, many of the Dakotas had been captured by the Minnesota

11. Hayden V. White, *Metahistory: The Historical Imagination in Nineteenth-Century Europe* (Baltimore: Johns Hopkins University Press, 2000).

12. Martha C. Howell and Walter Prevenier, *From Reliable Sources: An Introduction to Historical Methods* (Ithaca, NY: Cornell University Press, 2001).

Militia. In 1862, just a week before signing the Emancipation Proclamation, President Lincoln ordered the execution of thirty-eight of those prisoners. It remains the largest mass execution in US history. In 1863 Taoyateduta was murdered by Minnesotan settlers. The state of Minnesota paid his murderers $500 for his scalp, body, and decapitated head. These are brutal facts of American history.

As historian and citizen of the Lower Brule Sioux Tribe, Nick Estes observes that in the aftermath of the Civil War, many white southern leaders of that insurgency against the United States were given back their property and status. In contrast, leaders of the Dakota who had fought to protect their independent nations and communities against the incursion of settlers were hunted down and killed. Minnesota's governor, Alexander Ramsey, "ordered the extermination or complete banishment of remaining Dakotas from the state."[13] In support of that, "Settlers were encouraged and rewarded to take their own revenge with government-issued scalp bounties." This is not ancient violence. In the grand scheme of history, this is a recent event that any viable telling of US history must contend with. Beyond that, what happened to Taoyateduta's body, and the bodies of many other indigenous peoples, is something that cultural-memory institutions need to contend with, too.

As a grim trophy display of the founding conquest narrative of the state of Minnesota, the Minnesota Historical Society put Taoyateduta's remains on public display in the state capital. His body stayed on display until 1915. His remains remained in custody of the Minnesota Historical Society until 1971, when they were finally returned, after more than a decade of requests from his descendants.[14] It's worth noting that the return of the remains of Indigenous people from the collections of cultural-memory institutions continues still. Since the 1990 enactment of the US National Park Service's Native American Graves Protection and Repatriation grant program, that program has provided funding every year to projects that support precisely this sort of return of human remains largely put into the collections of memory institutions as anthropological artifacts.[15] The story of Taoyatedu-

13. Nick Estes, *Our History Is the Future: Standing Rock versus the Dakota Access Pipeline, and the Long Tradition of Indigenous Resistance* (New York: Verso, 2019), 102.

14. Minnesota Historical Society, "Did the Minnesota Historical Society Display the Remains of Taoyateduta (Little Crow) at the Minnesota State Capitol?" The U.S.-Dakota War of 1862, accessed March 12, 2022, https://www.usdakotawar.org/frequently-asked-questions/1325

15. National Park Service, "Previous Grant Awards—Native American Graves Protection and Repatriation Act (U.S. National Park Service)," accessed March 19, 2022, https://www.nps.gov/subjects/nagpra/previously-awarded-grants.htm

ta's life and death is just one of a series of necessary correctives in understanding the nature of US history and of history itself that Estes presents in his 2019 book *Our History Is the Future: Standing Rock versus the Dakota Access Pipeline, and the Long Tradition of Indigenous Resistance*.

Estes forcefully demonstrates that there is a fundamental disconnect in the way that settlers and many indigenous peoples, such as the Sioux, approach history. I think it is important for settlers like myself, and I imagine many of my readers, to reflect on the arguments he makes about different conceptions of the nature and practice of history. Estes asks, "How does one relate to the past?" He explains that "Settler narratives use a linear conception of time to distance themselves from the horrific crimes committed against Indigenous peoples and the land." He argues that by contrast, "Indigenous notions of time consider the present to be structured entirely by our past and by our ancestors. There is no separation between past and present, meaning that an alternative future is also determined by our understanding of our past. Our history is the future."[16] Notably, this notion of a blurred past, present, and future resonates directly with the previously discussed Haudenosaunee conception of seventh-generation thinking. If we don't teach or tell stories of this violence and reconcile and integrate them into our understanding of US history, we are fundamentally failing to engage in an honest historical enterprise.

With this insight in place, it is important to draw forward the presence of the past regarding the role that the Minnesota Historical Society played in enacting and celebrating violent conquest. The past is never past, and it is critical that institutions of cultural-memory work to identify, rectify, and repair the damage they have done and are currently doing. On this point, Estes's book is valuable for helping us better understand and frame how we can approach memory work while engaging directly with the realities of the present. We return to his thoughts and line of argument later in the chapter. But before that, we return to the question of the Benin Bronzes and the student protesters from the introduction of this chapter.

Chronopolitics of Trophies of Conquest and Violence

Thirty-five years after the mass executions of the Dakota war, across the Atlantic in Africa, the British conducted a distinct but related colonial genocidal assault. The story of that conquest is alive and present in the col-

16. Nick Estes, *Our History Is the Future: Standing Rock versus the Dakota Access Pipeline, and the Long Tradition of Indigenous Resistance* (New York: Verso, 2019), 14–15.

lections and exhibitions of museums in the US and Europe. In February of 1897, British troops sacked the city of Benin, located in what is now Nigeria. More than 160 museums and galleries in North America and Europe display objects looted during that event. In *The Brutish Museums: The Benin Bronzes, Colonial Violence and Cultural Restitution*, anthropologist Dan Hicks asks us to consider, "What does it mean that, in scores of museums across the western world, a specially written museum interpretation board tells visitors the story of the Benin Punitive Exhibition?"[17] He explores that question directly in the context of his experience as a curator at one of those museums.

As the curator of world archeology at the Pitt Rivers Museum, Hicks is directly responsible for a significant collection of these looted objects from Benin. The book is in large part an exploration of the question of what cultural-memory institutions should do with the many objects in their collections that were looted through violence. Hicks argues that "the arrival of loot into the hands of western curators, its continued display in our museums and its hiding-away in private collections, is not some art-historical incident of reception." Instead, it is "an enduring brutality that is refreshed each day that an anthropology museum like the Pitt Rivers opens its doors."[18] Further, "Every day that our museums open their doors to retell the story of the punitive expedition with the loot that was taken, this loss is re-enacted, and this loss is re-doubled and extended across time and space."[19]

To some there is a misconception, or self-deception, "that the looting of Benin City was a coherent exercise of collecting and safeguarding." Throughout the book, Hicks clearly demonstrates that "Nothing could be further from the truth; this act of vandalism and cultural destruction possesses no logic of salvage, or of saving culture for the world." The attack was itself sponsored by sales of the loot: "the Benin Bronzes were auctioned to cover the costs of the mission."[20] Even when a paternalistic attempt is made to somehow make the history of those bronzes into a perverse story

17. Dan Hicks, *The Brutish Museums: The Benin Bronzes, Colonial Violence and Cultural Restitution* (London: Pluto Press, 2020).

18. Dan Hicks, *The Brutish Museums: The Benin Bronzes, Colonial Violence and Cultural Restitution* (London: Pluto Press, 2020), 137.

19. Dan Hicks, *The Brutish Museums: The Benin Bronzes, Colonial Violence and Cultural Restitution* (London: Pluto Press, 2020), 149.

20. Dan Hicks, *The Brutish Museums: The Benin Bronzes, Colonial Violence and Cultural Restitution* (London: Pluto Press, 2020), 142.

about care, about saving culture, the facts simply cannot be stretched to support such a claim.

The limited efforts that museums have made to address the histories of these objects in their collections are fundamentally inadequate. In Hicks's words, "No amount of institutional self-consciousness or re-writing of the labels to make the story more direct, or less euphemistic will work—to tell the story of this colonial violence in the gallery space is itself to repeat it, to extend it, as long as a stolen object is present and no attempt is made to make a return."[21] This point is even more pressing when we accept the realities of the argument Estes forwarded. Settler cultures and colonizer ideologies of the past and future attempt to distance themselves from the brutal realities of murder and conquest in their past. That past is indeed very much present in collections that contain objects like these bronzes. The desire to see oneself as part of a narrative of progress from the past into the future in the settler and colonial imaginary effectively requires acts of self and community dissociation and delusion from the very recent and continuing brutality of colonialism. But that past is always present. The display of trophies of conquest in the present is still always on some level a display of trophies of conquest that reinforces the original intention of their collection.

It is worth pausing here to draw out some specifics about what the Benin Bronzes themselves mean as objects and artifacts of memory. As Hicks explains, "In the Edo language, the verb *sa-e-y-ama* means 'to remember,' but its literal translation is 'to cast a motif in bronze,' the act of casting constituting a form of recollection."[22] The bronzes are in fact literal objects of memory. Looting these objects was, quite literally a theft of memory itself.

Hicks's argument is anchored in the work of Cameroonian historian Achille Mbembe's conception of necropolitics, the ways that social and political power dictate who lives and who dies and what happens to the remains of the dead. The implications of the notion of necropolitics have cut to the core of memory work and the functions of memory institutions. In *Necropolitics*, Mbembe specifically identifies functions of museums, also relevant to a range of other memory institutions, as playing a role in the world's social and political structure; "one of the museum's functions has been the production of statues, mummies, and fetishes." A function of

21. Dan Hicks, *The Brutish Museums: The Benin Bronzes, Colonial Violence and Cultural Restitution* (London: Pluto Press, 2020), 218.

22. Dan Hicks, *The Brutish Museums: The Benin Bronzes, Colonial Violence and Cultural Restitution* (London: Pluto Press, 2020), 139.

museums is to process and distribute artifacts that enact a specific colonial view, often through displaying looted objects and in many cases actual looted human remains. Mbembe argues that "Mummification, statuefication, and fetishization all correspond perfectly to the logic of separation." Specifically, "The point is generally not, it so happens, to offer the sign that has long accommodated the form some peace and rest. It was first necessary to chase out the spirit behind the form, as occurred with the skulls gathered during the wars of conquest and 'passification'"[23] Objects and remains had to be removed from context, placed behind glass, and provided with an interpretation largely to the colonizers' audiences. These artifacts serve a function. Here Hicks argues that "museums became a key regime of practice through which Africans were dehumanized."[24]

For Hicks, this constitutes a core problem of chronopolitics, which he defines as "the use of time as a mode of colonial domination, including the weaponization of the discipline of Archaeology." Hick's observations about the Benin Bronzes are even stronger regarding human remains in collections. The presentation of Taoyateduta's body by the Minnesota Historical Society, and every indigenous person's remains robbed from a grave and held by a memory institution as an archeological artifact, is an instance of this weaponization of anthropology. From this perspective the impossibility of neutrality as a value for cultural-memory institutions becomes even more clear. Many objects in the collections of memory institutions, their descriptions, and the processes by which people obtain access to them operate on the logic of "Mummification, statuefication, and fetishization" articulated by Mbembe. When we accept the totality of that history, the stakes and challenge of enacting repair is a staggering responsibility.

To address this problem, Hicks asks us to "imagine anthropology museums where nothing is stolen, where everything is present with the consent of all parties," and also to "imagine museums where the curator's principle task is that of detailed necrological research—understanding what was taken, and from whom, and facilitating its return where this is demanded."[25] He concludes by asking if "like the *cire perdue* (lost wax) process through which Benin's brass heads were cast, so the negative framework of the brut-

23. Achille Mbembe and Steve Corcoran, *Necropolitics* (Durham, NC: Duke University Press, 2019), 171.
24. Dan Hicks, *The Brutish Museums: The Benin Bronzes, Colonial Violence and Cultural Restitution* (London: Pluto Press, 2020), 180.
25. Dan Hicks, *The Brutish Museums: The Benin Bronzes, Colonial Violence and Cultural Restitution* (London: Pluto Press, 2020), 227.

ish museums can be melted away, to leave something new—not a return to form, but something multiplied, recast from diverse materials."[26] In enacting return, the resulting absences of the looted objects could be locations for something more honest and more powerful.

For Hicks, the answer is that "The world needs anthropology museums where nothing has been stolen." I contend that this point should be extended from anthropology museums to all galleries, libraries, archives, museums, historical societies, and other institutions of memory. The only way that will be possible is if we turn inward and deeply explore the problems inherent to cultural-memory collections. In his words, "We need to open up and excavate our institutions, dig up ongoing pasts, with all the archeological tools that can be brought to hand."[27] Given how much of the collections of institutions like the British Museum are made up of looted artifacts, a genuine, earnest effort to return looted objects would have a profound impact on their holdings. To that Hicks observes, "If that ends up emptying out many of these museums then so be it." Those newly empty museums could start up new "commissioning programmes, through which each gap made by returns is filled by new work made by artists, designers, writers and others from the dispossessed community paid for by the museum, to help museums remember and bear witness to colonialism today."[28] I personally find this to be a powerful concept; as he observes, the Benin Bronzes are themselves cast and created through a negative relief. If we were to understand the histories of these objects and remove and return any that were looted, the negative relief created by newly commissioned objects in their places could turn those institutions from presenters of the story of conquest to presenters of the story of the effort to repair and address the devastating and brutal facts of that conquest.

Repair toward Liberatory Archives

The issues of return and repair are coming to the foreground in museum studies, but they are increasingly central concerns in areas of library and archives scholarship as well. In the 2021 book *Urgent Archives: Enacting*

26. Dan Hicks, *The Brutish Museums: The Benin Bronzes, Colonial Violence and Cultural Restitution* (London: Pluto Press, 2020), 241.
27. Dan Hicks, *The Brutish Museums: The Benin Bronzes, Colonial Violence and Cultural Restitution* (London: Pluto Press, 2020), xiii.
28. Dan Hicks, *The Brutish Museums: The Benin Bronzes, Colonial Violence and Cultural Restitution* (London: Pluto Press, 2020), 240.

Liberatory Memory, archival scholar Michelle Caswell demonstrates that Estes's perspective on indigenous conceptions of time is broadly true of a wide range of cultural perspectives on time and the past. This includes various indigenous perspectives as well as traditions in Hindu thinking, and the approaches to time of other marginalized groups. As she observes, "Settler colonialism seeks to obliterate these cyclical temporalities in its ongoing quest for extraction."[29] Significantly, this is also true of racial categorization of time. Drawing on the work of philosopher Charles W. Mills, Caswell observes how "white time" functions separately from other experiences of time, specifically in "settler societies that deny history before colonization; in dominant expectations of productivity and proper use of time; and in carceral regimes of waiting and 'serving' time."[30] As Mills argues, "Whites are self-positioned as the masters of their own time, as against those mastered by time."[31] Relevant to this line of thinking, scholarship in disability studies has identified "crip time" as a context in which "Disability and illness have the power to extract us from linear, progressive time with its normative life."[32] In short, while normative, linear, progressive conceptions of time and history dominate the cultural imaginary, they poorly relate to the varied lived experience of most people. What is widely asserted and assumed to be the natural or default universal nature of time is in fact a particular form of cultural imperialism.

The question then becomes how should archivists and other memory workers become more engaged in their present instead of working from a perspective that views the past as a distant place where things were less good, and the future as a never-ending frontier of progress where things inherently get better. For Caswell, the answer is that "Archivists interested in enacting liberatory memory work may abandon the past and the future for the now." Specifically, "Our labor can be harnessed in the contemporary moment as a disruption of both dominant white progress narratives and cycles of oppression that inequitably target BIPOC and LGBTQ+ communities."[33]

29. Michelle Caswell, *Urgent Archives: Enacting Liberatory Memory Work*, Routledge Studies in Archives (Abingdon, UK: Routledge, 2021), 28.

30. Michelle Caswell, *Urgent Archives: Enacting Liberatory Memory Work*, Routledge Studies in Archives (Abingdon, UK: Routledge, 2021), 32.

31. Charles W. Mills, "White Time: The Chronic Injustice of Ideal Theory," *Du Bois Review: Social Science Research on Race* 11, no. 1 (2014): 27–42.

32. Ellen Samuels, "Six Ways of Looking at Crip Time," *Disability Studies Quarterly* 37, no. 3 (August 31, 2017), https://doi.org/10.18061/dsq.v37i3.5824

33. Michelle Caswell, *Urgent Archives: Enacting Liberatory Memory Work*, Routledge Studies in Archives (New York: Routledge, 2021), 103.

In parallel to the way that Hicks wants anthropologists to turn their tools and techniques to "dig where they work" and uncover and make repairs and amends for their looted collections, Caswell calls for "memory workers, and archivists in particular" to "take a lead role in the movement for material reparations for the descendants of enslaved Africans in the United States."[34] Specifically, "archivists are experts on records. We can use our expertise in records to communicate their potential and their shortcomings, what got recorded and what did not, and why. We can activate the records in our care in support of efforts toward material reparations for descendants of enslaved Africans."[35] "We can mobilize the records in our care regarding previous successful claims to reparation to show that material reparations are not unrealistic dreams, but have historical precedent." She specifically notes how "Nazi records were used to figure out which Holocaust survivors were entitled to payment from the German Claims Conference. US government records were used to figure out which Japanese Americans were incarcerated during WWII and entitled to a cash payment. Cambodian archivists have activated records in their care to both convince U.N. officials to launch a tribunal and provide evidence to convict Khmer Rouge officials of genocide." In this context, "Archivists have done this before. We can do it again, more concertedly, and on a larger scale."[36]

This call can work directly in tandem with archivist Lae'l Hughes-Watkins's call to move toward reparative archives, "to challenge traditional repositories, more specifically, recordkeepers in scholarly institutions, to claim a greater stake in this discourse and begin to repair their holdings by targeted efforts to increase the diversification of collections and to advocate for and promote those collections for utilization within scholarly spaces."[37] "Engaging in social justice through reparative archival work in the form of the diversification of archives, advocacy/promotion, and then utilization within an academic archive has set a process in motion that has shown early signs of creating feelings of inclusivity within the archival space."[38]

34. Michelle Caswell, *Urgent Archives: Enacting Liberatory Memory Work*, Routledge Studies in Archives (New York: Routledge, 2021), 103.

35. Michelle Caswell, *Urgent Archives: Enacting Liberatory Memory Work*, Routledge Studies in Archives (New York: Routledge, 2021), 104.

36. Michelle Caswell, *Urgent Archives: Enacting Liberatory Memory Work*, Routledge Studies in Archives (New York: Routledge, 2021), 104.

37. Lae'l Hughes-Watkins, "Moving Toward a Reparative Archive: A Roadmap for a Holistic Approach to Disrupting Homogenous Histories in Academic Repositories and Creating Inclusive Spaces for Marginalized Voices," *Journal of Contemporary Archival Studies* 5, no. 1 (May 16, 2018), https://elischolar.library.yale.edu/jcas/vol5/iss1/6

38. Lae'l Hughes-Watkins, "Moving Toward a Reparative Archive: A Roadmap for a

The goals of repair are relevant to nearly every function of cultural-memory work. One key area of growing activity is reparative description. Access to collections in libraries, archives, and museums is largely mediated by descriptive practices. These institutions produce descriptions of items and collections in catalogs and finding aids, and all those works of description enact points of view and perspectives.

The term "reparative description" is now being widely used in archival practice. The Society of American Archivists' dictionary of archival terminology defines reparative description as "remediation of practices or data that exclude, silence, harm, or mischaracterize marginalized people in the data created or used by archivists to identify or characterize archival resources."[39] Illustrative of how mainstream work in reparative description has become, in 2022 the US National Archives published its own "Guiding Principles for Reparative Description," which note that descriptive practices "impact how events are remembered, whose stories are told, and which communities can find their experiences reflected in the national narrative." The document opens with the recognition that the National Archives and Records Administration "has a responsibility to repair inequities through our archival descriptive practices."[40] I assert that all cultural-memory institutions have the same responsibility.

Significantly, it's not just the content of description that needs consideration, but the very structures and relationships that are at the heart of the construction of systems of description. In this context, scholars such as Sandra Littletree, Miranda Belarde-Lewis, and Marisa Duarte are engaged in important work to rethink the nature of relationality in knowledge organization based on a range of indigenous conceptual models.[41]

For archival practice, as Jarret Drake argues, it is becoming necessary to reconsider foundational principles like arranging and describing collections around their provenance. As he argues, "the patriarchal origins of

Holistic Approach to Disrupting Homogenous Histories in Academic Repositories and Creating Inclusive Spaces for Marginalized Voices," *Journal of Contemporary Archival Studies* 5, no. 1 (May 16, 2018), https://elischolar.library.yale.edu/jcas/vol5/iss1/6

39. Society of American Archivists, "SAA Dictionary: Reparative Description," accessed March 13, 2022, https://dictionary.archivists.org/entry/reparative-description.html

40. US National Archives, "Guiding Principles for Reparative Description at NARA," National Archives, January 10, 2022, https://www.archives.gov/research/reparative-description/principles

41. Sandra Littletree, Miranda Belarde-Lewis, and Marisa Duarte, "Centering Relationality: A Conceptual Model to Advance Indigenous Knowledge Organization Practices," *Knowledge Organization* 47, no. 5 (November 2020): 410–26.

provenance penetrated the language of archival description." In this context, "archivists often write massive memorials and monuments to wealthy, white, cisgendered and heterosexual men, including selective details about the creator that have minimal bearing on the records, and instead serve to valorize and venerate white western masculinity."[42] Indeed, many archival collections are organized around the names of wealthy collectors, donors, slave owners, and patriarchs. This is an even larger issue for museums, which often are named and established by wealthy benefactors and collectors whose descendants often hold prominent places on their boards. Accessing collections organized and maintained in this way involves wading through a lot of lofty prose about how heroic they were in hoovering up all these materials, when in many cases that was only possible because of their connections to capitalism, extractive colonialism, slavery, and patriarchy. Approaching this problem in archival description has the potential to build directly on the points that Hicks made about turning anthropology museums into sites that themselves need excavations. To Caswell's point, this is a context from which archivists can turn toward the records they hold as sources for tracing accountability and culpability, instead of being sites of veneration through provenance. Provenance can become a means of tracing culpability instead of a site for lofty praise. Many collections are thus unintentional documentation of crime scenes.

In arguing for changing the language of description around collections, Drake calls on memory workers to anchor their practices in allyship. He draws on the Anti-Oppression Network, which offers a definition of allyship: "an active, consistent, and arduous practice of unlearning and re-evaluating, in which a person of privilege seeks to operate in solidarity with a marginalized group." Under this definition, "allyship is not an identity—it is a lifelong process of building relationships based on trust, consistency, and accountability with marginalized individuals and/or groups of people"; further, "allyship is not self-defined—our work and our efforts must be recognized by the people we seek to ally ourselves with."[43] This can serve as a guiding star for the work of repair in cultural-memory work. Just as working from an understanding of the importance of care must always be relational, and the perspectives of the one giving care and the one

42. Jarrett M. Drake, "RadTech Meets RadArch: Towards A New Principle for Archives and Archival Description," *Medium*, April 6, 2016, https://medium.com/on-archivy/expanding-archivesforblacklives-to-traditional-archival-repositories-b88641e2daf6#.6w6jkmgul

43. Anti-Oppression Network, "Allyship," *Anti-Oppression Network* (blog), December 10, 2011, https://theantioppressionnetwork.com/allyship/

receiving it need to be respected, so the work of repair is only legitimate if it is anchored in allyship. That allyship must be a guiding principle for work of repair in cultural-memory work. The disability justice mantra of "nothing about us without us" is similarly central to allyship-centered work to enact repair.

I imagine many readers working in libraries, archives, and museums reading this chapter may be thinking something like "this all sounds good, but who has the time? There are backlogs of material that need to be processed, and we are down staff and can't even keep up with what we have. Where are we going to find the time to go back and rework descriptions and engage in this kind of dialog and thinking?" This question of time as resource, and how that resource should be used, is central to the issues at hand. This is a manifestation of how neoliberalism upends discussions of something as fundamental as time itself, which is targeted as a "resource" for management and extraction. Each unit of time in this framework is understood to be a potential resource that should be maximized in support of meeting particular metrics.

This line of thinking brings us back to many of the core problems that came out of the first half of the book: the demand for productivity, the demand for key performance indicators to track data on graphs that are intended to perpetually trend up and to the right. In response to this line of questioning my answer is simply, yes, you're right. There aren't time and resources to do it all. So, we need to step back and think about what is genuinely important about our work, and reframe how we approach our goals and objectives. If the goals of an institution are to produce more product in the form of items that have descriptions, then any work that goes into reparative description is going to be at cross-purposes with work intended to rapidly produce more of that product. That being noted, if we instead shift to think about ways to assess the quality of the work, or the extent to which it manifests the goals and values of the organization, then we can probably move away from strictly productivist mindsets focused around comparing the stats on which organization has the most items. This is particularly important when we recognize that many of the "products" of libraries, such as descriptions, could well be actively harming intended user communities. If our goal is to do less harm, then investing time in undoing problematic work from the past would become one of our highest priorities.

Kimberly Christen and Jane Anderson, key thinkers who have developed platforms for better stewarding Indigenous knowledge for and by

indigenous communities, have advanced the notion of the value of "the slow archives." In their words, "Slowing down creates a necessary space for emphasizing how knowledge is produced, circulated and exchanged through a series of relationships. Slowing down is about focusing differently, listening carefully, and acting ethically."[44] If we were to audit and enumerate the numerous ways that memory institutions enact harm through how collections are organized, described, and made available, we could very well track progress in efforts to remediate and repair those harms.

Learning to Repair from the Yukatek Mayan World

Recent collaborative cultural-heritage initiatives on Yukatek Maya culture heritage in Mexico offer powerful positive examples of what repair-centered cultural heritage work can look like. This is evident both in how Mayan culture is increasingly being presented in museum settings and in ongoing archeological research partnerships.

Much of the cultural heritage work on the Maya focuses on a precolonial past, ignoring the fact that the Maya are still here and have a history that runs right into the present. In contrast to the default frame of many anthropological museums, the Gran Museo del Mundo Maya de Mérida's permanent exhibition starts visitors out in the Mayan present. The museum's exhibit begins with the contemporary life of Mayan people in the region and then works backward from there through history. Like many of the cultural heritage sites in the Yucatan, all the labels and description texts are posted in Yukatek Maya and Spanish. At the level of the labels, these sites see Mayan language and its history is not just as a subject or an object of history. It is an active part of how this history is communicated to all its visitors. .

When the museum does present the Mayan past, it includes embroideries created by contemporary Mayan artists that directly give voice to contemporary Mayan points of view.[45] Those embroideries are focal points of the exhibition, and they present rich interpretations of both history and culture from present Mayan points of view. Those embroideries are them-

44. Kimberly Christen and Jane Anderson, "Toward Slow Archives," *Archival Science* 2, no. 19 (June 4, 2019): 87–116, https://doi.org/10.1007/s10502-019-09307-x

45. Laura Osorio Sunnucks, "De-Centring Museums in Indigenous Community Engagement: Contemporary Maya Art, Thought, and Archaeological Collections," in *The Oxford Handbook of Museum Archaeology*, edited by Alice Stevenson (Oxford: Oxford University Press, 2022), https://doi.org/10.1093/oxfordhb/9780198847526.013.29

selves accessioned objects in the permanent collection of the museum, and as such they are not just adornments or embellishments of the narrative of the site. They are themselves full participants as objects of history in the collection.

Archeological practice has for a long time played a role in estranging Mayan peoples from their past,[46] objectifying and setting the anthropological record as something outside or distinct from the contemporary world. Of particular significance in this area, the Tihosuco Heritage Preservation and Community Development Project is a powerful model of how cultural-heritage professionals can join in and support the work of indigenous memory workers in helping reclaim and advocate for more just representations of the past that connect with the contemporary world as well.[47]

As a direct collaboration with local communities, the project works to support local activists in making the case for archeological work on the Caste War, a period of struggle between 1847 and 1915 in which Mayan peoples operated an autonomous and independent state. This effort helped to preserve sites relevant to the history of the Caste War, and in so doing has helped to document the vibrancy of resistance and independence in the region. Increasingly, mainstream anthropology and archeology scholars are shifting to focus more attention on centering indigenous perspectives in shaping the future of archeological work in the region and in working to invest resources in the cultural heritage in the region to have a positive impact on Mayan communities.[48] Collectively, these examples of Mayan cultural heritage work give me hope. I think they provide a model for what allyship can look like for memory workers with considerable privilege to partner with and support the work of indigenous memory workers.

From Manifest Destiny to Manifest Dismantling

Part of enacting repair, supporting revision, and enabling return involves replacing old stories intended to manifest particular futures with new ones

46. Tiffany C. Fryer and Diserens Morgan, "Heritage Activism in Quintana Roo, Mexico: Assembling New Futures through an Umbrella Heritage Practice," *Trowels in the Trenches: Archaeology as Social Activism* (Gainesville: University Press of Florida, 2020).

47. Tiffany C. Fryer and Diserens Morgan, "Heritage Activism in Quintana Roo, Mexico: Assembling New Futures through an Umbrella Heritage Practice," *Trowels in the Trenches: Archaeology as Social Activism* (Gainesville: University Press of Florida, 2020).

48. Richard M. Leventhal, "Rethinking Maya Heritage: Past and Present," 2022 Gordon R. Willey Lecture, Peabody Museum of Archaeology & Ethnology, October 20, 2022, https://peabody.harvard.edu/video-rethinking-maya-heritage-past-and-present

that dismantle them. In *How to Do Nothing: Resisting the Attention Economy*, artist Jenny Odell concludes her argument about the importance of doing nothing by contrasting the historical narrative of Manifest Destiny with a notion of manifest dismantling. I think this distinction powerfully resonates as a way to close this chapter on repair and draw out connections between a belief in trajectories of history and the need to establish a positive story in which to anchor visions of repair.

The story of Manifest Destiny, that the future of the United States was to spread from sea to shining sea, is in many ways best exemplified in John Gast's 1872 painting *American Progress*. If you grew up in the United States, there is a good chance you can call up an image of the painting in your mind. I remember it clearly as an image reproduced in more than one of the American history textbooks I read in school. Columbia, the goddess-like personification of the United States, dominates the center of the painting. Light radiates from her as she releases a coil of telephone wire, and the railroads follow. Behind her, farmers bring dark and unruly nature under control, and covered wagons advance as indigenous peoples and herds of buffalo retreat from the advance of their light.

The context of the painting's creation is relevant to understanding its function. George A. Crofutt commissioned it as a foldout for *Crofutt's Trans-Continental Tourist's Guide*, which was itself part of a sales pitch for Manifest Destiny. As Crofutt explained in the preface to the book, it was produced to provide a guide to "a vast empire" and "a country that only a few years ago was wholly unexplored and unknown to the white race." With the completion of the Pacific Railroad, "it has become occupied by over half a million of the most adventurous, active, honest and progressive white people that the world can produce." Those white people are "building cities, towns and villages as though by magic, prospecting, discovering and developing the great treasure chambers of the continent." They are also "engaged in the cultivation of the inexhaustible soil, which is literally causing the wilderness to blossom like a rose."[49] The painting was created as part of telling the story of Manifest Destiny, and it fit directly into a narrative about white people taking over, building towns, prospecting, and

49. George A. Crofutt, *Crofutt's Trans-Continental Tourist's Guide: Containing a Full and Authentic Description of over Five Hundred Cities, Towns, Villages, Stations, Government Forts and Camps, Mountains, Lakes, Rivers, Sulphur, Soda and Hot Springs, Scenery, Watering Places, Summer Resorts . . . : Over the Union Pacific Railroad, Central Pacific Railroad of Cal., Their Branches and Connections by Stage and Water, from the Atlantic to the Pacific Ocean*. Fifth vol., Fourth annual revise (New York: G. A. Crofutt, 1873), http://nrs.harvard.edu/urn-3:HUL.FIG:008733059

cultivating the seemingly "inexhaustible soil." This racist genocidal extractive narrative has brought massive harm to people, and is causally related to the global climate catastrophe we find ourselves in. Returning to the points about broken-world thinking from earlier in this chapter, we find ourselves living in the aftermath of this ideological frame, attempting to repair and make sense of the broken world this ideology has brought about. It's worth underscoring that the narrative of the frontier, of progress, is itself directly tied into the story of disruptive innovation that we started this book with. The story of the "electronic frontier" is itself a replay of the same kinds of ideas of conquest at play in historical notions of "the frontier."

American Progress is literally on display in a permanent exhibition at the Autry Museum of the American West in Los Angeles.[50] What does encountering this painting in the museum say about the persistence and vibrancy of the Manifest Destiny narrative? Underscoring the extent of the painting's prominence in history education, popular history and fashion blogger Janey Ellis's reflections on her visit in 2016 are illustrative. She notes, "My history major heart leapt when I saw the original painting of John Gast's 1872 work, *American Progress*."[51] The presence of this image is powerfully engrained in her. She recalled, "I can't tell you how many times I saw images of this piece during college. I took of course the basic US history courses, but I also took the History of the Pacific Northwest, as well as the American West through Film, and in each this image was discussed as the epitome of 'Manifest Destiny' and we analyzed [it] in every single class." She recognizes it as part of the narrative of Manifest Destiny, but her response is not one of revulsion at the problems brought by this ideology, but of excitement at a first-person experience with a key primary source from her education. As she explains, "It's just so rare that you get to see the real deal of something you study and that is so widely circulated." While it's clear that consideration of this painting was part of discussing the historical concept of manifest destiny, it's also worth thinking about how its frequent display also functions to further its original intent. It was created as a sales pitch for Manifest Destiny, and wherever it reappears it on some level functions as exactly that kind of advertisement. This is one of the reasons I have chosen not to represent the image in this book. The reproduction and

50. Autry Museum of the American West, "Autry's Collections Online—Painting American Progress," accessed March 13, 2022, http://collections.theautry.org/mwebcgi/mweb.exe?request=record;id=M545330;type=101

51. Janey Ellis, "A Return to the Autry," *Atomic Redhead* (blog), May 21, 2016, https://atomicredhead.com/2016/05/21/a-return-to-the-autry/

distribution of the image, on some level, further reinforces the idea of the centrality of Manifest Destiny.

American Progress was painted ten years after the mass execution of the Dakota people who had attempted to defend their land, and five years before Taoyateduta's desecrated body was put on permanent display by the Minnesota Historical Society. The painting made genocidal war seem like something else entirely. The presence of the buffalo in the darkness is also important. The 1868 Fort Laramie Treaty had established a massive 33-million-acre reservation for the Sioux, and an additional area of roughly the same size to function as a preserve "so long as the buffalo may range there in such numbers to justify the chase."[52] Red Cloud, who had negotiated the treaty, would later reflect that it was a multispecies treaty: "The country of the buffalo was the country of the Lakota. We told them that the buffalo must have their country and the Lakota must have their buffalo." As Estes explains, the treaty was "not just an agreement between two human nations, but also an agreement among the nonhuman ones as well—including the buffalo nations."[53] So, when the US Army went out to engage in mass slaughter of the buffalo between 1865 and 1883, it was simultaneously a war on the Sioux and a war on nature and wilderness. Here we see the heart of the genocidal death impulse at the heart of the very vision of progress. The painting simultaneously presents and obscures the war on indigenous peoples and on the more sustainable and harmonious practices of living in relationship with nonhumans, the buffalo.

As a counter to this story of death and destruction, Odell asks, "What's the opposite of Manifest Destiny?"[54] In reply she offers the idea of manifest dismantling, which could take the form of "another painting, one where Manifest Destiny is trailed not by trains and ships but by manifest dismantling, a dark-robed woman who is busy undoing all the damage wrought by Manifest Destiny, cleaning up her mess."[55]

Odell's vision is itself tied to another story of repair and return based on the removal of the San Clemente Dam and restoration of the Carmel

52. Nick Estes, *Our History Is the Future: Standing Rock versus the Dakota Access Pipeline, and the Long Tradition of Indigenous Resistance* (New York: Verso, 2019), 109.

53. Nick Estes, *Our History Is the Future: Standing Rock versus the Dakota Access Pipeline, and the Long Tradition of Indigenous Resistance* (New York: Verso, 2019), 109.

54. Jenny Odell, *How to Do Nothing: Resisting the Attention Economy* (Brooklyn, NY: Melville House, 2019), 189.

55. Jenny Odell, *How to Do Nothing: Resisting the Attention Economy* (Brooklyn, NY: Melville House, 2019), 190.

River ecosystems. Originally built in 1921 to provide power to Monterey residents, by the 1940s it had been superseded by a larger dam built farther upstream. In the '90s it was "declared not only useless but seismically unsafe. An earthquake might have sent not only water but 2.5 million cubic yards of accumulated sediment into towns downstream." The dam was a problem for humans and for a number of fish species.

To address the problem, it would have been possible to spend $49 million to reinforce it with more concrete so that it could survive an earthquake. This would have itself created further maintenance debt—the reinforced dam would continue to require future investment to sustain it. But instead, an $84 million plan was enacted that "not only removed the dam but included habitat restoration for the trout and the California red-legged frog." As the dam was removed and the river allowed to flow again, repair undid a small bit of the vision of Manifest Destiny. "Seen through the lens of manifest dismantling, tearing down the dam is indeed a creative act, one that put something new in the world, even if it's putting it back."[56] The end result of this act of repair is more sustainable, more maintainable, and more supportive caring relations among humans and between humans and nonhumans.

I think we can use this notion of manifest dismantling as a frame to connect the work of reparative description and revisionist history to the work of identifying and returning looted objects from cultural-memory collections. We can anchor our work on repair in the work of allyship, in a commitment to enacting and supporting caring relationships. Under this banner, it becomes essential to engage in and support initiatives such as the Association of Research Libraries' recent call to establish a Truth Commission and an Archive of Racial and Cultural Healing.[57] This can be the century of undoing, the century of rectifying injustices and committing to the rights and dignity of all peoples, which includes rights to find belonging and community in public memory.

To this end, I find Estes's arguments particularly powerful. As he observes, "Traditions of indigenous resistance have far-reaching implications, extending beyond the world that is normally understood as

56. Jenny Odell, *How to Do Nothing: Resisting the Attention Economy* (Brooklyn, NY: Melville House, 2019), 192.

57. "Why the US Needs a Truth Commission and an Archive of Racial and Cultural Healing," *Association of Research Libraries* (blog), November 10, 2021, https://www.arl.org/blog/why-the-us-needs-a-truth-commission-and-an-archive-of-racial-and-cultural-healing/

indigenous."[58] The "ancestors of Indigenous resistance didn't merely fight against settler colonialism; they fought for Indigenous life and just relations with human and nonhuman relatives, and with the Earth."[59] Significantly, the coalitions of Indigenous-led efforts of resistance against the death cult enacted by the production of the Dakota Access Pipeline were joined in and supported by many poor settler farmers. This is a partnership that would have been unimaginable in the past. Settler farmers were the tip of the spear of conquest of that land. Therein lies a central lesson: the gaping maw of consumption in capitalism and imperialism has turned on the settlers it sent out to the region. The same fate awaits us all, as the ongoing and ever-escalating extraction, destruction, and consumption of nature as resources accelerates the effects of the global climate catastrophe. This is a system dead-set on consuming everything, including itself and all of us. In this respect, it is essential that settlers like myself, and many of the memory workers I imagine to be this book's readers, build solidarity and stand with and support the long-standing traditions of resistance, like these actions of indigenous resistance, against the death cult of extractive neoliberalism.

In good news, we have a range of thoughtful and creative practices to draw from for enacting repair, for engaging in manifest dismantling, as part of cultural-memory work. Along with the previously discussed reparative description and the slow archives movement, we can look to examples like the Maine Historical Society's approach to its 2019 exhibit "Holding Up the Sky: Wabanaki People, Culture, History & Art."[60] This exhibition was developed from oral histories collected as part of Maine's Truth and Reconciliation Commission. The exhibition repositions Maine as an indigenous space. As Jess Cowing observes, the exhibition was created by a "team of advisors including Abenaki and Wabanaki people, and featuring work from Wabanaki artists, presents a narrative of Wabanaki sovereignty in a place that is currently called Maine."[61] By decentering official state narratives of Manifest Destiny, and creating space for indigenous voices and

58. Nick Estes, *Our History Is the Future: Standing Rock versus the Dakota Access Pipeline, and the Long Tradition of Indigenous Resistance* (New York: Verso, 2019), 21.

59. Nick Estes, *Our History Is the Future: Standing Rock versus the Dakota Access Pipeline, and the Long Tradition of Indigenous Resistance* (New York: Verso, 2019), 248.

60. Maine Historical Society, "Holding up the Sky: Wabanaki People, Culture, History & Art," Maine Memory Network, April 12, 2019, https://www.mainememory.net/sitebuilder/site/2976/page/4665/display

61. Jess L. Cowing, "Review of 'Holding Up the Sky,' or Naming Maine as Wabanaki Homelands." *Disability Studies Quarterly* 41, no. 4 (2021), https://doi.org/10.18061/dsq.v41i4.8486

histories to be presented and supported in venues like this exhibition, we can see ways to invest in essential repair necessary to support a more just and equitable future.

We don't need "creative destruction." We don't need "disruptive innovation." The rhetoric of revolution in innovation-speak is, again, false. We need deliberate, focused efforts to remodel and repair our institutions. We can make our institutions better versions of themselves that dare to live up to the lofty values like freedom and justice that were carved above many of their stone entrances centuries ago. In artist Jenny Odell's words, we can engage in acts of manifest dismantling. As Odell notes, the intentional dismantling of the San Clemente Dam in California involved working to repair and recultivate ecosystems the dam had disrupted. The dam was built to control and dominate nature, and the answer wasn't to blow it up, but to intentionally dismantle it and work to repair the damage it had done. We can similarly engage in manifest dismantling of the structures, systems, and processes that work against equity, justice, and inclusion in institutions of cultural memory.

CHAPTER 8

A Future for Cultural Memory

Every weekday in New York, trend analysts curate cultural signals and present them to clients. In London, analysts at the Future Laboratory are similarly producing forecasts for their clients on trends in "retail, beauty, luxury and placemaking."[1] At conferences like LaFutura, hosted in cosmopolitan destinations such as Amsterdam, Helsinki, Berlin, Singapore, and Dubai, futurists are able to connect with the "central trend intelligence network to bridge the gap between trends, innovation and tomorrow's opportunities." These areas of work are what communication and media scholar Devon Powers refers to as the trends industry. They produce and market the future as a product.

Before getting into how we can enact a better and more just future for cultural memory, it is important to improve our understanding of how the future is produced in the present and how that production could work differently. Powers's book *On Trend: The Business of Forecasting the Future* is a useful resource for this task. She interviewed a wide range of individuals involved in the trends industry and participated in and observed events and conferences like LaFutura through ethnographic fieldwork.

Powers explains, "Trends are property owned and developed, circulated through reports and conferences, marketed and sold for high sums to clients in need of insurance against risk."[2] Significantly, this industry is only really invested in the futures of specific kinds of people; as one of

1. Devon Powers, *On Trend: The Business of Forecasting the Future* (Urbana: University of Illinois Press, 2019), 84.

2. Devon Powers, *On Trend: The Business of Forecasting the Future* (Urbana: University of Illinois Press, 2019), 144.

her informants explained, "Very few clients take any interest in income brackets below $60,000 a year."[3] In keeping with the theme of this book, much of the work of the future industry is selling some form of control of perpetual disruption. While this work is "superficially progressive, the goal of trends is apolitical or even anti-political; it is to envision a future that keeps the fundamental structures and relations of the present intact."[4] The futures industry is here to manufacture the product of the future on behalf of specific intentions of the wealthy. In Power's observations, "If we want to envision a truly visionary future, one not decreed through the puissant charge of disruption," then "we need to radically rethink how trends behave, where they come from, how they travel, and whom they are for."[5]

The implications for cultural memory are powerful. It's critical that memory workers find ways to assert control of visions regarding the future for memory. As an example of this different kind of futurist thinking, Powers turns to one of the sites we looked at in the first chapter, Afrofuturism. In her analysis, Afrofuturism models how to imagine and enact a better and more just future with broader interests than the corporate clients of the trend industry—what writer, theorist, and filmmaker Kodwo Eshuan calls "counter-futures." In this framing, "Counter-futures transcend and decenter whiteness and white supremacy; they dare to tinker with history and to contemplate a future that upends the present's foundational assumptions."[6] The need to "tinker with history" returns us to points we have come across throughout this book. The need to revise and update our understanding of the past, to find belonging and community in memory, is itself an essential part of illuminating the path toward better, more just futures. As Eshuan argues, "the powerful employ futurists and draw from the futures they endorse, thereby condemning the disempowered to live in the past."[7] That relationship, between the present and the past, and the role of the past in envisioning the future of memory, has been a central issue of the journey through this book.

3. Devon Powers, *On Trend: The Business of Forecasting the Future* (Urbana: University of Illinois Press, 2019), 144.

4. Devon Powers, *On Trend: The Business of Forecasting the Future* (Urbana: University of Illinois Press, 2019), 137.

5. Devon Powers, *On Trend: The Business of Forecasting the Future* (Urbana: University of Illinois Press, 2019), 137.

6. Devon Powers, *On Trend: The Business of Forecasting the Future* (Urbana: University of Illinois Press, 2019), 137.

7. Kodwo Eshun, "Further Considerations of Afrofuturism," *CR: The New Centennial Review* 3, no. 2 (2003): 289.

Significantly, a living social memory itself turns out to be a key concept in Powers's analysis that differentiates movements like Afrofuturism from the mainstream trends industry. In her analysis, a "central difference between Afrofuturism and the kind of futuritivity that proliferates in business contexts is Afrofuturism's deep focus on the continuity between the past, present and future."[8] As Moor Mother Goddess explained in the anthology *Black Quantum Futurism*, "our past futurism, the hopes and dreams of our ancestors, act as important metaphysical tools that serve as agents to help one discover hidden information in the present time."[9] Powers observes, "One of the objectives of black futures is not to erase, abandon, or disrupt but to reclaim and repair; the past is a constant passenger in future endeavors."[10] Herein again we affirm what must come after the perpetual refrain of disruption: maintenance, care, and repair.

Mainstream concepts of the future are a product produced by an industry. In this context, the future is capital that is already being harnessed to take us on a trajectory. Powers asks us if we can use the tools of the futures industry, if we can bend and rework them, to make a better future. Drawing on Afrofuturism, she argues that part of what is essential to envisioning a better future is a more in-depth integration of memory. So, Afrofuturism's approach to enacting a future more integrated and tied in with memory and the past is one source of insight for us for thinking about how to enact a better future for cultural memory.

Building on Powers's work, this last chapter explores how varied contemporary scholarship can develop an alternative futures practice or cultural memory. One source of inspiration is Max Liboiron's work to develop a basis for practicing anticolonial science in *Pollution Is Colonialism*, which resonates with literary theorist Caroline Levine's approach to analyzing systems in *Forms: Whole, Rhythm, Hierarchy, Network*. In connections between these approaches in anticolonial science and literary theory I see further support for adrienne maree brown's arguments about how we manifest a better future together in *Emergent Strategy: Shaping Change, Changing Worlds*. In this chapter, I work to draw out and synthesize ideas from these varied approaches and then use them as a platform to offer sug-

8. Devon Powers, *On Trend: The Business of Forecasting the Future* (Urbana: University of Illinois Press, 2019), 147.

9. Moor Mother Goddess, "Forethought," *Black Quantum Futurism Theory & Practice* 1 (2015): 8.

10. Devon Powers, *On Trend: The Business of Forecasting the Future* (Urbana: University of Illinois Press, 2019), 147.

gestions about how and why it's important for memory workers to reorient our daily practices to bring about an emergent better future for cultural memory.

Daily Practice toward Anticolonial Futures

In *Pollution Is Colonialism*, Max Liboiron, the director of CLEAR (Civic Laboratory for Environmental Action Research), offers several valuable insights for developing our practices to enact a better future for cultural memory. While the focus is on the practices of scientific research in a lab studying plastic pollution, I believe that many of the approaches described can help us imagine what anticolonial memory work practices might be.

Given how fraught the functions of science and cultural institutions are, as exemplified in many of the points previously explored in the chapter on repair, one might rightly wonder where to start. Liboiron observes, "Often I hear scholars and activists alike talking as if capitalism (or patriarchy or racism, but mostly capitalism) is a solid monolith that we mush dash our soft bodies against, to little avail." I often hear this sentiment from others and have at times felt those same kinds of impulses about memory institutions. Liboiron offers a key insight, that "that characterization gives capitalism and colonialism more power than they merit by erasing not only their diversity, but also the patchiness, the unevenness, and the failures of those systems to fully reproduce themselves."[11] In diagnosing systems of oppression and control, it's essential to keep in mind that these are loose assemblages enacted and reenacted through a confluence of different, often competing systems and processes.

For Liboiron, the basis of change comes in the practices of everyday life. "Every morning when I put on my lab coat, I have decisions to make. How will we do science today? How will we work against scientific premises that separate humans from Nature, that envision natural relations as universal, and that assume access to Indigenous Land, especially when so much of our scientific training has primed us to reproduce these things?" We can similarly commit ourselves to do just and ethical memory work with a renewed commitment to think about how we do it, how we can commit to doing right in our work in each of our daily actions, or habits, and our patterns of work. As they further underscore, "These are not theoretical questions—they are practical questions, questions of method-and-

11. Max Liboiron, *Pollution Is Colonialism* (Durham: Duke University Press, 2021), 130.

ethics (hyphenated because they are the same thing). Critique is important but it can only take you so far when you are a practitioner trying to work in a good way."[12]

Notably, doing the work instead of just engaging in armchair critique and criticism brings with it a wide range of compromises. As they observe, "Doing anticolonial science within a dominant scientific context is simultaneously a commitment to dominant science and a divestment from it, which makes it uniquely compromised." The same kind of compromise comes with doing work in institutions of cultural memory, given all the observations on the complicity of institutions of memory in controlling and silencing aspects of the past. But "Compromise is not about being caught with your pants down, and it is not a mistake or a failure—it is the condition for activism in a fucked-up field."[13] Given this reality, "we are always caught up in the contradictions, injustices, and structures that already exist, that we have already identified as violent and in need of change."[14] To do work in cultural-memory institutions requires accepting exactly this kind of compromised situation. Working to change institutions of memory requires working within their existing bureaucracies. It requires constantly evaluating which norms and defaults need to be challenged at which point, and which it's necessary to accept and roll with, at least for the time being.

On that front, it is worth noting that Liboiron's use of "anticolonial" instead of "decolonial" is itself relevant to defining work in cultural-memory institutions. "Appropriating terms of Indigenous suivivance and resurgence, like decolonization, is colonial."[15] Decolonization is not a metaphor.[16] We can learn more from Liboiron's approach here, on their terms setting up space "where anticolonial methods in science are characterized by how they do not reproduce settler and colonial entitlement to Land and Indigenous cultures, concepts, knowledges (including Traditional Knowledge), and lifeworlds. An anticolonial lab does not foreground settler and colonial goals."[17] This prompts a key set of questions: how can libraries, archives, and museums act as their own forms of "anticolonial labs," sites that do not foreground settler and colonial goals? I think many of the argu-

12. Max Liboiron, *Pollution Is Colonialism* (Durham: Duke University Press, 2021), 143.
13. Max Liboiron, *Pollution Is Colonialism* (Durham: Duke University Press, 2021), 134.
14. Max Liboiron, *Pollution Is Colonialism* (Durham: Duke University Press, 2021), 134.
15. Max Liboiron, *Pollution Is Colonialism* (Durham: Duke University Press, 2021), 26.
16. Eve Tuck and K. Wayne Yang, "Decolonization Is Not a Metaphor," *Tabula Rasa*, no. 38 (2021): 61–111.
17. Max Liboiron, *Pollution Is Colonialism* (Durham: Duke University Press, 2021), 27.

ments that Dan Hicks made in the previous chapter, about the need to engage in actions of both return and repair of the Benin Bronzes, are critical aspects of this work.

Here it is essential to note that the arrangement of time and the function of memory are key aspects of how Liboiron reads anticolonial practice. As they argue, "The transformation of Land into Resource is achieved not only through an arrangement of space but also through the arrangement of time. The temporality of Resource is anticipatory—it makes and even aims to guarantee colonial futures."[18] The relationship between colonialism and land as resources quite literally colonizes the future. "Crucial to this temporality is the belief that this future can be chosen and that the present can be directed toward it via management practices," which ends up meaning that "the future is reserved for settler goals, colonized in advance." Relating to earlier points about planning for the future, they note that "Risk management, disaster plans, homeland security (and other securities) all share managerial ontologies dedicated to containing time for chosen futures."[19] Given the key role that stories like Manifest Destiny play in supporting this colonization of the future, it becomes all the more critical that we draw on notions like manifest dismantling to change how the past is mobilized to enact better and more just futures.

Working Tensions in the Forms

Our daily practices, our routines, and our everyday interactions with the colleagues we work with in memory institutions and the communities they serve are the sites where we can manifest a more just future for cultural memory. The future is not produced through collisions between -isms. The future emerges through the accretion of humdrum day-to-day patterns in existence. We need to think about how to change the patterns in those daily rhythms.

Here, literary theorist Caroline Levine's approach in *Forms: Whole, Rhythm, Hierarchy, Network* offers a useful set of frameworks to think through how structures emerge and persist through a wide range of formal patterns. In her words, "Though we have not always called them forms, they are the political structures that have most concerned literary and cultural studies scholars." She identifies them as "bounded wholes, from

18. Max Liboiron, *Pollution Is Colonialism* (Durham: Duke University Press, 2021), 65.
19. Max Liboiron, *Pollution Is Colonialism* (Durham: Duke University Press, 2021), 65.

domestic walls to national boundaries; temporal rhythms, from reputations of industrial labor to the enduring patterns of institutions over time; powerful hierarchies, including gender, race, class and bureaucracy; and networks that link people and objects, including multinational trade, terrorism, and transportation."[20]

One of Levine's central conceits is that forms collide. In any given context a series of different competing sociopolitical forms are at play, which struggle to resolve into maintaining or rupturing any given status quo. In her words, "in practice, we encounter so many forms that even in the most ordinary daily experience they add up to a complex environment composed of multiple and conflicting modes of organization—forms arranging and containing us, yes, but also competing and colliding and rerouting one another."[21]

Identifying and traversing those competing and colliding forms becomes a critical part of navigating and enacting change in this compromised world. For Levine, this prompts a set of tactical considerations for working toward any given set of goals. She asks, "what tactics for change will work most effectively if what we are facing is not a single hegemonic system or dominant ideology but many forms, all trying to organize us at once?"[22] This line of questioning pushes us away from straightforward notions of resistance or compliance with a system and toward a tactical framing focused on working through and across the collisions of forms.

The politically entangled world of *The Wire* offers a context for Levine to illustrate how this approach can be used for reading systems in the world. Given how the story of *The Wire* already played a key role in our earlier consideration of the tyranny of metrics, this is a particularly relevant narrative. In Levine's words, *The Wire* "conceptualizes social life as both structured and rendered radically unpredictable by large numbers of colliding social forms."[23] Central to the story is a dialog about the power and nature of the system. However, Levine carefully picks apart what that actual system is. "Both characters and critics bewail the power of what they call 'the

20. Caroline Levine, *Forms: Whole, Rhythm, Hierarchy, Network* (Princeton: Princeton University Press, 2015), 21.

21. Caroline Levine, *Forms: Whole, Rhythm, Hierarchy, Network* (Princeton: Princeton University Press, 2015), 16.

22. Caroline Levine, *Forms: Whole, Rhythm, Hierarchy, Network* (Princeton: Princeton University Press, 2015), 22.

23. Caroline Levine, *Forms: Whole, Rhythm, Hierarchy, Network* (Princeton: Princeton University Press, 2015), 23.

system' portrayed on *The Wire*, but it is crucial to note that 'the system' is less an organized or integrated single structure than it is precisely this heaped assortment of wholes, rhythms, hierarchies, and networks."[24] In this context, "the system" is an emergent outcome of the ongoing collisions of forms. In Levine's reading, the central focus is that "individual decisions matter only within environments of colliding forms where no individual or elite group controls either procedures or outcomes."[25] Furthermore, Levine makes the case that the heroes of the story are the people who read and navigate the collision of forms to make their world bend toward being better or more just. "The few characters who recognize the power and significance of multiple forms—Lester Freeman, Bunny Colvin, and Omar Little—all make strategic decisions which, temporarily at least, permit outcomes that frustrate or elude the conventional distribution of power."[26] After finishing Levine's book and returning to my own reflections on *The Wire*, I find myself increasingly thinking about reading the various situations I confront in terms of these formal collisions. How can I best work within and through the competing forms that organize my life and work? How do I establish a trajectory for action that accepts the collision and competition of these forms as a basis to act from, and not as a system to define myself in opposition to?

Embracing Emergent Strategy

If we combine Levine's approach to navigating competing rhythms, networks, hierarchies, and wholes and Liboiron's approach to accepting the compromised nature of doing anticolonial science within existing power structures, we find ourselves circling many of the key points that came up at the beginning of this book in considering aderine marie brown's approach to emergent strategy.[27] That is, we now find ourselves close to some of the issues discussed earlier in the book, working out a tool kit for navigating this complexity.

On brown's terms, emergent strategy is "strategy for building complex

24. Caroline Levine, *Forms: Whole, Rhythm, Hierarchy, Network* (Princeton: Princeton University Press, 2015), 148.
25. Caroline Levine, *Forms: Whole, Rhythm, Hierarchy, Network* (Princeton: Princeton University Press, 2015), 149.
26. Caroline Levine, *Forms: Whole, Rhythm, Hierarchy, Network* (Princeton: Princeton University Press, 2015), 149.
27. Adrienne M. Brown, *Emergent Strategy* (Chico, CA: AK Press, 2017).

patterns and systems of change through relatively small interactions."[28] This allows for emergent change across interconnected systems. "Emergence notices the way small actions and connections create complex systems, patterns that become ecosystems and societies. Emergence is our inheritance as part of this universe; it is how we change. Emergent strategy is how we intentionally change in ways that grow our capacity to embody the just and liberated worlds we long for." Much like Liboiron, brown argues that we must view "our own lives and work and relationships as a front line, a first place we can practice justice, liberation, and alignment with each other and the planet."[29] Taking emergence as a serious point, drawing on the function of things like fractals and the flocking of starlings, brown asserts that a key point to strategy is that "Small is good, small is all."[30] Effectively, all large and powerful structures are emergent properties of a wide range of small and tiny everyday actions of many people around the world. Small changes in daily rituals, changes in how we structure our days, where we focus our time and attention, the intentions we set at the start of the day, can all compound into cascading effects. When we take these thinkers' work seriously, it becomes clear that we need to attend to all these little elements to find our way forward, and we can only do that if we work together to find the slack in our schedules where we can be deliberate about those small things.

So now what? Over the course of this book, I have contended that the rhetoric of disruptive innovation, of Moneyball thinking, and of hacker ethics persists as part of the spirit of our age. Those ideologies are part of the problem, not part of the solution. We can't disrupt our way out of the perils of the Anthropocene. It's the impulses behind disruption, the pursuit of limitless growth fueled by extraction of fossil fuels, by exploitation of labor and colonialism, that have allowed a small minority of people to imperil the sustainability and livability of humanity's future.

Given that, I have also worked to make a case and offer examples for how genuinely embracing and centering maintenance, care, and repair, in our work and our lives, demands that memory workers and the memory institutions we work for swim against those currents of our times. Throughout the book, I have attempted to offer a range of practical suggestions about the kinds of things that workers in various roles in cultural-memory institutions can do to swim against these currents. I now end the book by revis-

28. Adrienne M. Brown, *Emergent Strategy* (Chico, CA: AK Press, 2017), 2.
29. Adrienne M. Brown, *Emergent Strategy* (Chico, CA: AK Press, 2017), 53.
30. Adrienne M. Brown, *Emergent Strategy* (Chico, CA: AK Press, 2017), 41.

iting some of these points and observations and drawing them out further into a set of practical and pragmatic suggestions about how to approach memory work in the world we find ourselves in.

Maintenance, Care, and Repair as Bellwethers

We won't get a better past or future through masculine metaphors of destruction and construction. We need to tend a neglected garden. We need to cultivate networks of interdependence and care. We need to make a focused effort to rework the conceptual models and principles that we use to talk about and think about work and institutions. In this regard, it is critical that we draw on language and stories of maintenance, care, and repair not just as rhetorical flourishes, but as a basis for genuinely retraining our cultural narratives about our work and institutions.

Maintenance is antihype. It is about reliability, about keeping things together. It's about sustainability. If we were serious about focusing on maintenance and maintainability, we would prioritize a focus on a more sustainable pace of work and more modest goals for our work, and we would thinking more about the long-term costs and knock-on effects of new efforts and initiatives.

Care is anti-individualist. It is about interdependence. Care is about tending, pruning, and gardening instead of building, demolition, and construction. Care is antiviolence, and when care is good it is not paternalistic. If we center care in the work of memory institutions, we will be thinking about the networks of interdependence that emerge from memory institutions, of the workers and labor who collect and preserve, and the communities whose memories are recorded, documented, and interpreted from collections. We would focus on cyclicality, on engagement and exploration, and not on extraction and isolation. We would respect and honor memory as a living part of communities, identity, and belonging.

Repair is anti-breaking. It's about fixing. It's about renovating. It's about finding where we are broken and mending it, not only to keep things working but to make them better fit our needs. In keeping with the Japanese practice of *kintsugi*, repair need not conceal what has been fixed or mended. Instead, acts of repair can embrace imperfection and bear witness to how cracks in objects, organizations, histories, and civilizations have been mended. Repair requires that we look at the brutal facts of the history of cultural memory and revise our understanding of the past, working toward return of looted material and toward restitu-

tion, truth, reconciliation, and justice. We can identify what needs to be remodeled so that the lofty, high-minded missions and visions of cultural-heritage institutions better align with the lived experience of their functions and operations.

Abundance as a Mindset

If we are serious about centering maintenance, care, and repair in memory institutions, we need to replace the fear impulse that comes from narratives about navigating disruption and keeping up with the times, and intentionally shift to longer-term planning to develop robust and sustainable (in every sense of the words) infrastructures and engagement with our communities. When we step back from a false, scarcity mindset, we can better see that there are more than enough time and resources to support a more maintainable, sustainable, and just world.

We can strive to make sure that our institutions provide good jobs, and we can advocate for resources to support those good jobs. We can understand good jobs as positions that come with clear boundaries between work and the rest of life. Such jobs give people close to the work the ability to improve their craft, and give them the resources necessary to do their work in ways that don't burn them out. We can prioritize the development and improvement of resilient and generous systems in our organizations that can support people enacting care. In this context, we can support more holistic notions of outcomes, remaining mindful of the various issues that the communities we support participate in and are engaged by.

Draw on Systems and Ecological Thinking and Planning Frameworks

A key tool for doing this work can be supporting broader systems-thinking approaches to the problems we face. We can work to avoid reductionist models focused on single key metrics, and instead focus deliberate time and attention on understanding the complexity that emerges from dynamic systems that span across peoples, cultures, nature, and technology.

In all of this, if we center care in our work and our organizations, we will center allyship and the need to seek out reparative and restorative justice. At its heart, chasing after innovation has been a process of fear, fear of being left behind. In the wake of the disruption of innovation, in this time that we declare exists after disruption, we can accept our vulnerability as a starting point, and stop thinking about how to do more with less, thinking

more about what we should do with our limited time, space, and resources, and with the connections we have to each other and our communities.

Questions for Reflection on Daily Practice of Memory Work

Recognizing the centrality of our own daily practices, our routines and processes in enacting a future, I worked up the following questions, which I try to return to repeatedly in reflecting on my attempts to enact a better future for memory. I also try to create time and space, and to find ways to help my colleagues and friends and family create time and space to engage in this kind of reflective practice. We do in fact need to find or make time to step back from the urgency of the daily, weekly, quarterly schedule. The push to that urgency is itself part of how we end up in a reactive and panicked state, which is part of what the goals of disruption as an ideology push for.

So, consider asking yourself these questions as you engage in your own daily practice, or use them as a basis to craft your own. They can be things to consider at the start of a day or at the end of a day. They are also useful prompts to ask whenever you create time and space for reflection or engage in planning activities.

1. Am I pushing for narratives of limitless frontiers and endless growth in my work? Or am I centering issues of maintenance and sustainability?
2. How am I enacting caring relations through this work? Further, how can I know that those who would receive and provide care in this context get care on the terms that they want it?
3. What are the power relationships at play in my work? To what extent is the approach I am taking in my work enacting allyship? To what extent am I working to "stand with" as opposed to taking up space for people and communities facing any forms of oppression?
4. Is this work providing opportunities for communities facing oppression to find belonging and connection in memory? If not, how can I make that a priority?
5. What are my own and my organization's relationships to land, time, and settler colonialism? In what ways do my work or my approaches to work support thinking of land and time as resources to be consumed and managed instead of something to be held in a sacred trust?

Returning to My Own Daily Rituals

One of my primary hopes for this book is that the story of my journey through these ways of thinking about work and the world helps others like me, or not like me, to make a similar or related journey. The process of writing this book—reading, contemplating, and synthesizing a wide range of ideas about maintenance, care, and repair—has functioned as my own set of practices to process my experience. As a result, this book itself is my prayer, my personal meditation on how to shape and refine my thinking about reconciling the compromised nature of working in the realities of late capitalism and pushing to make the function of cultural memory in society a little more just and equitable every day.

Part of this book is a story of my personal journey. In this regard, the book's strengths and limitations are exemplified in the limits of my own embodied experience as a cis, white, heterosexual man. I started out my career enamored with a set of ideas that seemed powerful, helpful, and useful to me and many of my peers and colleagues, about how we could enact progress and make the world a better place. I realize that I, like so many others like me, was in fact far behind the curve in our thinking about the future of memory and technology. An early concept for this book, which I was thinking of calling *A Future for Memory Work: Confessions of a Reformed Technology Evangelist*, would have been much more personal and memoir-like. While I didn't take that approach, the memoir-like undercurrents and origins of the book still come through.

Two decades ago, I had fully bought into Silicon Valley's stories about technological progress. I started my career thinking that digital technologies could disrupt much of the infrastructure and function of memory, that through unconferences and open publishing on blogs, we could use the emancipatory power of the web to center cultural memory in enacting a better, more open world. As illustrated in this book, throughout my career thus far, at a history center, in federal funding for cultural memory, in working on infrastructure for memory in the world's largest library, and in teaching public history and archives and library students, I have largely changed my perspective on those ideas about disruption, data-driven thinking, and freelance and market-driven careers.

I have come to understand—and I hope it's particularly clear throughout my approach to the second half of this book—that I was looking in the wrong places for ideas about the future. We need to be looking away from centers of power and privilege for insights to enact a better future. Standpoint epistemology clarifies how and why the marginalized and oppressed

are uniquely positioned to see more clearly. In that regard, it makes sense that the work of indigenous historians and scientists, disability justice advocates and thinkers, queer studies scholars, feminist philosophers, majority-world critical theorists, and Afrofuturists is where we can all collectively engage with and learn from brilliant, creative, and novel perspectives for enacting a better and more just future for memory.

I say all of this, and conclude the book, with a bit of trepidation. I realize that there is a long history of white, cis, heterosexual male scholars like me appropriating and engaging in extractive forms of scholarship and citation. I have attempted to work against this social default as much as possible, to draw in the names of thinkers and writers who everyone should be engaging with, not just in the footnotes but very much front and center in the central flow of my writing as well. I hope that I have done so with some level of care in drawing out, not just a sentence here or there, but major ideas and themes from these works in a form that is less extractive. I hope I will be read as someone working to use whatever platform I have to build common cause and lift up the work of others, and not as someone who is strip mining and extracting their work in service to my own.

With all of that noted, I now go a step further and implore my readers to take the end of this book as a jumping-off point to engage more deeply with some of the works and thinkers I have learned so much from in the three years I spent writing this. Read Catherine D'Ignazio and Lauren F. Klein's *Data Feminism*. Read Nick Estes's *Our History Is the Future: Standing Rock versus the Dakota Access Pipeline, and the Long Tradition of Indigenous Resistance*. Read Candace Fujikane's *Mapping Abundance for a Planetary Future: Kanaka Maoli and Critical Settler Cartographies in Hawai'i*. Read Lae'l Hughes-Watkins's "Moving Toward a Reparative Archive: A Roadmap for a Holistic Approach to Disrupting Homogenous Histories in Academic Repositories and Creating Inclusive Spaces for Marginalized Voices." Read Max Liboiron's *Pollution Is Colonialism*. Read Charles W Mills's "White Time: The Chronic Injustice of Ideal." Read José Esteban Muñoz's *Cruising Utopia: The Then and There of Queer Futurity*. Read André Brock's *Distributed Blackness: African American Cybercultures*. Read Achille Mbembe's *Necropolitics*. Read Leah Lakshmi Piepzna-Samarasinha's *Care Work: Dreaming of Disability Justice*. Read Joan Tronto's *Caring Democracy: Markets, Equality, and Justice*. Read Robin Wall Kimmerer's *Braiding Sweetgrass: Indigenous Wisdom, Scientific Knowledge, and the Teachings of Plants*. Read adrienne marie brown's *Emergent Strategy*. All this work is much bigger and more complex and important than I can do justice to in this vol-

ume, and I encourage everyone to follow up with these authors and others as you develop your own daily rituals of imbedding maintenance, care, and repair in your work. At the end of this book, and in the act of writing the ending of the book, I find that a lot of my thoughts and assumptions about memory work, about the arc of history and about imagining the future, have been turned inside out. I wrote this book in part to share that process with others. With that noted, having grown up largely based in one set of ideas and stories about the past, which I now see that I need to put aside, I realize full well that the perspective I have come to, while shared by many, is also in many ways incomprehensible to those who haven't taken this journey.

As I wake up every morning in Hyattsville, Maryland, in a home built on land that was part of Riversdale plantation, I try to center the reality of that history in my work. Slaves built the Riversdale plantation on land taken from Piscataway peoples. Our home sits at the intersection of trails, rivers, and rail networks. Traversing those intersections and historical layers presents an opportunity for memory work. Engaging with place lets us see the presence of slavery and settler colonialism everywhere. My hope is that more and more of us can see the need to reflect on that reality, to observe and confront the presence of that past every day, and bring in sets of questions to ask each day about how our work either further advances those injustices or works to counter them. My hope for a future of cultural memory is that it will be anchored in a continual attempt to seek justice and sustainability through acts of maintenance, care, and repair.

Bibliography

Abrams, Lynn. *Oral History Theory*. London: Routledge, 2016.
AFSCME Cultural Workers United. "Cultural Institutions Cashed In, Workers Got Sold Out." AFSCME CWU, October 2021. https://report.culturalworkersunited.org/
Ahuja, Simone Bhan, and James M. Loree. *Disrupt-It-Yourself: Eight Ways to Hack a Better Business—Before the Competition Does*. New York: HarperCollins Leadership, 2019.
Allington, Daniel, Beatriz L. Buarque, and Daniel Barker Flores. "Antisemitic Conspiracy Fantasy in the Age of Digital Media: Three 'Conspiracy Theorists' and Their YouTube Audiences." *Language and Literature* 30, no. 1 (2021): 78–102.
Allington, Daniel, and Tanvi Joshi. "'What Others Dare Not Say': An Antisemitic Conspiracy Fantasy and Its YouTube Audience." *Journal of Contemporary Antisemitism* 3, no. 1 (2020): 35–53.
Amnesty International. "Failing to Do Right: The Urgent Need for Palantir to Respect Human Rights." London, September 27, 2020. https://www.amnestyusa.org/wp-content/uploads/2020/09/Amnest-International-Palantir-Briefing-Report-092520_Final.pdf
Andreessen, Marc. "Why Software Is Eating the World." *Wall Street Journal* 20, August 20, 2011.
Andromeda. "'Just a Few Files': Technical Labor, Academe, and Care." *Andromeda Yelton* (blog), December 3, 2021. https://andromedayelton.com/2021/12/03/just-a-few-files-technical-labor-academe-and-care/
Anti-Oppression Network. "Allyship." *The Anti-Oppression Network* (blog), December 10, 2011. https://theantioppressionnetwork.com/allyship/
Archivists Responding to Climate c\Change. "PROJECT_ARCC—Archivists Responding to Climate Change." *Project_ARCC* (blog), June 7, 2015. https://projectarcc.org/about-us/
Arnold, Hillel, Dorothy J. Berry, Elizabeth M. Caringola, Angel Diaz, Sarah Hamerman, Erin Hurley, Anna Neatrour, et al. "Do Better—Love(,) Us: Guidelines

for Developing and Supporting Grant-Funded Positions in Digital Libraries, Archives, and Museums," January 2020. https://dobetterlabor.com

Association of Research Libraries. *Focus on Innovations, ARL-CNI Fall Forum*, October 2011. https://www.youtube.com/watch?v=um3f_FLCL8s

Association of Research Libraries. "Why the US Needs a Truth Commission and an Archive of Racial and Cultural Healing," November 10, 2021. https://www.arl.org/blog/why-the-us-needs-a-truth-commission-and-an-archive-of-racial-and-cultural-healing/

Autry Museum of the American West. "Autry's Collections Online—Painting American Progress." Accessed March 13, 2022. http://collections.theautry.org/mwebcgi/mweb.exe?request=record;id=M545330;type=101

Bad Ass Visionary Healers. "Healing Justice Principles: Some of What We Believe," October 19, 2012. https://badassvisionaryhealers.wordpress.com/healing-justice-principles/

Bailey, Moya. "All the Digital Humanists Are White, All the Nerds Are Men, but Some of Us Are Brave." *Journal of Digital Humanities* 11. Accessed January 9, 2022. http://journalofdigitalhumanities.org/1-1/all-the-digital-humanists-are-white-all-the-nerds-are-men-but-some-of-us-are-brave-by-moya-z-bailey/

Barlow, John Perry. "A Declaration of the Independence of Cyberspace." Electronic Frontier Foundation, February 8, 1996. https://www.eff.org/cyberspace-independence

Becker, Carl. "Everyman His Own Historian." *American Historical Review* 37, no. 2 (1932): 221–36.

Bellotti, Marianne. *Kill It with Fire: Manage Aging Computer Systems (and Future-Proof Modern Ones)*. San Francisco: No Starch Press, 2021.

Benes, Ross. "What's Driving the Publisher Pivot to Video, in 5 Charts (Hint: Ad $$$)." *Digiday* (blog), August 31, 2017. https://digiday.com/future-of-tv/publishers-pivoting-video-5-charts/

Berardi, Franco. *After the Future*. Oakland, CA: AK Press, 2011.

Berger, Warren. *A More Beautiful Question: The Power of Inquiry to Spark Breakthrough Ideas*. New York: Bloomsbury, 2014.

Berners-Lee, Mike. *There Is No Planet B: A Handbook for the Make or Break Years*. Cambridge, UK: Cambridge University Press, 2019.

Blumenthal, Karl, Peggy Griesinger, Julia Kim, Shira Peltzman, and Vicky Steeves. "What's Wrong with Digital Stewardship: Evaluating the Organization of Digital Preservation Programs from Practitioners' Perspectives." *Journal of Contemporary Archival Studies* 7, no. 1 (August 17, 2020). https://elischolar.library.yale.edu/jcas/vol7/iss1/13

Bowker, Geoffrey C. *Memory Practices in the Sciences*. Inside Technology. Cambridge, MA: MIT Press, 2005.

Boyatzis, Richard E., and Annie McKee. *Resonant Leadership: Renewing Yourself and Connecting with Others through Mindfulness, Hope, and Compassion*. Boston: Harvard Business School Press, 2005.

Bredbenner, Stephanie, Alison Fulmer, Meghan Rinn, Rose Oliveira, and Kimberly Barzola. "'Nothing About It Was Better Than a Permanent Job': Report of the New England Archivists Contingent Employment Study Task Force." New

England Archivists Inclusion and Diversity Committee, February 2022. https://newenglandarchivists.org/resources/Documents/Inclusion_Diversity/Continent-Employment-2022-report.pdf

Brindle, Margaret, and Peter N. Stearns. *Facing Up to Management Faddism: A New Look at an Old Force*. Westport, CT: Quorum Books, 2001.

Brock, André L. *Distributed Blackness: African American Cybercultures*. Critical Cultural Communication. New York: New York University Press, 2020.

Brown, Adrienne M. *Emergent Strategy*. Chico, CA: AK Press, 2017.

Bunderson, J. Stuart, and Jeffery A. Thompson. "The Call of the Wild: Zookeepers, Callings, and the Double-Edged Sword of Deeply Meaningful Work." *Administrative Science Quarterly* 54, no. 1 (2009): 32–57.

Burdick, Anne, Johanna Drucker, Peter Lunenfeld, Todd Presner, and Schnapp Jeffrey. *Digital_Humanities*. Cambridge, MA: MIT Press, 2012.

Burnham, Jack. "Problems of Criticism IX: Art and Technology." *Artforum*, January 1971. https://www.artforum.com/print/197101/problems-of-criticism-ix-art-and-technology-38921

Caswell, Michelle. *Urgent Archives: Enacting Liberatory Memory Work*. Routledge Studies in Archives. Abingdon, UK: Routledge, 2021.

Caswell, Michelle, and Marika Cifor. "From Human Rights to Feminist Ethics: Radical Empathy in the Archives." *Archivaria*, May 6, 2016, 23–43.

Caswell, Michelle, and Marika Cifor. "Revisiting a Feminist Ethics of Care in Archives: An Introductory Note." *Journal of Critical Library and Information Studies* 3 (June 11, 2021). https://journals.litwinbooks.com/index.php/jclis/article/view/162

Caswell, Michelle, Marika Cifor, and Mario H. Ramirez. "'To Suddenly Discover Yourself Existing': Uncovering the Impact of Community Archives." *American Archivist* 79, no. 1 (June 1, 2016): 56–81. https://doi.org/10.17723/0360-9081.79.1.56

Cecire, Natalia. "When Digital Humanities Was in Vogue Journal of Digital Humanities." *Journal of Digital Humanities* 1, no. 1. Accessed January 9, 2022. http://journalofdigitalhumanities.org/1-1/when-digital-humanities-was-in-vogue-by-natalia-cecire/

Chaddha, Anmol, and William Julius Wilson. "'Way Down in the Hole': Systemic Urban Inequality and *The Wire*." *Critical Inquiry* 38, no. 1 (2011): 164–88. https://doi.org/10.1086/661647

Chambers, Sally. "Library Labs as Experimental Incubators for Digital Humanities Research." In *TPDL 2019, 23rd International Conference on Theory and Practice of Digital Libraries, Abstracts*, 2019. http://hdl.handle.net/1854/LU-8645483

Chatzidakis, Andreas, Jamie Hakim, Jo Littler, Catherine Rottenberg, and Lynne Segal. *The Care Manifesto: The Politics of Interdependence*. New York: Verso Books, 2020.

Christen, Kimberly, and Jane Anderson. "Toward Slow Archives." *Archival Science* 2, no. 19 (June 4, 2019): 87–116. https://doi.org/10.1007/s10502-019-09307-x

Christenson, Heather. "HathiTrust: A Research Library at Web Scale." *Library Resources & Technical Services* 55, no. 2 (April 29, 2011): 93–102. https://doi.org/10.5860/lrts.55n2.93

Chun, Wendy Hui Kyong. *Programmed Visions: Software and Memory*. Software Studies. Cambridge, MA: MIT Press, 2011.
Clark, Andy. *Supersizing the Mind: Embodiment, Action, and Cognitive Extension*. Oxford: Oxford University Press, 2008.
Collins, James C. *Good to Great: Why Some Companies Make the Leap and Others Don't*. New York: Harper Business, 2001.
Collins, Patricia Hill. "Learning from the Outsider Within: The Sociological Significance of Black Feminist Thought." *Social Problems* 33, no. 6 (1986): s14–s32.
Committee on Ethics and Professional Conduct. "Recommended Revisions to SAA Core Values Statement and Code of Ethics." Society of American Archivists, August 3, 2020. https://www2.archivists.org/sites/all/files/0820-IV-A-CEPC-CodeRevisions_0.pdf
Connerton, Paul. *How Societies Remember*. Themes in the Social Sciences. Cambridge, UK: Cambridge University Press, 1989.
Corby-Tuech, Jacques. "OKR's, YouTube and the Danger of Unintended Consequences." *Jacques Corby-Tuech* (blog), January 22, 2020. https://www.jacquescorbytuech.com/writing/okr-youtube-unintended-consequences.html
Crymble, Adam. *Technology and the Historian: Transformations in the Digital Age*. Topics in the Digital Humanities. Urbana: University of Illinois Press, 2021.
Cukier, Kenneth, and Viktor Mayer-Schönberger. "The Dictatorship of Data." *MIT Technology Review*, May 31, 2013. https://www.technologyreview.com/2013/05/31/178263/the-dictatorship-of-data/
Daub, Adrian. *What Tech Calls Thinking*. New York: Farrar, Straus and Giroux, 2020.
Davies, William. *The Happiness Industry: How the Government and Big Business Sold Us Well-Being*. London: Verso, 2015.
Dean, Courtney, Lori Dedeyan, M. Angel Diaz, Melissa Haley, Margaret Hughes, and Lauren McDaniel. "UCLA Temporary Librarians," June 11, 2018. https://docs.google.com/document/d/1h-P7mWiUn27b2nrkk-1eMbDkqSZtk4Moxis07KcMwhI/mobilebasic
De Jesus, N. "Locating the Library in Institutional Oppression." *In the Library with the Lead Pipe*, September 24, 2014.
Dewey, M. "Editorial Notes." *American Library Journal* 11, no. 1 (1870): 395.
D'Ignazio, Catherine, and Lauren F. Klein. *Data Feminism*. Strong Ideas Series. Cambridge, MA: MIT Press, 2020.
Doerr, John E. *Measure What Matters: How Google, Bono, and the Gates Foundation Rock the World with OKRs*. New York: Portfolio/Penguin, 2018.
Downie, J. Stephen, Mike Furlough, Robert H. McDonald, Beth Namachchivaya, Beth A. Plale, and John Unsworth. "The HathiTrust Research Center: Exploring the Full-Text Frontier." May 1, 2016. https://experts.illinois.edu/en/publications/the-hathitrust-research-center-exploring-the-full-text-frontier
Drake, Jarrett M. "RadTech Meets RadArch: Towards A New Principle for Archives and Archival Description." *On Archivy*, April 6, 2016. https://medium.com/on-archivy/radtech-meets-radarch-towards-a-new-principle-for-archives-and-archival-description-568f133e4325#.gk8s8781p
Drucker, Johanna. "Graphesis: Visual Knowledge Production and Representation." *Poetess Archive Journal* 2, no. 1 (December 10, 2010). http://paj.muohio.edu/paj/index.php/paj/article/view/4

Drucker, Johanna. "Sustainability and Complexity: Knowledge and Authority in the Digital Humanities." *Digital Scholarship in the Humanities* 36, Supplement_2 (October 1, 2021): ii86–ii94. https://doi.org/10.1093/llc/fqab025

Drucker, Peter F. *The Age of Discontinuity: Guidelines to Our Changing Society.* New York: Harper & Row, 1969.

The Economist. "Jeremy Corbyn, Entrepreneur," June 15, 2017. https://www.economist.com/britain/2017/06/15/jeremy-corbyn-entrepreneur

Edwards, Paul N. *The Closed World: Computers and the Politics of Discourse in Cold War America.* Inside Technology. Cambridge, MA: MIT Press, 1996.

Ellis, Janey. "A Return to the Autry." *Atomic Redhead* (blog), May 21, 2016. https://atomicredhead.com/2016/05/21/a-return-to-the-autry/

Eshun, Kodwo. "Further Considerations of Afrofuturism." *CR: The New Centennial Review* 3, no. 2 (2003): 287–302.Estes, Nick. *Our History Is the Future: Standing Rock versus the Dakota Access Pipeline, and the Long Tradition of Indigenous Resistance.* New York: Verso, 2019.

Ettarh, Fobazi. "Vocational Awe and Librarianship: The Lies We Tell Ourselves." *In the Library with the Lead Pipe*, January 10, 2018. http://www.inthelibrarywiththeleadpipe.org/2018/vocational-awe/

Florida, Richard L. *The Rise of the Creative Class.* New York: Basic Books, 2002.

Florida, Richard L. *The Rise of the Creative Class: Revisited.* New York: Basic Books, 2012.

Ford, Anne. "Saving Lives in the Stacks." *American Libraries* 48, no. 9–10 (2017): 44–49.

Franklin, Benjamin, and Bliss Perry. *Benjamin Franklin: Selections from Autobiography, Poor Richard's Almanac, Advice to a Young Tradesman, The Whistle, Necessary Hints to Those That Would Be Rich, Motion for Prayers, Selected Letters.* Little Masterpieces, edited by Bliss Perry. New York: Doubleday & McClure Co., 1898.

Freedman, David H. "Why Scientific Studies Are So Often Wrong: The Streetlight Effect." *Discover Magazine*, December 9, 2010. https://www.discovermagazine.com/the-sciences/why-scientific-studies-are-so-often-wrong-the-streetlight-effect

Fujikane, Candace. *Mapping Abundance for a Planetary Future: Kanaka Maoli and Critical Settler Cartographies in Hawai'i.* Durham, NC: Duke University Press, 2021.

Gallon, Kim. "Making a Case for the Black Digital Humanities." In *Debates in the Digital Humanities*, 42–49. Minneapolis: University of Minnesota Press, 2016.

Garrison, Dee. *Apostles of Culture: The Public Librarian and American Society, 1876–1920.* New York: Macmillan Information, 1979.

Geary, Jade, and Brittany Hickey. "When Does Burnout Begin? The Relationship Between Graduate School Employment and Burnout Amongst Librarians." *In the Library with the Lead Pipe*, October 16, 2019. http://www.inthelibrarywiththeleadpipe.org/2019/when-does-burnout-begin/

Gibbs, Fred, and Trevor Owens. "The Hermeneutics of Data and Historical Writing." In *Writing History in the Digital Age*, edited by Kristen Nawrotzki and Jack Dougherty. Ann Arbor: University of Michigan Press, 2013. http://hdl.handle.net/2027/spo.12230987.0001.001

Giddens, Anthony. *Runaway World: How Globalisation Is Reshaping Our Lives*. 2nd ed. New York: Routledge, 2003.
Gil, Alex. "Nimble Tents: Xpmethod, #tornapart, and Other Tensile Approaches to the Fourth Estate." Presented at the MITH Digital Dialogue, University of Maryland, College Park, November 6, 2018. https://mith.umd.edu/dialogues/dd-fall-2018-alex-gil/
Gillis, John R., ed. *Commemorations: The Politics of National Identity*. Princeton, NJ: Princeton University Press, 1996.
Gimpl, Martin L., and Stephen R. Dakin. "Management and Magic." *California Management Review* 27, no. 1 (October 1, 1984): 125–36. https://doi.org/10.2307/41165117
Gitelman, Lisa, ed. *"Raw Data" Is an Oxymoron*. Infrastructures Series. Cambridge, MA: MIT Press, 2013.
Glass, Gene V. *Fertilizers, Pills, and Magnetic Strips: The Fate of Public Education in America*. Charlotte, NC: Information Age Publishing, 2008.
Global Digital Humanities Working Group. "Minimal Computing." Accessed April 2, 2017. http://go-dh.github.io/mincomp/
Goddess, Moor Mother. "Forethought." *Black Quantum Futurism Theory & Practice* 1 (2015): 7–10.
Goodrow, Cristos. "You Know What's Cool? A Billion Hours." *YouTube Official Blog* (blog), February 27, 2017. https://blog.youtube/news-and-events/you-know-whats-cool-billion-hours/
Greenberg, Andy. "How a 'Deviant' Philosopher Built Palantir, a CIA-Funded Data-Mining Juggernaut." *Forbes*, September 1, 2013. https://www.forbes.com/sites/andygreenberg/2013/08/14/agent-of-intelligence-how-a-deviant-philosopher-built-palantir-a-cia-funded-data-mining-juggernaut/
Greenleaf, Robert K. *Servant Leadership: A Journey into the Nature of Legitimate Power and Greatness*. New York: Paulist Press, 1977.
Gregg, Melissa. *Counterproductive: Time Management in the Knowledge Economy*. Durham, NC: Duke University Press, 2018.
Grinspoon, David. *Earth in Human Hands: Shaping Our Planet's Future*. New York: Grand Central Publishing, 2016.
Guyau, Jean-Marie. "Memory and Phonograph." In Friedrich Kittler, *Gramophone, Film, Typewriter*, translated by Geoffrey Winthrop-Young and Michael Wutz (Stanford, CA: Stanford University Press, 1999), 30–33. First published in *Revue Philosophique de La France et de l'étranger* 5, 1880, 319–22.
Halbwachs, Maurice, and Lewis A. Coser. *On Collective Memory*. The Heritage of Sociology. Chicago: University of Chicago Press, 1992.
Halverson, Erica, Alexandra Lakind, and Rebekah Willett. "The Bubbler as Systemwide Makerspace: A Design Case of How Making Became a Core Service of the Public Libraries." *International Journal of Designs for Learning* 8, no. 1 (2017).
Haraway, Donna. "Anthropocene, Capitalocene, Plantationocene, Chthulucene: Making Kin." *Environmental Humanities* 6, no. 1 (2015): 159–65.
Haraway, Donna. "Situated Knowledges: The Science Question in Feminism and the Privilege of Partial Perspective." *Feminist Studies* 14, no. 3 (1988): 575–99. https://doi.org/10.2307/3178066

Haraway, Donna. *Staying with the Trouble: Making Kin in the Chthulucene.* Experimental Futures: Technological Lives, Scientific Arts, Anthropological Voices. Durham, NC: Duke University Press, 2016.

Harding, Sandra. "Rethinking Standpoint Epistemology: What Is 'Strong Objectivity?'" *Centennial Review* 36, no. 3 (1992): 437–70.

Harris, Roma M. *Librarianship: The Erosion of a Woman's Profession.* Norwood, NJ: Ablex Publishing Corporation, 1992. http://archive.org/details/librarianshiper00000harr

Harvard Library. "About Harvard Library." Harvard Library. Accessed May 9, 2022. https://library.harvard.edu/visit-about/about-harvard-library

Hauben, Michael. "The Netizens and Community Networks." Presented at the Hypernetwork '95 Beppu Bay Conference. Beppu Bay, Japan, November 24, 1995. http://www.columbia.edu/~hauben/text/bbc95spch.txt

Haudenosaunee Confederacy. "Values—Haudenosaunee Confederacy." Accessed April 30, 2022. https://www.haudenosauneeconfederacy.com/values/

Held, Virginia. *The Ethics of Care: Personal, Political, and Global.* Oxford: Oxford University Press, 2006.

Hickel, Jason. *Less Is More: How Degrowth Will Save the World.* London: William Heinemann, 2020.

Hicks, Dan. *The Brutish Museums: The Benin Bronzes, Colonial Violence and Cultural Restitution.* London: Pluto Press, 2020.

Honan, Mat. "Why Facebook And Mark Zuckerberg Went All In On Live Video." *BuzzFeed News*, April 6, 2016. https://www.buzzfeednews.com/article/mathonan/why-facebook-and-mark-zuckerberg-went-all-in-on-live-video

Horan, Hubert. "Will the Growth of Uber Increase Economic Welfare?" *Transportation Law Journal* 44 (2017): 33.

Howell, Martha C., and Walter Prevenier. *From Reliable Sources: An Introduction to Historical Methods.* Ithaca, NY: Cornell University Press, 2001.

Hughes-Watkins, Lae'l. "Moving Toward a Reparative Archive: A Roadmap for a Holistic Approach to Disrupting Homogenous Histories in Academic Repositories and Creating Inclusive Spaces for Marginalized Voices." *Journal of Contemporary Archival Studies* 5, no. 1 (May 16, 2018). https://elischolar.library.yale.edu/jcas/vol5/iss1/6

Hutchins, Edwin. *Cognition in the Wild.* Cambridge, MA: MIT Press, 1995.

Jackson, Steven J. "Rethinking Repair." In *Essays on Communication, Materiality, and Society*, edited by Kirsten A. Foot, Pablo J. Boczkowski, and Tarleton Gillespie,. Cambridge, MA: MIT Press, 2014.

Jarvis, Jeff. *What Would Google Do?* New York: HarperCollins, 2009.

Johnson, Whitney. *Disrupt Yourself: Putting the Power of Disruptive Innovation to Work.* Brookline, MA: Bibliomotion, 2015.

Jordanova, L. J. *History in Practice.* 2nd ed. London: Hodder Arnold, 2006.

Kallis, Giorgos. *The Case for Degrowth.* The Case for Series. Cambridge, UK: Polity Press, 2020.

Kelly, Kevin. "Scan This Book!" *New York Times Magazine*, May 14, 2006.

Kendrick, Kaetrena Davis. "The Low Morale Experience of Academic Librarians: A Phenomenological Study." *Journal of Library Administration* 57, no. 8 (November 17, 2017): 846–78. https://doi.org/10.1080/01930826.2017.1368325

Kim, Dorothy, and Jesse Stommel. "Disrupting the Digital Humanities: An Introduction." In *Disrupting the Digital Humanities*. Santa Barbara, CA: Punctum Books, 2018.

Kimmerer, Robin Wall. *Braiding Sweetgrass: Indigenous Wisdom, Scientific Knowledge, and the Teachings of Plants*. Minneapolis, MN: Milkweed Editions, 2020.

Kinney, Alison. *Hood*. New York: Bloomsbury Academic, 2016.

Kipps-Brown, Lisa, Steve Sims, and Charles Kipps. *Disrupt Your Now: The Successful Entrepreneur's Guide to Reimagining Your Business & Life*, 2021.

Koo, Wei Lin, and Tracy Van Hoy. "Determining the Economic Value of Preventive Maintenance." Jones Lange LaSalle, 2002. http://cdn.ifma.org/sfcdn/docs/default-source/default-document-library/determining-the-economic-value-of-preventative-maintenance.pdf?sfvrsn=2

Kuehn, Kathleen, and Thomas F. Corrigan. "Hope Labor: The Role of Employment Prospects in Online Social Production." *The Political Economy of Communication* 1, no. 1 (May 16, 2013). https://polecom.org/index.php/polecom/article/view/9

Lareau, Annette. *Unequal Childhoods: Class, Race, and Family Life*. Berkeley: University of California Press, 2003.

Lederman, Doug. "The Faculty Shrinks, but Tilts to Full-Time." *Inside Higher Ed*, November 27, 2019. https://www.insidehighered.com/news/2019/11/27/federal-data-show-proportion-instructors-who-work-full-time-rising

Leon, Sharon. "Complicating a 'Great Man' Narrative of Digital History in the United States." In *Bodies of Information: Intersectional Feminism and Digital Humanities*, edited by Elizabeth Losh and Jacqueline Wernimont. Debates in the Digital Humanities. Minneapolis: University of Minnesota Press, 2018. https://dhdebates.gc.cuny.edu/read/untitled-4e08b137-aec5-49a4-83c0-38258425f145/section/53838061-eb08-4f46-ace0-e6b15e4bf5bf

Lepore, Jill. "What the Gospel of Innovation Gets Wrong." *New Yorker*, June 16, 2014. http://www.newyorker.com/magazine/2014/06/23/the-disruption-machine

Levine, Caroline. *Forms: Whole, Rhythm, Hierarchy, Network*. Princeton: Princeton University Press, 2015.

Levy, Steven. *Hackers: Heroes of the Computer Revolution*. Garden City, NY: Anchor Press/Doubleday, 1984.

Liboiron, Max. *Pollution Is Colonialism*. Durham, NC: Duke University Press, 2021.

LIS Microaggressions. "Microaggressions in Librarianship." Accessed March 19, 2022. https://lismicroaggressions.com/

Littletree, Sandra, Miranda Belarde-Lewis, and Marisa Duarte. "Centering Relationality: A Conceptual Model to Advance Indigenous Knowledge Organization Practices." *Knowledge Organization* 47, no. 5 (November 2020): 410–26.

Lloyd, Patrick. "The Public Library as a Protective Factor: An Introduction to Library Social Work." *Public Library Quarterly* 39, no. 1 (2020): 50–63.

Mackay, Ralph. "Publisher's Devices: Harper & Brothers: Passing the Torch." *Chumley & Pepys On Books* (blog), May 17, 2010. http://chumleyandpepys.blogspot.com/2010/05/publishers-devices-harper-brothers.html

Mackenzie, Ewan, and Alan McKinlay. "Hope Labour and the Psychic Life of Cul-

tural Work." *Human Relations* 74, no. 11 (November 1, 2021): 1841–63. https://doi.org/10.1177/0018726720940777

Madrigal, Alexis C. "The Uber IPO Is a Landmark." *The Atlantic*, April 11, 2019. https://www.theatlantic.com/technology/archive/2019/04/ubers-ipo-historic-despite-its-10-billion-loss/586999/

Margulis, Lynn. *Symbiotic Planet: A New Look at Evolution*. Science Masters. New York: Basic Books, 1998.

Mattern, Shannon. *A City Is Not a Computer: Other Urban Intelligences*. Places Books. Princeton: Princeton University Press, 2021.

Mazurczyk, T., N. Piekielek, E. Tansey, and B. Goldman. "American Archives and Climate Change: Risks and Adaptation." *Climate Risk Management* 20 (January 1, 2018): 111–25. https://doi.org/10.1016/j.crm.2018.03.005

Mbembe, Achille, and Steve Corcoran. *Necropolitics*. Theory in Forms. Durham, NC: Duke University Press, 2019.

McClellan, Andrew. *Inventing the Louvre: Art, Politics, and the Origins of the Modern Museum in Eighteenth-Century Paris*. Cambridge, UK: Cambridge University Press, 1994.

McCracken, Krista, and Skylee-Storm Hogan. "Residential School Community Archives: Spaces of Trauma and Community Healing." *Journal of Critical Library and Information Studies* 3, no. 2 (2021). https://doi.org/10.24242/jclis.v3i2.115

McGuigan, Glenn S. "Publishing Perils in Academe: The Serials Crisis and the Economics of the Academic Journal Publishing Industry." *Journal of Business & Finance Librarianship* 10, no. 1 (2004): 13–26.

McKenna, Christopher D. *The World's Newest Profession: Management Consulting in the Twentieth Century*. New York: Cambridge University Press, 2006.

Mears, Jaime. "Memory Lab Network: An Interview with Project Manager Lorena Ramirez-Lopez." *The Signal* (blog), December 7, 2017. //blogs.loc.gov/thesignal/2017/12/memory-lab-network-an-interview-with-project-manager-lorena-ramirez-lopez/

Miller, Daniel Taninecz. "Characterizing QAnon: Analysis of YouTube Comments Presents New Conclusions about a Popular Conservative Conspiracy." *First Monday*, 2021.

Mills, Charles W. "White Time: The Chronic Injustice of Ideal." *Du Bois Review: Social Science Research on Race* 11, no. 1 (2014): 27–42.

Minnesota Historical Society. "Did the Minnesota Historical Society Display the Remains of Taoyateduta (Little Crow) at the Minnesota State Capitol?" The U.S.-Dakota War of 1862. Accessed March 12, 2022. https://www.usdakotawar.org/frequently-asked-questions/1325

Mintzberg, Henry. *The Rise and Fall of Strategic Planning: Reconceiving Roles for Planning, Plans, Planners*. Toronto: Free Press; Maxwell Macmillan Canada, 1994.

Muller, Jerry Z. *The Tyranny of Metrics*. Princeton: Princeton University Press, 2018.

Muñoz, José Esteban. *Cruising Utopia: The Then and There of Queer Futurity*. 10th Anniversary Edition. Sexual Cultures. New York: New York University Press, 2019.

Murphy, Michelle. "Unsettling Care: Troubling Transnational Itineraries of Care in Feminist Health Practices." *Social Studies of Science* 45, no. 5 (2015): 717–37.

Museums Association. "The Museums Charter." In *Museum Provision and Professionalism*, edited by Gaynor Kavanagh. Leicester Readers in Museum Studies. New York: Routledge, 1994.

Nakamura, Lisa. *Cybertypes: Race, Ethnicity, and Identity on the Internet*. New York: Routledge, 2002.

Narayan, Uma. "Colonialism and Its Others: Considerations On Rights and Care Discourses." *Hypatia* 10, no. 2 (1995): 133–40. https://doi.org/10.1111/j.1527-2001.1995.tb01375.x

Nash, Jennifer C. "Re-Thinking Intersectionality." *Feminist Review*, no. 89 (2008): 1–15.

National Archives. "Mission, Vision and Values." National Archives, August 15, 2016. https://www.archives.gov/about/info/mission

National Park Service. "Previous Grant Awards—Native American Graves Protection and Repatriation Act (U.S. National Park Service)." Accessed March 19, 2022. https://www.nps.gov/subjects/nagpra/previously-awarded-grants.htm

New Faculty Majority. "Facts about Adjuncts." Accessed November 14, 2021. https://www.newfacultymajority.info/facts-about-adjuncts/

Nichol, Peter B. *Think Lead Disrupt: How Innovative Minds Connect Strategy to Execution*. Self-published. 2021.

Noble, Safiya Umoja. *Algorithms of Oppression: How Search Engines Reinforce Racism*. New York: New York University Press, 2018.

Noddings, Nel. *Caring: A Feminine Approach to Ethics & Moral Education*. 2nd ed. Berkeley: University of California Press, 2003.

Nowviskie, Bethany. "Digital Humanities in the Anthropocene." *Bethany Nowviskie* (blog), July 10, 2014. https://nowviskie.org/2014/anthropocene/

Odell, Jenny. *How to Do Nothing: Resisting the Attention Economy*. Brooklyn, NY: Melville House, 2019.

Olson, D., J. Meyerson, M. A. Parsons, J. Castro, M. Lassere, D. J. Wright, H. Arnold, et al. "Information Maintenance as a Practice of Care," June 17, 2019. https://doi.org/10.5281/zenodo.3251131

Ordóñez, Lisa D., Maurice E. Schweitzer, Adam D. Galinsky, and Max H. Bazerman. "Goals Gone Wild: The Systematic Side Effects of Overprescribing Goal Setting." *Academy of Management Perspectives* 23, no. 1 (2009): 6–16.

O'Reilly, Charles A., III, and Michael L. Tushman. *Lead and Disrupt: How to Solve the Innovator's Dilemma*. 2nd ed. Stanford: Stanford Business Books, 2021.

Owens, Trevor. "Defining Data for Humanists: Text, Artifact, Information or Evidence." *Journal of Digital Humanities* 1, no. 1 (2011): 1.

Owens, Trevor. "The Digital Humanities as the DIY Humanities." *Trevor Owens* (blog), July 23, 2011. http://www.trevorowens.org/2011/07/the-digital-humanities-as-the-diy-humanities/

Owens, Trevor. "A Good Jobs Strategy for Libraries." *Library Leadership & Management* 35, no. 3 (November 15, 2021). https://doi.org/10.5860/llm.v35i3.7486

Paolillo, John C. "The Flat Earth Phenomenon on YouTube." *First Monday*, 2018.

Patton, Michael Quinn. *Blue Marble Evaluation: Premises and Principles*. New York: Guilford Press, 2020.

Pendergrass, Keith L., Walker Sampson, Tim Walsh, and Laura Alagna. "Toward

Environmentally Sustainable Digital Preservation." *American Archivist* 82, no. 1 (March 2019): 165–206. https://doi.org/10.17723/0360-9081-82.1.165

Perlin, Ross. *Intern Nation: How to Earn Nothing and Learn Little in the Brave New Economy*. Brooklyn, NY: Verso Books, 2011.

Perry, Dave. "Be Online or Be Irrelevant." *Academhack: Thoughts on Emerging Media and Higher Education* (blog), January 11, 2010. https://web.archive.org/web/20161114014524/http://academhack.outsidethetext.com:80/home/2010/be-online-or-be-irrelevant/

Petersen, Anne Helen. *Can't Even: How Millennials Became the Burnout Generation*. Boston: Houghton Mifflin Harcourt, 2020.

Phillips, Patricia C., ed. *Mierle Laderman Ukeles: Maintenance Art*. New York: DelMonico Books/Prestel, 2016.

Piepzna-Samarasinha, Leah Lakshmi. *Care Work: Dreaming Disability Justice*. Vancouver: Arsenal Pulp Press, 2018.

Pink, Daniel H. *Free Agent Nation: The Future of Working for Yourself*. New edition. New York: Warner Books, 2002.

Powers, Devon. *On Trend: The Business of Forecasting the Future*. Urbana: University of Illinois Press, 2019.

Project Management Institute. *A Guide to the Project Management Body of Knowledge*. 6th ed. PMBOK Guide. Newtown Square, PA: Project Management Institute, 2017.

Puig de la Bellacasa, María. *Matters of Care: Speculative Ethics in More than Human Worlds*. Posthumanities 41. Minneapolis: University of Minnesota Press, 2017.

Purdy, Jedediah. *After Nature: A Politics for the Anthropocene*. Cambridge, MA: Harvard University Press, 2015.

Raschke, Greg. "ARL Collections Presentation: Moneyball, the Extra 2%, and What Baseball Management Can Teach Us About Fostering Innovation in Managing Collections." October 2011. https://www.slideshare.net/gkraschk/arl-collections-presentation-moneyball-the-extra-2-and-what-baseball-management-can-teach-us-about-fostering-innovation-in-managing-collections

Reed, Brandon. An Act Relating to Education and Declaring an Emergency, Pub. L. No. HB487 (2022). https://trackbill.com/bill/kentucky-house-bill-487-an-act-relating-to-education-and-declaring-an-emergency/2225062/

Reid, Donald M. *Whose Pharaohs? Archaeology, Museums, and Egyptian National Identity from Napoleon to World War I*. Berkeley: University of California Press, 2002.

Risam, Roopika. *New Digital Worlds: Postcolonial Digital Humanities in Theory, Praxis, and Pedagogy*. Evanston, IL: Northwestern University Press, 2019.

Roemer, Robin Chin, and Verletta Kern, eds. *The Culture of Digital Scholarship in Academic Libraries*. Chicago: ALA Editions, 2019.

Rose, Matthew, and Jonathan Star. "Using Scenarios to Explore Climate Change: A Handbook for Practitioners." 2013, US National Park Service, Climate Change Response Program. Online at https://www.nps.gov/subjects/climatechange/resources.htm

Salo, Dorothea. "Innkeeper at the Roach Motel." *Library Trends* 57, no. 2 (2008): 98–123.

Samit, Jay. *Disrupt You! Master Personal Transformation, Seize Opportunity, and Thrive in the Era of Endless Innovation.* New York: Flatiron Books, 2015.

Samuels, Ellen. "Six Ways of Looking at Crip Time." *Disability Studies Quarterly* 37, no. 3 (August 31, 2017). https://doi.org/10.18061/dsq.v37i3.5824

Scheinfeldt, Tom. "Brand Name Scholar." *Found History* (blog), February 26, 2009. https://foundhistory.org/2009/02/brand-name-scholar/

Scott, James C. *Seeing Like a State: How Certain Schemes to Improve the Human Condition Have Failed.* New Haven: Yale University Press, 1998.

Scranton, Roy. *Learning to Die in the Anthropocene: Reflections on the End of a Civilization.* San Francisco: City Lights Books, 2015.

Shayler, Mark. *Do Disrupt—Change the Status Quo or Become It.* Do Book Company. 2017.

Shirky, Clay. *Here Comes Everybody: The Power of Organizing without Organizations.* New York: Penguin Books, 2009.

Sinetar, Marsha. *Do What You Love, the Money Will Follow: Discovering Your Right Livelihood.* New York: Dell, 1989.

Skinner, Katherine, Sarah Lippincott, Julie Griffin, and Tyler Walters. "Library-as-Publisher: Capacity Building for the Library Publishing Subfield." *Journal of Electronic Publishing* 17 (2), 2014.

Smithsonian Institution. "Purpose and Vision." Smithsonian Institution. Accessed May 9, 2022. https://www.si.edu/about/mission

Society of American Archivists. "SAA Core Values Statement and Code of Ethics," 2011. https://www2.archivists.org/statements/saa-core-values-statement-and-code-of-ethics.

Society of American Archivists. "SAA Dictionary: Reparative Description." Accessed March 13, 2022. https://dictionary.archivists.org/entry/reparative-description.html

Southern Poverty Law Center. "Whose Heritage? Public Symbols of the Confederacy." Montgomery, AL: Southern Poverty Law Center, February 1, 2019. https://www.splcenter.org/20190201/whose-heritage-public-symbols-confederacy

Srnicek, Nick. *Platform Capitalism.* Theory Redux. Cambridge, UK: Polity, 2017.

Stieber, David. "America's Teachers Aren't Burned Out. We Are Demoralized." *EdSurge News*, February 14, 2022. https://www.edsurge.com/news/2022-02-14-america-s-teachers-aren-t-burned-out-we-are-demoralized

Stroh, David Peter. *Systems Thinking for Social Change: A Practical Guide to Solving Complex Problems, Avoiding Unintended Consequences, and Achieving Lasting Results.* White River Junction, VT: Chelsea Green Publishing, 2015.

Sweeney, Liam, and Roger Schonfeld. "Inclusion, Diversity, and Equity: Members of the Association of Research Libraries." Ithaka S+R, August 30, 2017. https://doi.org/10.18665/sr.304524

System Company. *How to Systematize the Day's Work.* System Company, 1911.

TallBear, Kim. "Annual Meeting: The US-Dakota War and Failed Settler Kinship." *Anthropology News* 57, no. 9 (2016): e92–e95. https://doi.org/10.1111/AN.137

Taplin, Jonathan. *Move Fast and Break Things: How Facebook, Google, and Amazon Cornered Culture and Undermined Democracy.* New York: Little, Brown and Company, 2017.

Tenopir, Carol, Robert J. Sandusky, Suzie Allard, and Ben Birch. "Research Data Management Services in Academic Research Libraries and Perceptions of Librarians." *Library & Information Science Research* 36, no. 2 (2014): 84–90.

Terrile, Vikki C. "Public Library Support of Families Experiencing Homelessness." *Journal of Children and Poverty* 22, no. 2 (2016): 133–46.

Tharani, Karim. "Collections Digitization Framework: A Service-Oriented Approach to Digitization in Academic Libraries," *Canadian Journal of Library and Information Practice and Research* 7, no. 2 (2012).

Thiel, Peter A. *Zero to One: Notes on Startups, or How to Build the Future*. New York: Crown Business, 2014.

Tokumitsu, Miya. *Do What You Love: And Other Lies about Success and Happiness*. New York: Regan Arts, 2015.

Ton, Zeynep. *The Good Jobs Strategy: How the Smartest Companies Invest in Employees to Lower Costs and Boost Profits*. Boston: New Harvest, 2014.

Toronto, Joan, and Bernice Fischer. "Toward a Feminist Theory of Caring." In *Circles of Care: Work and Identity in Women's Lives*, edited by Emily K. Abel and Margaret K. Nelson. Albany: State University of New York Press, 1990.

Trevor-Roper, Hugh. "The Invention of Tradition: The Highland Tradition of Scotland." In *The Invention of Tradition*, 15–41. Cambridge, UK: Cambridge University Press, 1983.

Tronto, Joan C. *Caring Democracy: Markets, Equality, and Justice*. New York: New York University Press, 2013.

Tsing, Anna Lowenhaupt. *The Mushroom at the End of the World: On the Possibility of Life in Capitalist Ruins*. Princeton: Princeton University Press, 2015.

Tuck, Eve, and K. Wayne Yang. "Decolonization Is Not a Metaphor." *Tabula Rasa*, no. 38 (2021): 61–111.

Turner, Fred. *From Counterculture to Cyberculture: Stewart Brand, the Whole Earth Network, and the Rise of Digital Utopianism*. Chicago: University of Chicago Press, 2008.

Ukeles, Mierle Laderman. "Manifesto for Maintenance Art 1969! Proposal for an Exhibition, 'CARE,'" 1969. Queens Museum. https://queensmuseum.org/wp-content/uploads/2016/04/Ukeles-Manifesto-for-Maintenance-Art-1969.pdf

unmakethecollection. "Unmake the Collection." *Unmake the Collection* (blog), November 6, 2018. https://unmakethecollection.wordpress.com/2018/11/06/unmake-the-collection/

U.S. National Archives. "Guiding Principles for Reparative Description at NARA." National Archives, January 10, 2022. https://www.archives.gov/research/reparative-description/principles

Vaidhyanathan, Siva. *The Googlization of Everything: And Why We Should Worry*. Los Angeles: University of California Press, 2012.

Vinsel, Lee, and Andrew L. Russell. *The Innovation Delusion: How Our Obsession with the New Has Disrupted the Work That Matters Most*. New York: Currency, 2020.

Vranica, Suzanne, and Jack Marshall. "Facebook Overestimated Key Video Metric for Two Years." *Wall Street Journal*, September 22, 2016, sec. Business. https://www.wsj.com/articles/facebook-overestimated-key-video-metric-for-two-years-1474586951Waldman, Peter, Lizette Chapman, and Jordan Robert-

son. "Palantir Knows Everything About You." *Bloomberg.Com*, April 19, 2018. https://www.bloomberg.com/features/2018-palantir-peter-thiel/

Watters, Audrey. "MOOC Mania: Debunking the Hype around Massive Open Online Courses." *The Digital Shift* (blog), April 18, 2013. http://www.thedigitalshift.com/2013/04/featured/got-mooc-massive-open-online-courses-are-poised-to-change-the-face-of-education/

Weber, Chela Scott. "Research and Learning Agenda for Archives, Special, and Distinctive Collections and Research Libraries." Dublin, OH: OCLC Research, 2017. https://doi.org/10.25333/C3C34F

Weber, Chela, Martha Conway, Nicholas Martin, Gioia Stevens, and Brigette Kamsler. "Total Cost of Stewardship: Responsible Collection Building in Archives and Special Collections," 2021. https://doi.org/10.25333/ZBH0-A044

Weber, Max, and Talcott Parsons. *The Protestant Ethic and the Spirit of Capitalism*. Mineola, NY: Dover Publications, 2003.

Werner, David. *Nothing About Us Without Us: Developing Innovative Technologies For, By, and With Disabled Persons*. Palo Alto, CA: Healthwrights, 1998.

White, Hayden V. *Metahistory: The Historical Imagination in Nineteenth-Century Europe*. Baltimore: Johns Hopkins University. Press, 2000.

Williams, Luke. *Disrupt: Think the Unthinkable to Spark Transformation in Your Business*. Upper Saddle River, NJ: FT Press, 2010.

Winn, Samantha R. "Dying Well in the Anthropocene: On the End of Archivists." *Journal of Critical Library and Information Studies* 3, no. 1 (May 17, 2020). https://doi.org/10.24242/jclis.v3i1.107

Winston, Ali. "License-Plate Readers Let Police Collect Millions of Records on Drivers." Center for Investigative Reporting, June 26, 2013. https://web.archive.org/web/20170616021807/http://cironline.org/reports/license-plate-readers-let-police-collect-millions-records-drivers-4883

Wood, Barbara A., Ana B. Guimaraes, Christina E. Holm, Sherrill W. Hayes, and Kyle R. Brooks. "Academic Librarian Burnout: A Survey Using the Copenhagen Burnout Inventory (CBI)." *Journal of Library Administration* 60, no. 5 (July 3, 2020): 512–31. https://doi.org/10.1080/01930826.2020.1729622

Woodman, Spencer. "Palantir Provides the Engine for Donald Trump's Deportation Machine." *The Intercept* (blog), March 2, 2017. https://theintercept.com/2017/03/02/palantir-provides-the-engine-for-donald-trumps-deportation-machine/

Zeitlin, Matthew. "Why WeWork Went Wrong." *The Guardian*, December 20, 2019. http://www.theguardian.com/business/2019/dec/20/why-wework-went-wrong

Zeynep Tufekci. "YouTube, the Great Radicalizer." *New York Times* 10 (2018): 2018.

Zhao, Yong. *What Works May Hurt: Side Effects in Education*. New York: Teachers College Press, 2018.

Zimpfer, Geoff. *Disrupt or Die: How to Survive and Thrive the Digital Real Estate Shift*. Independently published, 2020.

Index

abundance mindset, 9, 128–130, 191
afrofuturism, 7–8, 182–183
allyship, 15–17, 171–178
Amazon, 22, 29, 33–35
American Progress, 175–177
anthropocene, 6–9, 77, 130, 151, 189
anthropology museums, 164–174
anticolonial, 154, 183–188
archaeology, 129, 152, 166–174
archives, 1–3, 12, 36–46, 120–124, 125–139; careers, 93–108; liberatory, 167–173
attention economy, 52–53, 79, 92, 103, 175

Benin bronzes, 152–157, 163–167, 186
biology, 149–150
blogging, 30, 79–83, 92, 108, 176–178, 193
British Museum, 156, 164–167
brown, adrienne maree, 7–8, 188–189
buffalo/bison, 175–177
burnout, 80, 91, 96–99, 118–119
buzzwords, 25

capitalism, 8, 35, 47, 87, 130, 137, 179, 184, 193
carbon, 130–132
care, 7–9, 16–17, 113–119, 135–156
Caswell, Michelle, 12, 145–146

Center for History and New Media, 80–83, 93, 109, 125
Chmiel, Marjee, 103, 109
Christensen, Clayton, 24–25, 32
climate change, 6–9, 77, 130–137
collective memory, 11–13
colonialism, 14, 17, 115, 129, 157–159, 184–198, 192–195
computing, 10–13, 22–28, 85, 131–132
concerted cultivation, 91–93, 103
COVID-19 pandemic, 5, 135–138, 154
crip time, 168
cultural heritage collections, 3, 17, 38, 43–45, 95, 117–126, 145–146, 157, 162–178

Dakota peoples, 161–163, 177–179
dashboards, 64–67
data, 10–13, 43–78, 117, 127, 170
data analytics, 1, 43–71
democracy, 51, 140–141
digital humanities, 6, 17, 79–84, 100, 108, 120–127
digitization, 38–39
disability justice movement, 8–9, 142–144, 168, 172
disruption, 21–42, 191–193
Doerr, John, 47–52
Drucker, Johanna, 121–124

211

economy, 7, 35, 85, 93–94, 132, 158
ecosystems, 128, 139, 149, 178–180
educational reform, 54–73,
electronic frontier, 28, 176
emergent strategy, 7–8, 183, 188–189
Estes, Nick, 151, 162–168, 178–179
ethics of care, 137–140, 154–158
evaluation, 47, 56, 72–77, 122
exhibition, 114, 122, 132, 164, 173–180
extinction, 1, 6, 8, 130
extractive thinking, 9, 77, 129–130, 179, 194

Facebook, 22–25, 31–36, 47, 70–71, 92
fear, 2, 9, 22–25, 41, 70, 91
feminist theory, 6–9, 21–22, 71–77, 114–115, 137–141, 152
Fischer, Bernice, 139–140
Florida, Richard, 6, 85–86
frontier, 28, 176, 192
future, 2–16, 61, 64–68, 71–72; 150–151, 181–186, of work, 85–101

genocide, 157, 169
gig economy, 5, 84–86, 94
Glass, Gene, 46, 52–55, 73
goal setting, 45–61, 72, 76–78, 134–138, 154, 172, 185
Goodrow, Cristos, 49–51, 66
Google, 5, 22, 31–40, 47–51
Government Performance and Results Act, 56–61
Greenleaf, Robert, 147–148

hacker ethic, 22, 26–40, 85, 90, 189
Haraway, Donna, 8, 73, 130, 150
Harper Brothers Publishing, 41
Hathitrust, 39
Haudenosaunee, 116, 127–128, 134, 163
healing, 142–146
historians, 1–2, 17, 45, 84, 93, 99, 108, 160
history, 10–12, 101, 160–168, 173–182
hope, 7, 90

hope labor, 87, 91–94, 96, 98–99, 103, 134
human remains, 165–166

imperialism, 168, 179
innovation, 22–24, 34–37, 43, 63, 100, 106, 111, 115–120, 134–138, 176, 189–191
Institute of Museum and Library Services, 55–62
interdependence, 9, 28, 115, 137–150, 190
internet, 4, 5, 33, 83, 145

key performance indicators, 45–49, 62–64
Kimmerer, Robin Wall, 128–129, 150–151

labor and work, 72, 79–112, 124–134, 153, 168, 187, 189–190
Levine, Caroline, 183–188
Liboiron, Max, 183–189
libraries, 1–3, 36–46, 55–59, 76, 93–95, 100–108, 118–120, 124, 135, 145, 153, 167, 170–172, 185
looted artifacts, 115, 156, 164–169, 178, 190

maintainers, 37–38, 118–119, 124–125
maintenance, 113–135, 138–139, 156–158, 178, 190–193
management consulting, 3, 24, 26–37, 45, 69, 76–78
manifest destiny, 17, 174–180
manifest dismantling, 116, 158, 174–180
Manifesto for Maintenance Art, 113–115, 134
Margulis, Lynn, 149–150
Maryland, 14, 99, 120, 195
Mattern, Shannon, 65–66
McNamara, Robert, 67–69
measurement, 44–46, 72–76
media, 10–13, 22, 29–42, 81–84

memory, 1–17, 26, 29–31, 34, 41–42, 52–53, 55, 84–85, 133–134, 145, 181–183, 192
metrics, 43–78, 117–118, 134, 172, 187, 191
millennials, 90–91, 103
Minnesota, 161–167
Mintzberg, Henry, 61–62, 74
Moneyball, 43–52, 74, 115, 189
Muller, Jerry, 45–47, 56–60, 68, 72
museums, 1–3, 36, 40, 46–48, 55–58, 93, 102–115, 120–124, 135–136, 152, 156, 164–176, 185

nationalism, 13–14
Native American Graves Protection and Repatriation Act, 162
nature, 67, 127, 138, 149–151, 175–180, 184–187, 191
necropolitics, 165–166

Odell, Jenny, 92–93, 116, 175–180
oppression, 151–157, 168, 171, 184, 192

Palantir, 46, 61–67, 73
patriarchy, 14, 17, 144, 153
Piepzna-Samarasinhala, Leah Lakshmi, 8–9, 142–143
Piscataway peoples, 195
platform monopolies, 22–25, 32–42, 71, 92
pollution, 9, 183–186
Powers, Devon, 181–183
precarity, 2, 5, 98, 143
privilege, 5, 15–16, 73–76, 80–83, 88, 94, 96, 99, 101–102, 108–112, 171, 174, 193
productivity, 97–99, 168, 172
publishing, 29–31, 40–46, 105, 193

quantification, 46, 55, 68–71
Queens Museum, 113–115

racism, 13–14, 73, 134, 151–152, 175–177

Raschke, Greg, 43–47, 61, 74
repair, 17, 115–116, 139, 156–180, 183–184, 190–195
reparative description, 170–172, 178
repositories, 12, 169
representational belonging, 11–14
resistance, 83–84, 134, 151, 162–163, 174, 178–179, 187
responsibilities, 96, 107, 141–145
restitution, 164
return, 115, 156–181, 186
revisionism, 13–14, 115, 157, 158–161, 174, 178
rights, 14, 64, 178
Riversdale plantation, 195
Russell, Andrew, 21, 37, 116, 118, 119

Scribes, 29–40
servant leadership, 146–148
settler colonialism, 9, 14, 17, 115, 134, 151, 157, 161–168, 179, 185–186, 192
seventh generation thinking, 116, 127–129, 133–134, 163
Shirky, Clay, 29–31, 41, 91
Silicon Valley, 4, 21–23, 26–27, 32, 42–48, 63, 70, 78, 84–85, 91, 108, 111, 193
Sinetar, Marsha, 88–90, 94
social justice, 7–9, 13, 17, 160, 169
software, 6, 10, 120–127, 133
Spotify, 31, 34–35
standpoint epistemology, 75–76, 111, 143, 193
Stanford University, 28, 39
statistical analysis, 43–45, 53, 67, 73, 115, 118
students, 28, 39, 53, 58, 60, 73, 82, 93, 99, 159, 193
surveillance, 28, 62–63
sustainability, 116, 121–133, 150, 192, 195
sweetgrass, 128–129, 150
symbiosis, 138, 149–150, 155
symbolic annihilation, 12

Uber, 3–4, 26

Taoyateduta (Little Crow), 161–166, 177
THATcamp, 82–83, 108, 120
The Wire, 46, 187–188
time management, 97–98
Tokumitsu, Miya, 89–94
tradition, 13, 26, 134, 145
Tronto, Joan, 139–141
Twitter, 1, 79–83, 100, 108
typewriter, 29–31, 32, 34

Ukeles, Mierle Laderman, 113–115, 134
Unicorns, 100–101
Unsustainable, 90, 99–101, 107, 119, 121, 130–133
Users, 35, 38, 70, 75, 97, 126, 143–148, 158
U.S. federal government, 14, 37, 45, 56–61, 103–104, 162, 174–178
Utopianism, 7, 27–28

Vietnam War, 28, 68
Vinsel, Lee, 21, 37, 100, 116–119
Violence, 116, 152–167, 190
vocational awe, 5, 80, 88–89, 94–96, 100

Wabanaki Confederacy, 179
water, 113, 131, 140, 150, 178
white supremacy, 14–17, 115, 153, 157–159, 182
white time, 168
Wired Magazine, 5–6, 38, 45, 84, 108

Yelton, Andromeda, 124
Youtube, 22, 29–31, 34, 40, 46, 49–56, 67
Yukatek Mayan peoples, 158, 173–174

Zeynep, Ton, 104–106
Zeynep, Tufekci, 51
Zookeepers, 95
Zuckerberg, Mark, 34, 70